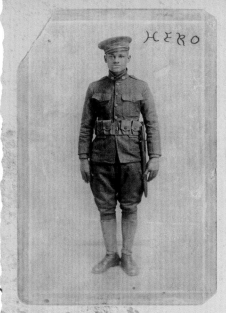

HERO

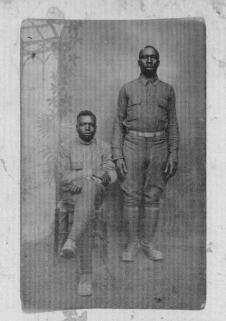

WE
RETURN
FIGHTING

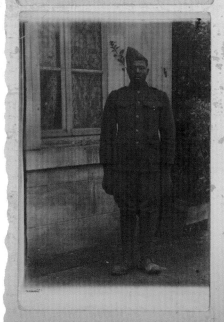

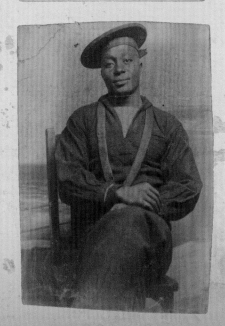

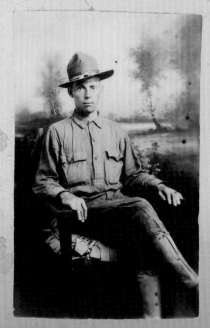

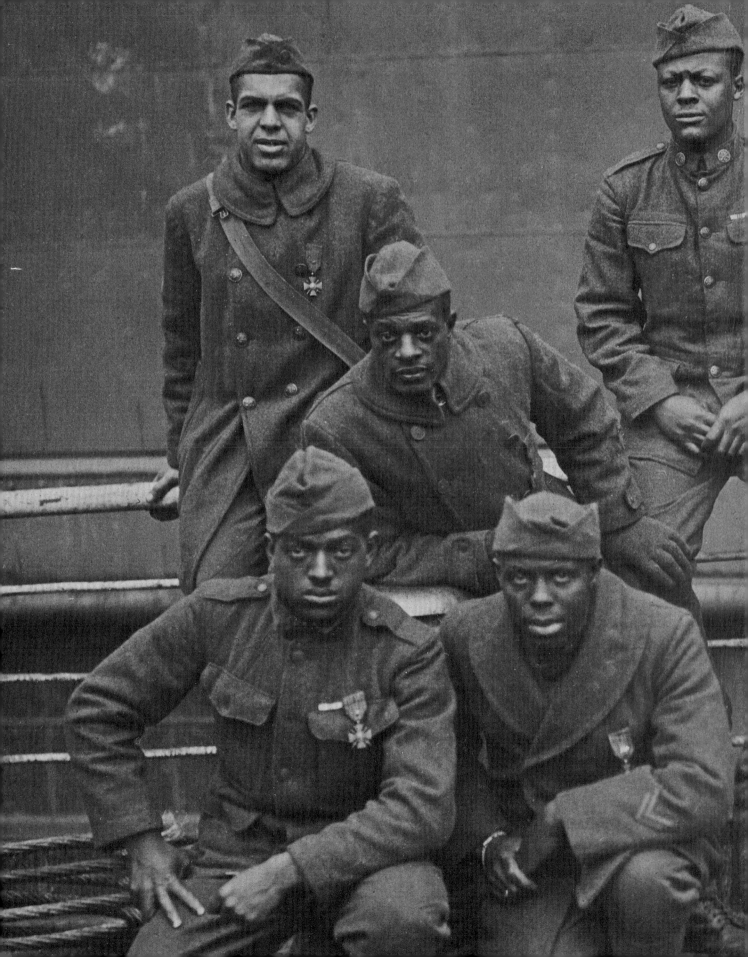

WE RETURN FIGHTING

WORLD WAR I AND THE SHAPING OF MODERN BLACK IDENTITY

Edited by Kinshasha Holman Conwill

Foreword by Philippe Étienne

Introduction and Epilogue by Lonnie G. Bunch III

Contributions by
Lisa M. Budreau, Brittney Cooper, John H. Morrow Jr., Krewasky A. Salter,
Chad Williams, Jay Winter, and Curtis Young

In Association with the National Museum of
African American History and Culture

Smithsonian Books

WASHINGTON, DC

Advising Editor: John H. Morrow Jr.
Profiles and object profiles by Krewasky A. Salter and Douglas Remley
Timeline by William Pretzer and Arlisha Norwood
Captions by Krewasky A. Salter, Patri O'Gan, and Douglas Remley

Published by Smithsonian Books
Director: Carolyn Gleason
Creative Director: Jody Billert
Senior Editor: Christina Wiginton
Editorial Assistant: Jaime Schwender
Designed by Gary Tooth / Empire Design Studio
Edited by Erika Büky and Laura Harger

National Museum of African American History and Culture
Founding Director: Lonnie G. Bunch III
Deputy Director: Kinshasha Holman Conwill
Publications Team: Jaye Linnen and Douglas Remley

This book may be purchased for educational, business, or sales promotional use. For information, please write: Special Markets Department, Smithsonian Books, PO Box 37012, MRC 513, Washington, DC 20013

Manufactured in Canada, not at government expense
23 22 21 20 19 1 2 3 4 5

Library of Congress Cataloging-in-Publication Data

Names: National Museum of African American History and Culture (U.S.), author. | Conwill, Kinshasha, editor. | Bunch, Lonnie G., writer of introduction. | Morrow, John Howard, 1944- contributor. | Salter, Krewasky A., 1962- contributor.

Title: We return fighting : World War I and the shaping of modern Black identity / National Museum of African American History and Culture ; edited by Kinshasha Holman Conwill ; introduction by Lonnie G. Bunch III ; contributions by John H. Morrow Jr. and Krewasky A. Salter.

Description: Washington, DC : Smithsonian Books, [2019] | Includes bibliographical references and index. | Summary: "A richly illustrated commemoration of African Americans' roles in World War I highlighting how the wartime experience reshaped their lives and their communities after they returned home"-- Provided by publisher.

Identifiers: LCCN 2019020417 (print) | LCCN 2019980989 (ebook) | ISBN 9781588346728 (hardcover) | ISBN 9781588346797 (ebook)

Subjects: LCSH: World War, 1914-1918--Participation, African American. | World War, 1914-1918--African Americans. | African American soldiers--History--20th century. | African Americans--History--1877-1964. | World War, 1914-1918--Influence. | African Americans--Civil rights--History--20th century. | African Americans--Race identity. | Blacks--Race identity--United States.

Classification: LCC D639.N4 N38 2019 (print) | LCC D639.N4 (ebook) | DDC 940.3/7308996073--dc23

LC record available at https://lccn.loc.gov/2019020417

LC ebook record available at https://lccn.loc.gov/2019980989

Half title page: Photographs of African American soldiers, sailors, and nurses during World War I, 1916-19.

Title page: Soldiers of the 369th Infantry Regiment (Harlem Hellfighters) proudly wearing the Croix de Guerre they were awarded for gallantry in action on the battlefields of France, 1919.

Page 16: Soldiers of the 317th Supply Train (92nd Infantry Division) watching German planes in the skies above Belleville, France, October 1918.

Page 48: The 367th Machine Gun Battalion passing through St-Menehould, France, en route to the Argonne front, September 15, 1918.

Page 96: Crowds watch as the 369th Infantry Regiment marches through New York City during a victory parade, February 17, 1919.

Contents

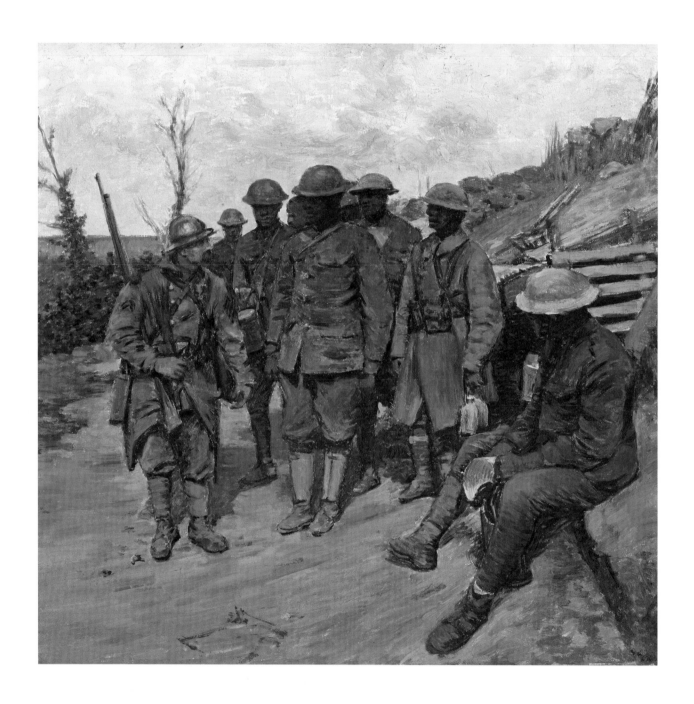

Joseph-Félix Bouchor was embedded with the Allied forces as a war artist. This painting, *Gassed French Infantry-man Alerting African American Soldiers* (1931), depicts a French soldier with African American soldiers of the 370th Infantry Regiment near Vauxaillon, France.

Foreword

One hundred years ago, France and the rest of the world were healing the wounds of a unique conflict of extraordinary dimensions. The exhibition "We Return Fighting: The African American Experience in World War I," organized by the National Museum of African American History and Culture, concludes, in a remarkable way, the commemoration of the centennial of World War I by acknowledging and paying tribute to the role of African Americans during the war and in the years that followed. We remember the sacrifice of all those who crossed the Atlantic to serve in France, especially the brave soldiers from the four African American units of the 93rd Infantry Division, who fought under French command, with French equipment and arms. The critical involvement of these men in combat earned the members of the legendary 369th Infantry Regiment—nicknamed the Harlem Hellfighters—the coveted French Croix de Guerre.

Beyond their valor during the war, the presence of these soldiers on French soil forever marked the French cultural landscape and started what can be described as a love story between Paris and the African American community, far from then-segregated America. African American soldiers in France brought with them elements of their own culture, and Paris became obsessed with jazz and black cultural heritage. During the interwar period, in particular, all emerging aspects of African American culture were welcomed and celebrated.

It is a great honor for the Embassy of France to be a partner of the National Museum of African American History and Culture, a museum that is distinguished by its ambition to undertake significant educational and cultural projects such as this one, and of course, by the quality of its collections. Organized with the support of France's First World War Centennial Mission, this exhibition shows that the Great War was a moment of confrontation with the "other," mixing races, nationalities, and cultures, profoundly changing the course of events and making this period unique in modern history.

Philippe Étienne
Ambassador of France to the United States

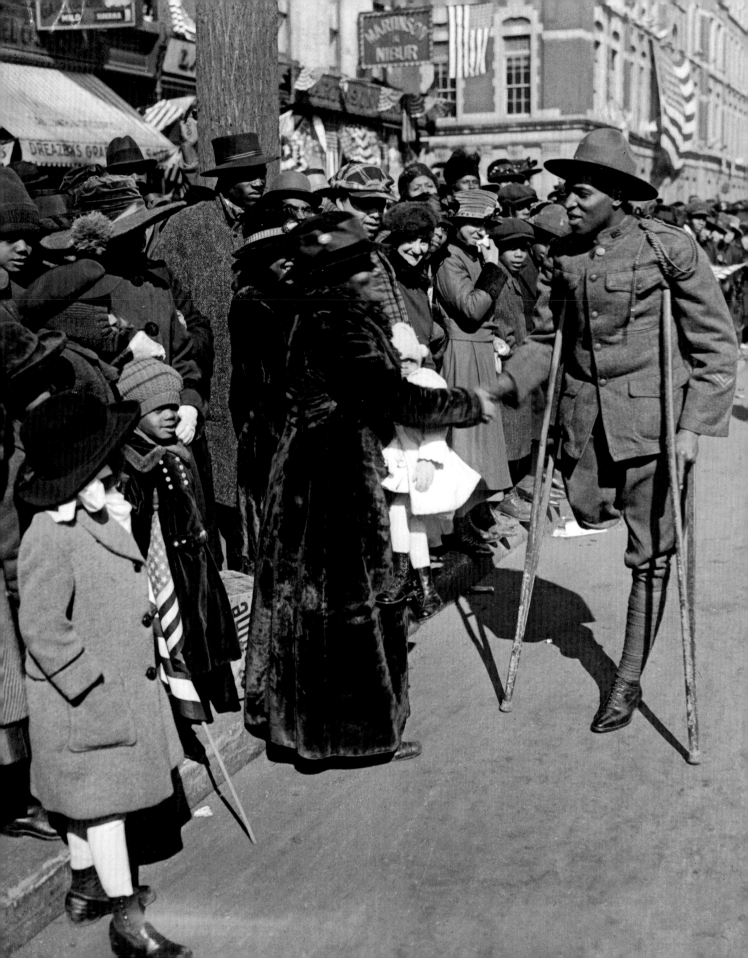

Introduction

When I was a small child, my grandfather would read to me before bedtime. Among my favorite books was a pictorial history by Emmett Scott titled *The American Negro in the World War*, which entranced me with its photographs, including one of an African American soldier recently returned from battle at the European front. Marching along New York's Fifth Avenue in a homecoming parade in the winter of 1919, he has stopped to shake the hand of a woman in a long fur coat. At first I focused on the woman: with her wide smile and slight build, she looked just like my grandmother. Only later did I focus on the soldier himself: he is on crutches, and his right leg is missing below the thigh. Serving in the military, I realized then, was not only about valor and victory celebrations for returning warriors. It was also about sacrifice.

The sacrifices that African Americans made in World War I, and the ways that the war transformed the soldiers themselves, might seem distant to Americans today. The war ended more than a century ago, on November 11, 1918, and it now seems a conflict remote in our history, fought far from American shores. Nonetheless, it remains a central and transformative episode in the African American experience, and thus the Smithsonian National Museum of African American History and Culture has chosen to devote an exhibition to it.

Although American involvement in World War I lasted only about nineteen months, it proved to be an economic and cultural watershed for the United States and for black Americans in particular. Black soldiers had served in all of the nation's wars, from the Revolutionary War to the Civil War, the Spanish-American War of 1898, and the Philippine-American War of the following year. With a few exceptions, including some battles during the Revolution, they served in segregated units, and this pattern continued in World War I. Yet their sheer numerical presence in the US ranks—more than 200,000 black soldiers served among the 2 million soldiers of the American Expeditionary Force on the war's Western Front before the Armistice—meant, almost inevitably, that their wartime experience would reshape the lives of millions, both the soldiers and members of their communities, when they returned home.

Not only did African Americans such as the famed Harlem Hellfighters of the 369th Infantry Regiment prove what black combatants could achieve, but black soldiers in Europe, especially in France, enjoyed a level of respect not afforded them by the US military. Even those who had volunteered for service (out of both patriotism and a hope

A wounded soldier of the 369th Infantry (known as the Harlem Hellfighters) is welcomed home at the February 17, 1919, victory parade in New York.

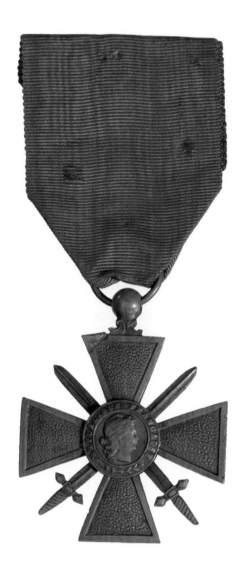

France recognized the valor of the 369th Infantry Regiment by awarding each of its members the Croix de Guerre. The unit fought with distinction on the front lines in France for 191 consecutive days and suffered more than 1,400 casualties.

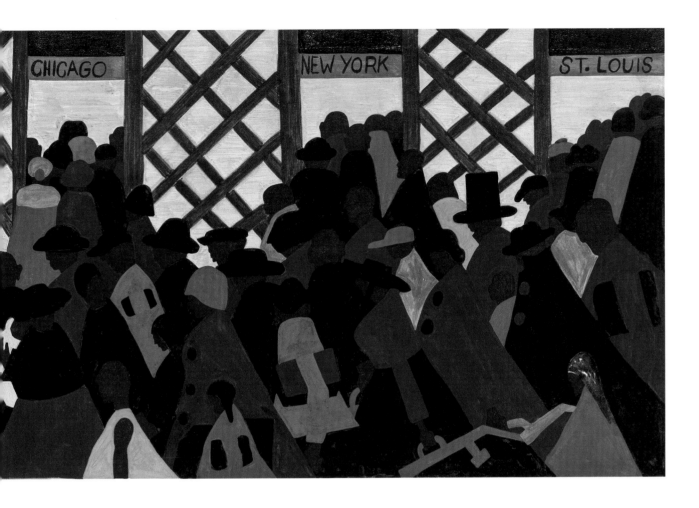

that military duty would advance the cause of full citizenship for African Americans at home) often found themselves relegated by American commanders to labor and support duties. By contrast, African American fighting units seconded to the French army received combat training and served on the front lines. Whereas the French awarded members of the Harlem Hellfighters the Croix de Guerre, France's highest military honor, as well as 170 other medals, the United States awarded very few medals to any black soldiers for their service in World War I—and often not until decades later.

On the domestic front, the war overlapped with and drove the first wave of the Great Migration, from 1914 until the Great Depression, in which hundreds of thousands of black people moved from the Southern states to urban areas of the North, gaining new economic and cultural power but also confronting prejudices and political barriers even in places where Jim Crow segregation (legitimized by the catastrophic *Plessy v. Ferguson* decision of the US Supreme Court in 1896) did not reign. The war economy played a significant role in this population shift, as white workers departing for the European battlefronts left factories with thousands of vacancies that were filled by black Southerners.

The great cultural flowerings in the North, including the Cultural Renaissance of the 1920s, were made possible by burgeoning new black urban communities. Black newspapers such as the *Chicago Defender*, the *Pittsburgh Courier*, and the *Washington Bee*

Jacob Lawrence's *The Migration Series* (1940–41) evokes the excitement and movement of African Americans departing for the North during the Great Migration. The piece shown above, *Panel 1: During World War I there was a great migration north by southern African Americans,* is one of sixty panels.

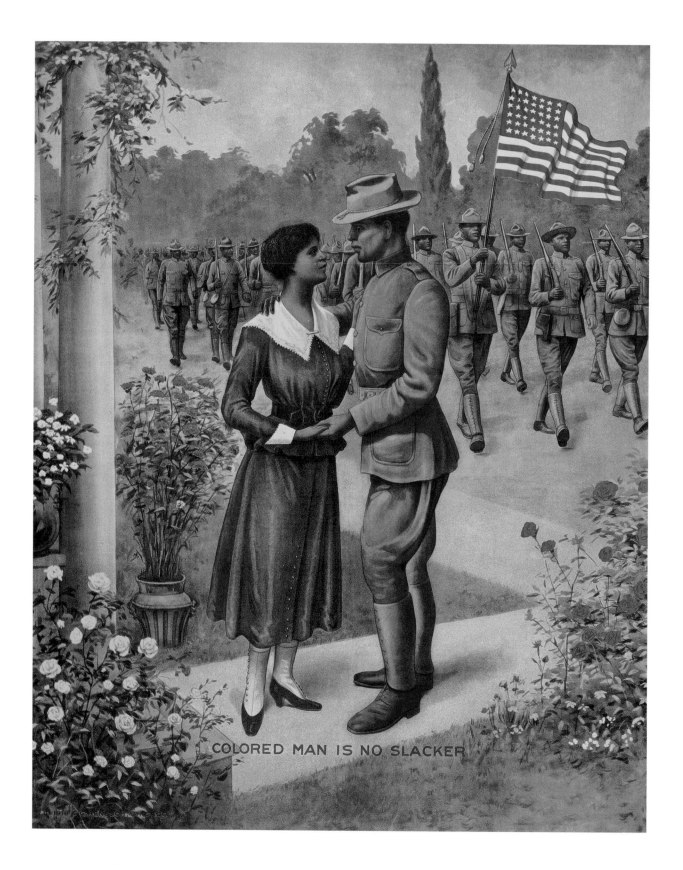

COLORED MAN IS NO SLACKER

highlighted new economic opportunities and encouraged African Americans to leave behind the pain and hatred of the South. In those papers, too, readers encountered accounts of black soldiers fighting abroad, in stories that celebrated each African American military achievement as another crack in the wall of American oppression.

Despite the general disregard in which the US military held its own black soldiers, some change was apparent during the war years. The military began to appeal to black recruits using the same tactics and language that they directed toward white men. "The Colored Man Is No Slacker!" read one Army recruitment poster, showing a black soldier bidding a gallant farewell to his wife and family as his brothers in arms march proudly behind him. Opportunities for black soldiers increased: the Fort Des Moines Provisional Army Officer Training School accepted its first class of black officer candidates in 1917 and graduated hundreds of black captains and lieutenants. The four all-black segregated regiments in existence before the war (the 9th and 10th Cavalry and the 24th and 25th Infantry), whose role was limited to support functions, were augmented by the establishment in 1917 of the 92nd and 93rd Combat Divisions. Battlefield experience and officer training encouraged some young African American soldiers to stay in service after the war.

Overall, however, the country to which black soldiers returned after November 1918, ready to claim the rights to which their service entitled them, was little different from the one they had left. Indeed, the summer of 1919 was wracked by antiblack riots across the nation. Lynchings rose sharply; their victims included black veterans. The stories of many individual African American soldiers are scarred by postwar mistreatment: Private Needham Roberts, decorated for valor by the French for his service in 1918, could not obtain steady employment when he returned disabled from the war. Corporal Freddie Stowers of the Hellfighters, recommended for the Medal of Honor for valor against German infantry in the battle that killed him, was awarded the medal only in 1991. The US military itself was not desegregated until 1948, after a second World War had once again wracked the globe.

The objects, artifacts, medals, and photos in *We Return Fighting* not only remind viewers of the central role of African American soldiers in the war that made their country a world power. They also reveal the way the conflict reshaped black Americans' views of ourselves, lending weight to our longstanding efforts to demand full civil rights and to stake our place in the country's cultural and political landscape. The essays in this book capture the depth and breadth of the experience of African Americans during what was called the Great War—a war that changed the tint and tone of US urban centers, including New York, Newark, Chicago, Detroit, Los Angeles, and Oakland, and a war, now too little remembered, that transformed a nation and a people. I hope this book encourages America to remember, much as I have always remembered that picture of a wounded black soldier.

Lonnie G. Bunch III
Secretary of the Smithsonian

In War and Peace:
A Century of Challenge and Change—1863–1963

William Pretzer and
Arlisha Norwood

Open to see timeline. ➤➤

Panoramic photographs
were created regularly
during World War I to
document entire units,
war-torn landscapes, and
military installations.
These photographs
depict a detachment of
the 372nd Infantry at
Camp Custer in Battle
Creek, Michigan, in 1918
(top) and the 365th
Infantry and 350th
Machine Gun Battalion in
formation at Camp Grant
in Rockford, Illinois, in
1918 (bottom).

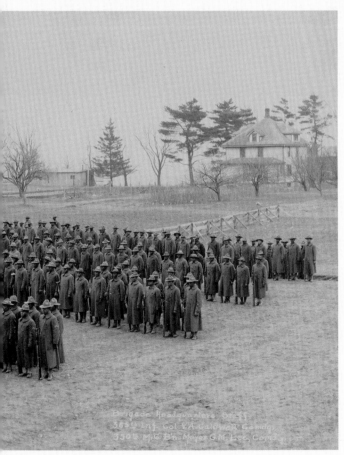

Brigade Headquarters Staff
368th Inf. Col. V.A. Gilpin, Comdg.
350th M.G. Bn. Maj. O.N. Lee, Comdg.

In War and Peace
A Century of Challenge and Change—1863-1963

1863: Emancipation Proclamation
President Abraham Lincoln issues the Emancipation Proclamation, freeing enslaved African Americans in Confederate states.

1863: Creating the United States Colored Troops
The US War Department establishes the Bureau of Colored Troops in May and recruits African Americans along with some Asian Americans, Native Americans, and Pacific Islanders for the Union military.

1865: Confederate Surrender
Confederate General Robert E. Lee surrenders to Union General Ulysses S. Grant at Appomattox Courthouse, Virginia, ending the Civil War.

1863 1865

1919: Red Summer
Between April and November, more than two dozen anti-black riots erupt across the nation. White suprema-cists murder more than two hundred African Americans, injure hundreds more, and destroy homes and businesses in cities like Chicago and Washington, DC.

1919: Pan-African Congress
W. E. B. Du Bois and Ida Alexander Gibbs, the African American wife of a prominent African American diplomat, organize a Pan-African Congress in Paris. The congress unsuccessfully insists that the liberation of African nations from colonial rule be included in the peace treaty.

1919: H R
T A 36 pa a t "t

1931: The Scottsboro Boys
Nine black teenagers are wrongfully accused of raping two white women near Scottsboro, Alabama. After a series of trials and appeals, the young men are released after spend-ing an average of ten years each in jail. The case results in significant Supreme Court decisions regarding the right to adequate counsel and to an unbiased jury.

1931

1939: World War II Begins
In September, Germany invades Poland, leading Britain and France to declare war on Hitler's Nazi state. Hitler intends to occupy Poland to provide *lebensraum*, or "living space," for the "racially superior" German people.

1943-1944: Pioneering Black Units
The Tuskegee Airmen, African Americ pilots trained by the US military, enga in their first combat missions. A year later, two African American units that had served in WWI, the 92nd and 93r Divisions, deploy overseas. That same year, the African American Montfort Point Marines serve in the South Paci

1939

1941 1943–1944

1941: Desegregating Wartime Industries
Pressured by African American labor and civil rights leader A. Philip Randolph, President Franklin D. Roosevelt signs Executive Order 8802, prohibiting discrimination in wartime industries.

1941: United States Enters the War
After the Japanese attack Pearl Harbor, Hawaii, on December 7, the United States declares war on Japan on December 11. Germany declares war on the United States the same day, and the United States finds itself in a two-front global war. Eventually, fifty nations will be at war.

1866: Army Reorganization Act of 1866
After the Civil War, Congress creates for the first time all-black military units, the so-called Buffalo Soldiers, as permanent elements of the regular army.

1868-1870: Fourteenth and Fifteenth Amendments
The Fourteenth Amendment extends the rights of citizenship to formerly enslaved African Americans and guarantees all citizens equal rights and protection under the law. The Fifteenth Amendment explicitly forbids the denial of the right to vote of any citizen based on race, color, or previous condition of servitude.

1875: Civ
Co
Rig
ing
jur
tra
dat
Cou
und
way
rac

365: Thirteenth Amendment
The states ratify the Thirteenth Amendment to the Constitution, abolishing slavery and all forms of indentured servitude, except as a punishment for a criminal conviction.

1866

1868–1870

18

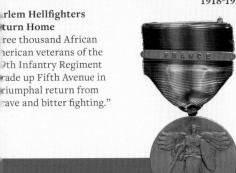

rlem Hellfighters turn Home
ree thousand African merican veterans of the 9th Infantry Regiment rade up Fifth Avenue in riumphal return from rave and bitter fighting."

1918-1919: The Armistice and the Treaty
The Allies and Germany agree to a cease-fire in November 1918. But the war officially ends in June 1919 with the Treaty of Versailles. The treaty redraws national boundaries and forces Germany to pay reparations and relinquish control of its colonial territories.

1917: African Americans in Combat
The segregated 92nd and 93rd Infantry Divisions are activated in late 1917 and see combat in France the next year, notably in the Meuse-Argonne and Oise-Aisne offensives. The 369th Infantry Regiment, the Harlem Hellfighters, is assigned to the French army, whose officers train and command them in battle.

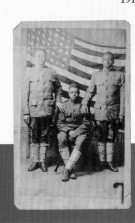

919

1918–1919

1945: Six Triple Eight Delivers
The all-black, all-female 6888th Central Postal Directory Battalion deploys to France. They develop an innovative tracking system using individual serial numbers to clear a six-month backlog of millions of pieces of undelivered mail in three months.

1948: Truman's Executive Order 9981
Influenced by postwar racial violence, A. Philip Randolph's opposition to a Jim Crow military, and a presidential commission on civil rights, President Harry S Truman orders the desegregation of the US armed forces.

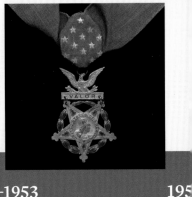

an
ge

1945: World War II Ends
Germany agrees to an unconditional surrender on May 8, 1945, and the war officially ends when Japan surrenders on September 2, 1945.

c.

1945

1948

1950–1953

195

1950–1953: Korean War
In 1950, North Korean troops cross the 38th Parallel and invade South Korea, initiating three years of conflict that results in a stalemate. The last segregated units in the United States military are disbanded during the brutal fighting, in which more than five thousand African Americans die.

1954:

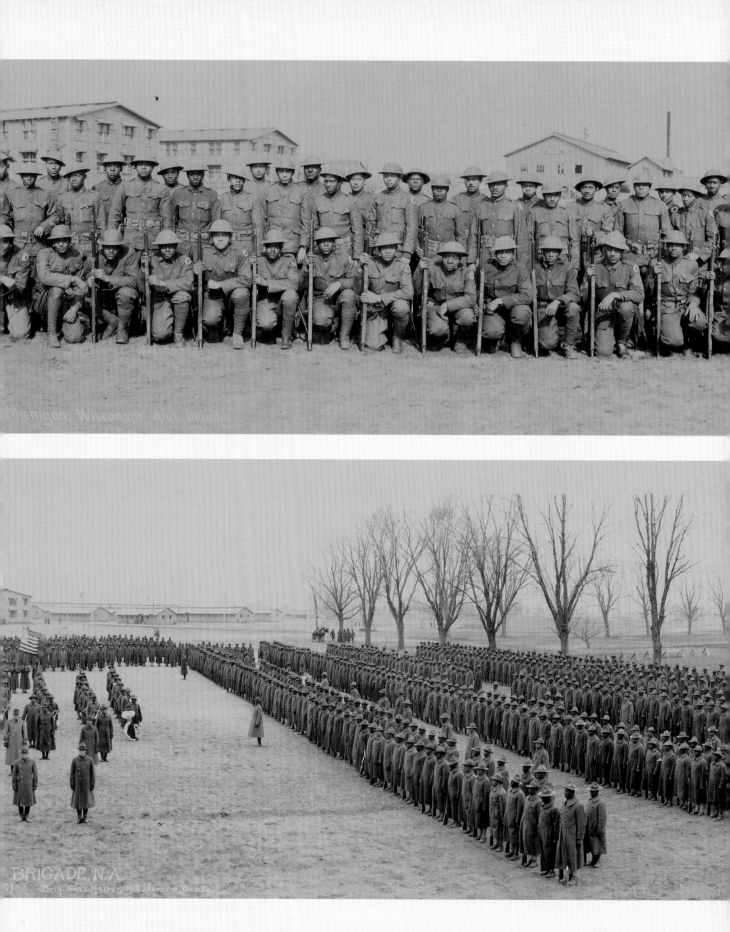

Michigan, Wisconsin and Indiana

BRIGADE, N.A.
Brig. Gen'l Malvern Hill Barnum, Comd.

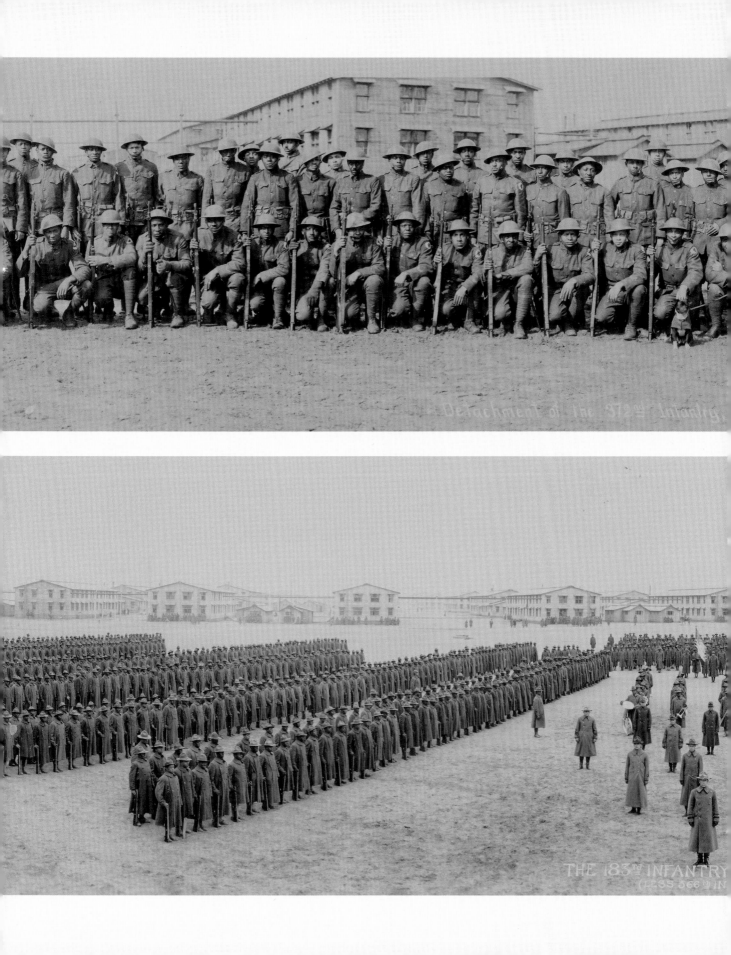

A Detachment of the 372nd Infantry.

THE 183RD INFANTRY
(LESS 566 9 IN

Compromise of 1877

il Rights Act of 1875
gress passes the Civil
ts Act of 1875 guarantee-
equal treatment in voting,
selection, and public
sportation and accommo-
ons. In 1883, the Supreme
rt declares this legislation
onstitutional, clearing the
for the states to codify
al segregation.

Compromise of 1877
To resolve a contested presidential
election, the Democratic Party
agrees to the election of a
Republican, Rutherford B. Hayes,
in exchange for the removal of all
Union troops from Southern
states. The compromise allows the
Democratic Party to dominate the
South and leaves African
Americans without protection
from racist violence.

**1895: Washington's Atlanta
Compromise Speech**
Booker T. Washington delivers
his "Atlanta Compromise
Speech" before a predominantly
white audience at the Cotton
States and International
Exposition in Atlanta. Publicly,
he advises African Americans
to focus on agricultural work
and vocational training but
privately he funds lawsuits
promoting civil rights.

1896: *Plessy v. Fergus*
"Separate but
In *Plessy v. Fergu*
Supreme Court
endorses racial
public facilities
the "equal prote
of the Fourteen
ment applies on
and civil rights.

75 **1877** **1895** **1896**

1917: Russian Revolutions
In February, members of the
imperial parliament oust Czar
Nicholas and establish the
Provisional Government. In
October, the Bolsheviks, led
by Vladimir Lenin, overthrow
the Provisional Government
and in March 1918 sign a peace
treaty with Germany.

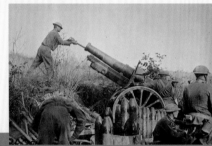

**1917: United States Enters
World War I**
The US maintains its neutrality
during the war's early years.
Public opinion shifts dramatically
in April when the Germans
resume unrestrained submarine
warfare and the British expose a
secret German proposal to align
with Mexico against the US.

1914–1920: The Great Migration
Escaping the violent r
poverty of the South,
half a million black Sc
to the North during a
World War I. Over the
five million more Afri
will migrate, creating
of African American c
urban North.

1917

**1955–1956: Rosa Parks and the
Montgomery Bus Boycott**
The civil rights activist Rosa Parks
is arrested for refusing to give up
her seat on a segregated city bus
in Montgomery, Alabama. A
381-day boycott of the bus system
ends when the Supreme Court
rules the local segregation laws
unconstitutional.

**1960: African National Liberation
Movements**
After decades of pan-African anti-
colonial agitation, including violent
uprisings, nearly twenty African
nations gain their independence
in 1960, dismantling much of the
European colonial system and
inspiring African American civil
rights activists.

**1960: Founding the Student Nonviolent
Coordinating Committee**
Inspired by the sit-in movement,
African American students convene
at Shaw University in Raleigh, North
Carolina. Encouraged by veteran
activist Ella Baker, the students
establish the Student Nonviolent
Coordinating Committee (SNCC),
quickly organizing grass-roots activists
and promoting voter registration.

**FR
R
C**

4 **1955–1956** **1960** **1961**

Brown v. Board of Education
The Supreme Court issues a unanimous
decision declaring segregated schools to
be a violation of the Fourteenth Amend-
ment. The landmark ruling overturns the
1896 *Plessy v. Ferguson* decision that gave
constitutional protection to "separate but
equal" public facilities.

1960: Sit-in Movement
Four African American college
students stage a sit-in at a
segregated Woolworth's lunch
counter in Greensboro, North
Carolina. The sit-in movement
soon spreads to college towns
throughout the South.

1961: Freedom R
Organized
(CORE), b
interstate b
challenge s
Birmingha
white gang
the authori

**on Codifies
"qual"**
...son, the
...explicitly
...egregation in
...by ruling that
...ction" clause
...h Amend-
...y to political

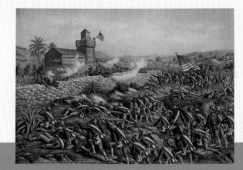

1898: Spanish-American War
Intervening in the Cuban war of independence against Spain, the United States defeats Spanish forces in the Caribbean and Pacific. The Buffalo Soldier regiments contribute to significant victories in Cuba. The United States acquires the former Spanish territories of Puerto Rico, Guam, and the Philippines.

1905: Niagara Movement
A group of black activists including W. E. B. Du Bois and William Monroe Trotter gather near Niagara Falls to form an organization dedicated to eradicating segregation, inequality, and violence through social and political agitation.

1898

1905

...cism and rural
...pproximately
...therners flee
...d shortly after
...ext five decades,
...an Americans
...ew centers
...lture in the

1914: World War I Begins
After the assassination of Archduke Franz Ferdinand by a Serbian nationalist, Austria-Hungary declares war on Serbia, setting off conflict among European nations that extends into their colonies in Africa and the Caribbean.

1913: Segregating the Federal Government
Ignoring his promise of "fair dealing" for African Americans, President Woodrow Wilson asserts that segregation benefits black Americans. He denies them promotions and permits his cabinet secretaries to segregate their departments.

1909

1909: National Association for the Advancement of Colored People
Inspired by the Niagara Movement and outraged by continual racial violence, veterans of the Niagara Movement join with white progressives to form the National Association for the Advancement of Colored People (NAACP).

1914

1913

1963: March on Washington for Jobs and Freedom
In August, a quarter of a million Americans gather peacefully on the National Mall in Washington, DC, to demand economic opportunity and racial equality.

1963: 16th Street Baptist Church Bombing
Just weeks after the March on Washington, members of the Ku Klux Klan (KKK), a white terrorist organization, bomb Birmingham's 16th Street Baptist Church, killing four young African American girls. Public outrage increases support for civil rights legislation such as the Civil Rights Act of 1964.

1963

...des
...y the Congress of Racial Equality
...k and white activists ride
...es into the Southern states to
...regation. In Anniston,
... and Montgomery, Alabama,
...ttack the Freedom Riders while
...es look the other way.

1963: Malcolm X Delivers His "Message to the Grassroots"
Speaking before a leadership conference in Detroit in December, Malcolm X delivers one of his most influential speeches, critiquing the civil rights movement and outlining his philosophy of black nationalism.

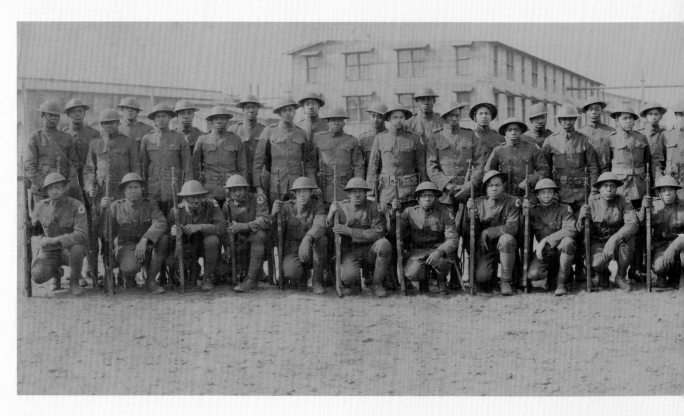

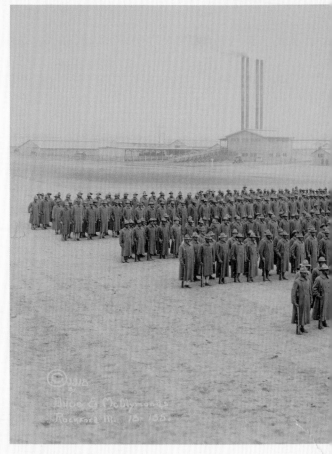

Chapter 1

A Global War

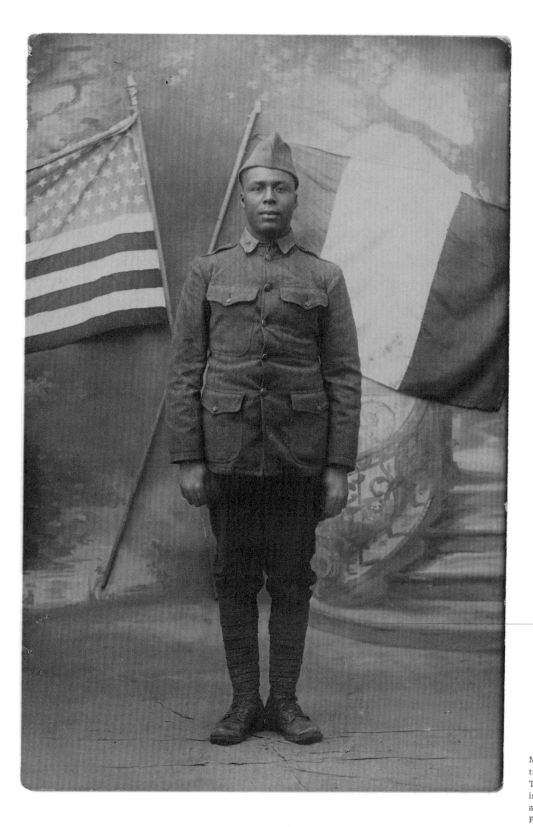

Many African Americans took patriotic pictures. This unidentified soldier is proud to be American and of his service to France as he stands before the American and French flags.

A Global War

Jay Winter

When the European powers went to war in August 1914, no one knew that the conflict would tear the world apart. And yet there were precedents to indicate what was in store when massive armies fought an industrialized war. The Balkans had had two such wars in 1912 and 1913; the Japanese defeated the Russians in 1904, and the bloodbath of the American civil war pointed to what was to come. And yet the leaders of all the great powers in Europe went to war believing it would be over in a few months.

No one knew, and few even imagined, that this global war would profoundly affect American history in general and African American history in particular. Only in recent years have historians uncovered and documented the role of African Americans in the first all-out war between the industrialized nations of the world.

In 1914, war seemed a natural extension of political divisions, arising in part out of popular beliefs in armed conflict as a test of a nation's vitality. Imperial expansion was seen as both the right and the duty of white Europeans, bringing "civilization" to Africans and Asians alike, often by brutal means. In Europe, nationalist movements threatened to tear apart the multinational Austro-Hungarian Empire, Germany's primary ally.

The initial crisis of the summer of 1914 did not touch American national interests in any major way. The first flashpoint was the assassination of Archduke Franz Ferdinand, the heir to the throne of Austria, by Serbian student terrorists in the Balkans. In retaliation, with German backing, Austria gave Serbia an ultimatum it was sure to reject, and on that basis went to war.

What turned this conflict from a minor regional skirmish into a global war was Germany's alliance with Austria-Hungary. When Germany backed Austria's punitive policy against Serbia, it gave Russia, a Serbian ally, the difficult choice of either acquiescing in the humiliation of Serbia or taking action. After much equivocation, Czar Nicholas II decided to act. His order for partial mobilization of his armies triggered the German response of mobilizing troops both on Germany's Eastern Front, facing Russia, and on the Western Front, facing Russia's principal ally, France.

The German high command had but one attack plan: to defeat France before Russia fully mobilized its giant army. The idea was to strike at France through Belgium and then turn south to sweep up the French army near Paris. When Germany attacked on August 4, 1914, Britain joined the war not primarily to defend little Belgium, which was

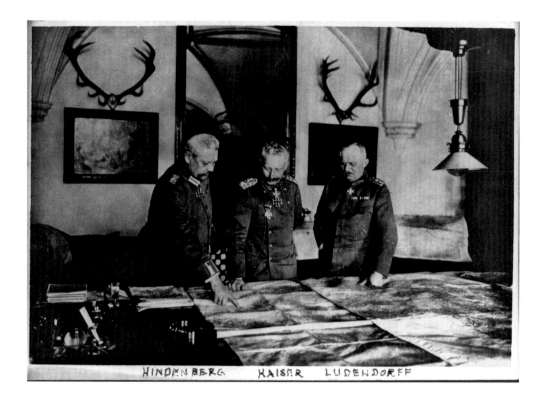

HINDENBERG. KAISER LUDENDORFF

the pretext at the time, but to prevent a German victory over France. Such a victory would have put the German naval fleet on the English Channel and thereby threatened British food imports, which at the time constituted 75 percent of the British food supply. And when Britain joined the war, so did its global dominions—including Canada, Australia, New Zealand, and South Africa—and its informal empire—formally independent territories over which it exerted economic and indirect political control arising out of a century of investments, such as Argentina, Egypt, and China.

Thus, from the very first day of the conflict, the European war was a global war. Yet that was not what any of the major powers had intended. They had failed to see that they could not contain the conflict between Austria and Serbia: they were tied into a system of alliances that embroiled all of Europe—and therefore, given the nature of empire, all of the globe—in war.

Among the many failures of European statesmanship, the blindness of the political and military leadership of imperial Germany stands out. Germany wanted to expand its colonial holdings, but Britain stood in its way. Despite Kaiser Wilhelm II's massive expansion of the German naval fleet, it was still no match for Britain's Royal Navy, which did indeed rule the waves. Moreover, Germany needed the resources of a global empire to win the war, but its colonies and other possessions paled in comparison to those of the British and the French. Germany's only hope was to win the war right away. If the short war failed, leading to a war of endurance whose outcome would be determined by wealth, food, and labor resources, the German and Austrian cause was doomed. And, indeed, the Germans lost the short war of 1914 and so faced the nightmare its leaders had hoped to avoid: a war on two fronts, spanning the European continent.

Above: General Paul von Hindenburg and General Erich Ludendorff, commanders of the German Army, are shown with Wilhelm II, emperor of Germany and king of Prussia, at German General Headquarters in Pless, January 1917.

Above right: Stereograph of a trench in France by the Keystone View Company. Trench warfare came to define World War I. Although trenches provided some protection from artillery fire, soldiers were still vulnerable to poison gas and bombs.

Right: Entrenching tools were a part of every soldier's field pack. They were used to dig trenches, latrines, and graves, and could also be used as weapons if necessary.

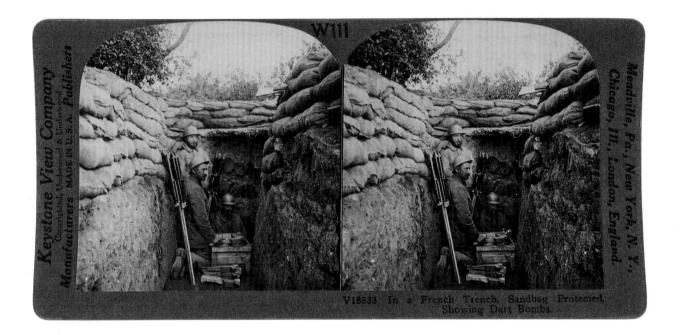

V18833 In a French Trench, Sandbag Protected, Showing Dart Bombs.

The Schlieffen plan—the German attempt to destroy the French army in forty-two days—failed. In early September 1914, the German army retreated from the Marne River and started to build fortifications thirty miles to the north, on the river Aisne. Wherever there was high ground, the German army dug in, and after failed attempts by each side to outflank the other, the Western Front was born. German troops turned it into a line that the French and British armies could not breach.

In Eastern Europe, a Russian invasion of eastern Prussia was defeated at the battle of Tannenberg in August 1914, transforming the new commanders of the German army in the east—Paul von Hindenburg and Erich Ludendorff—into heroic figures symbolizing German invincibility. But this victory was deceptive. It was not the work of the two new commanders, but of a staff officer, Max Hoffmann, and it was a defensive victory, which pushed the Russians out of German territory but did nothing to end the war.

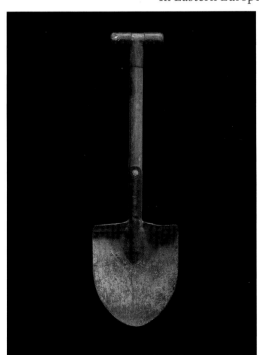

Artillery was the dominant weapon in World War I. Its primary role was to stop infantry advances, and it was responsible for roughly 80 percent of deaths in combat. For three years, massive barrages by the German army repulsed every major attack by the Allies on the Western Front. But the Allies had the guns to reply in similar fashion, frustrating several major German offensive operations.

The war was not going to be won by breakthrough, with holes punched in enemy lines that would have enabled a return to mobile warfare. Instead, trench warfare was the rule. It entailed the confinement of millions of men in underground and surface positions stretching four hundred miles, from Belgium

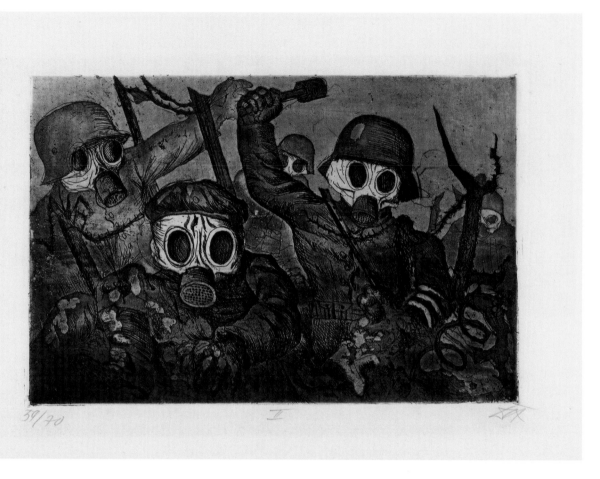

to the Swiss border, which afforded protection from both daily sniper and artillery fire and from infrequent attempts to break through enemy lines. Almost all such attempts failed. In 1915 the Germans tried to achieve a breakthrough by the introduction of poison gas at Ypres, in Belgium. The attempt failed in part because gas is a difficult weapon to control. When the wind changed direction, the German army got a dose of their own medicine. This failure did not deter the Allies from deploying poison gas as well, but chemical warfare failed to bring either side an advantage. After one year of war, roughly one million men had died in combat. And yet the Western front was immovable.

At the French town of Verdun in February 1916, the German army launched a massive offensive; in July 1916, the British and the French did the same to the north, on the Somme River. Both failed, with huge numbers of casualties. On the Eastern Front, a major Russian offensive in Galicia, in what is now Ukraine, also failed, leaving both the Russian attackers and the Austrian defenders exhausted. Yet none of the military leaders on either side gave up their dogged belief in an ineffectual strategy.

The strategy was doomed because the second industrial revolution of the 1880s and 1890s enabled both sides to produce the largest arsenal of massive guns and shells the world had ever seen. Advancements in metallurgy played a part in this development, as did the birth of assembly-line mass production. Accurate over a range of more than a dozen miles, these weapons could obliterate any infantry attacks launched by the other

Years after the war, the expressionist artist Otto Dix created a series of etchings titled *Der Krieg* (The War) depicting the horrors he witnessed as a soldier in the German army. This print, *Shock Troops Advance under Gas* (1924), depicts a German assault battalion throwing grenades while under a gas attack.

side. The Great War was dominated not by machine guns and bayonets but by heavy artillery. The fact that infantry attacks could be wiped out by artillery fire gave defensive operations a striking advantage over offensive operations. Only in 1918 would the use of air power and tanks change this balance, but that change took time, and a sea of blood flowed over Europe before it happened.

By the early days of 1917, over four million men had died in combat, and more than eight million had been wounded. Millions more had been mobilized to fill the gaps in the line. Women moved into industrial work to fill the vacancies left by men who went to fight (though at the end of the war the women were sent home again). Populations that were bereaved and exhausted by the effort to provide the armies with men and guns began to wonder whether the war would ever end. What price victory? was a question everyone asked and no one could answer.

The entry of the United States into the war in 1917 was reluctant and a long time coming. It was primarily a result of German arrogance and miscalculation on many levels. The impasse on the Western Front led the German leadership in early 1917 to bypass sober opinion and engage in a reckless attempt to throttle the British economy by waging unrestricted submarine warfare against shipping in the North Atlantic.

Earlier in the war, with its naval fleet penned up in the Baltic Sea by the Royal Navy, Germany had turned to submarine warfare to change the balance of power.

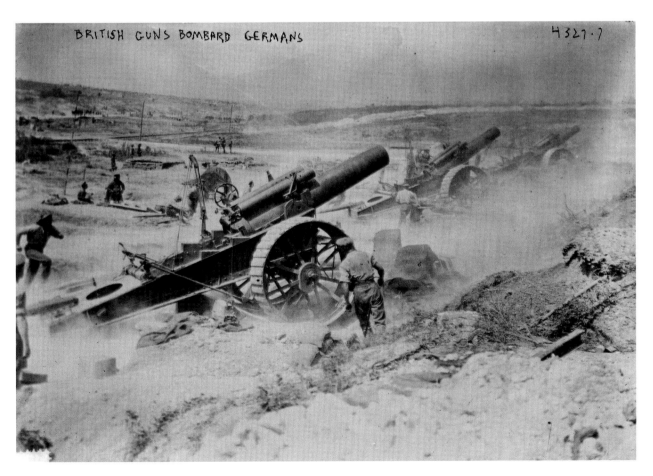

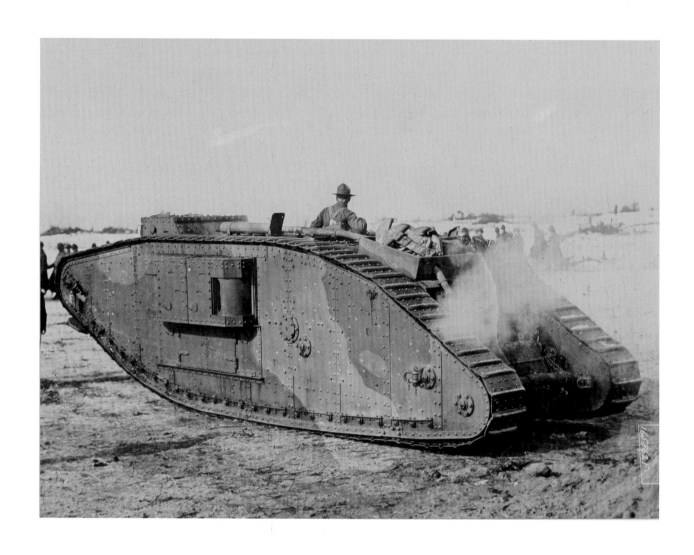

Above: Tanks were among the new weapons of war during World War I. Though initially deployed in 1916, the British were the first to have limited success with tank warfare at the Battle of Cambrai, November–December 1917.

Right: The Zimmermann Telegram of January 16, 1917, instructing Germany's ambassador to Mexico to offer American territory to Mexico in exchange for support in the war. The interception of this telegram by the British was pivotal in the US decision to enter World War I.

In 1915, the Germans torpedoed the liner *Lusitania*, with the loss of 1,200 lives, including 128 Americans. Unwilling to rouse American ire further, the German navy stood back from unrestricted submarine warfare for eighteen months. But as the stalemate on the Western Front persisted, the German U-boat fleet went back on the offensive. The decision was based on faulty reasoning. First, the Germans believed they could sink enough ships to starve Britain into suing for peace. Second, they underestimated the capacity of the United States to organize a massive land army and to transport it across the Atlantic. Third, they believed that Germany had nothing to lose by attacking US shipping and thereby drawing the United States into the war, because the nation was already informally at war with Germany by providing American financial and manufacturing aid to Britain and France. None of these arguments was valid.

A fourth mistake in German reasoning was particularly reckless. Just before the February 1917 German U-boat offensive began, the German foreign minister, Arthur Zimmermann, sent a cable to his ambassador in Mexico, instructing him to offer Mexico a military alliance in case the United States entered the war. The plan was to offer Mexico territory in Arizona, New Mexico, and California in the event of a German victory. The Germans did not consider, however, that Mexico was engaged in a civil war and that its army was in no position to recover land in the United States. The German foreign office risked everything on a hunch—and did so on an insecure cable line.

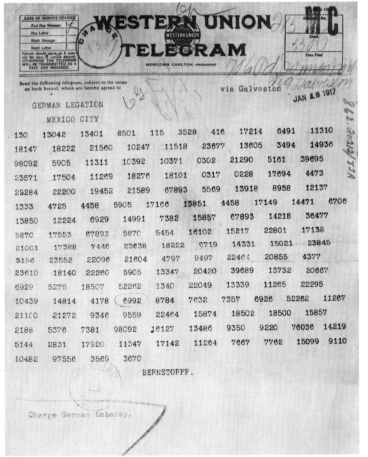

Room 40 of British Naval Intelligence intercepted the message, and Britain used it to persuade President Woodrow Wilson to join the Allied cause. On February 28 an enraged Wilson released the text of the Zimmermann telegram to the press. Facing both this threat to the territorial integrity of the US and unrestricted submarine warfare, President Wilson abandoned his long-term policy of neutrality in the war—a policy that had helped win him reelection just a few months before. Congress voted to declare war on April 6, 1917.

Before April 1917 Wilson had stated repeatedly that the United States would do all it could to secure a peace without victory: that is, to bring the conflict to an end without humiliating either side. The actions of imperial Germany changed his mind. In the first months of the war, he prepared the United States to wage a war to overthrow the imperial regime in Germany and to prevent future war by the creation of a League of Nations. Had such an international forum existed in 1914, he believed, war could have

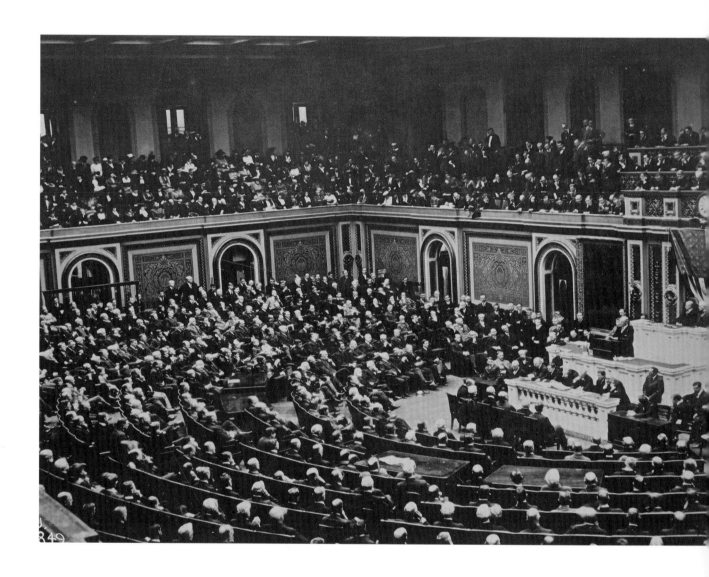

been avoided. Similar crises could be defused in the future only by collective international action. Hence American war aims included not just the defeat of Germany but the transformation of the international order.

The problem with this strategy was that it took no account of the events in Russia and Eastern Europe. The first Russian revolution, in February 1917, led to the abdication of the czar. The American entry into the war coincided with the emergence of a new provisional government in Russia. The new leaders decided to continue to wage war against Germany and Austria-Hungary while also exploring the possibility of a negotiated peace. But after American entry into the war, Wilson gave up any idea of an even-handed peace. France and Britain concurred: Germany had to be defeated.

Wilson and the Allies' persistence with a strategy of waging war until victory ensured the collapse of the moderates in Russia and the victory of the Bolsheviks in the second Russian revolution of November 1917. The president shared the British and French leaders' myopic obsession with the Western Front. The events unfolding in Russia were

Above: On April 2, 1917, President Wilson asked Congress to declare war against Germany, proclaiming that the "world must be made safe for democracy." America entered the war four days later.

Right: Moroccan troops march through Damblain, France, on their way to the front, February 1918. During the summer of 1918, African American soldiers of the 3rd Battalion, 369th Regiment, served on the right flank of the French 2nd Moroccan Division.

out of their line of sight. In December, the Bolsheviks pulled Russia out of the war. The Bolshevik leader Vladimir Lenin now offered the world another vision of a transformed international order.

In this global war, the imperial powers mobilized nonwhite soldiers by the hundreds of thousands. Most were conscripted into military service, though some joined up voluntarily. The French had recruited substantial numbers of combat troops in Senegal, Morocco, and Algeria, which was then an integral part of France. The British had half a million troops in the Indian army and mobilized West Indians and South African blacks as well. Their presence on various fronts brought out the racist sentiment common in British dominions and among the British officer class, in striking contrast to the integration and training of African troops in the French army. In many instances, the presence of black, yellow, and brown soldiers and of substantial numbers of Asian and African laborers intensified racial hatred and triggered the maltreatment of people of color both in and out of uniform. For white supremacists, the sight of large contingents of armed and trained African or African American soldiers was alarming. Sexual stereotypes deepened their racist nightmares. Would white women find these men of color in uniform irresistible?

One in ten US soldiers in Europe was African American, yet their service did nothing to reduce white racial prejudice at home. Even when set against the record of lynchings and violence against African Americans in preceding years, the American entry into World War I marked an increase in the incidence and intensity of racial violence. In 1917, bloody race riots broke out in East St. Louis, Illinois, and in Houston, Texas, where 156 black soldiers at a nearby military base mutinied in consequence. Sixteen civilians and four soldiers died during the riots. Following courts-martial, nineteen soldiers were hanged and more than forty imprisoned for long terms.

The American war effort was also marked by an increase in the criminalization of dissent and the suppression of radical elements in the American labor and women's

suffrage movements. In 1918, the Socialist party leader Eugene Debs, who had polled one million votes as a presidential candidate two years before, went to prison for violating the Espionage Act by urging men to resist the draft. In Maryville, Illinois, Robert Prager, a German national who was a trade unionist and an opponent of the war, was lynched. His killers were acquitted. The war had a polarizing effect on politics in all the countries involved. The British Liberal Party was

TROUPES FRANÇAIS

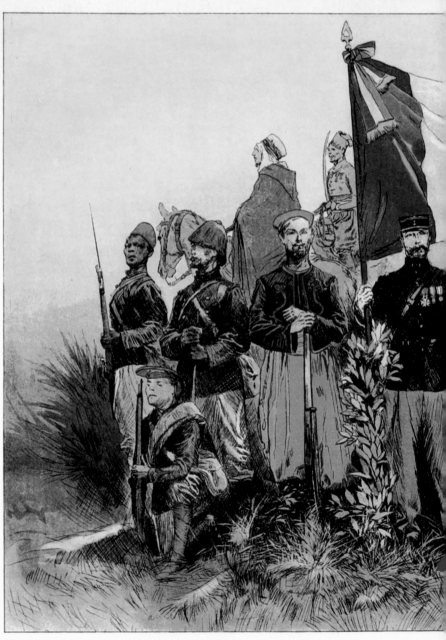

TIRAILLEURS ANNAMITE et TONKINOIS ZOUAVES LIEUTENANT D'INFANTER

TIRAILLEURS SÉNÉGALAIS et SOUDANAIS INFANTERIE COLONIALE
(Tenue aux Colonies)
SPAHI ALGÉRIEN SPAHI SÉNÉGALAIS

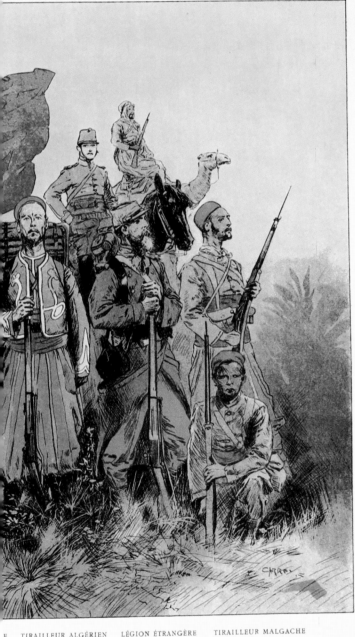

TIRAILLEUR ALGÉRIEN LÉGION ÉTRANGÈRE TIRAILLEUR MALGACHE

D'AFRIQUE TIRAILLEUR MAROCAIN

CHASSEUR D'AFRIQUE MEHARISTE

French colonial troops from roughly seventeen African countries and the African Diaspora participated in the war. This print depicts a variety of colonial troops from Senegal, Sudan, Algeria, Morocco, Madagascar, Tunisia, and the Caribbean region of Guadeloupe.

SENEGALESE UNIFORM

During World War I France recruited more than 192,000 French West African soldiers, 134,000 of whom served in France. Many of these soldiers were from Senegal. The Tirailleurs Sénégalais (Senegalese Sharpshooters) began the war wearing this blue uniform and shifted to a mustard uniform by 1917. A significant aspect of the Senegalese uniform was the machete. Some historians observed that German soldiers dreaded facing the Tirailleurs Sénégalais in battle, because the Senegalese rarely took prisoners. ⊛

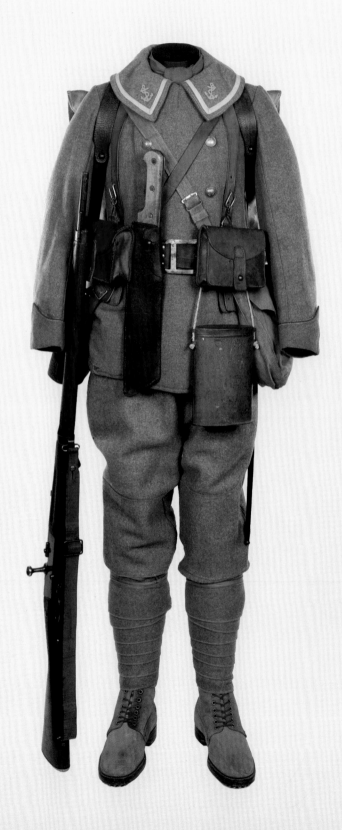

This uniform represents the distinctive Blue Horizon uniform that Senegalese soldiers wore on the Western Front in 1915.

destroyed in part by its heavy-handed repression of an Irish Republican uprising on Easter Monday 1916. Executing the ringleaders made them into martyrs.

In Germany, by 1917, the war effort was almost entirely in the hands of a military-industrial group that gave the army whatever it needed, at the price of creating massive bottlenecks and shortages on the home front. Social protest intensified as economic difficulties multiplied and hunger increased. Germany entered the worst inflationary spiral in its history. There were demonstrations for peace in major cities in Germany and Austria, many of them organized by women.

The German political Right was radicalized too. When the Reichstag issued a peace resolution in July 1917, calling on both sides to negotiate a compromise settlement, disgruntled deputies and their supporters formed the Vaterlandspartei (Fatherland Party), with the support of Admiral Alfred von Tirpitz, the leader of the German navy, and the industrialist Alfred Hugenberg. A seventy-hour work week for a pittance left many families hungry and run down. No government retains the loyalty of its soldiers when their families go without food and fuel.

Everywhere, the cost of living rose rapidly, and wages lagged behind. Men and women on strike on both sides of the world conflict asked why industrialists should make a killing out of war. In France, strikes and demonstrations were followed by mutinies after another doomed offensive in April and May 1917 along the Chemin des Dames in northern France. The mutinous soldiers refused to continue the futile and bloody offensive launched by General Robert Nivelle. Both the mutiny and widespread unrest on the home front reflected the exhaustion and anger felt by a substantial part of the French population, in and out of uniform. Only when Nivelle was fired and the

Eugene Debs, founder and leader of the Socialist Party of America, was vehemently opposed to the war. In 1918 he was sentenced to ten years in prison for his antiwar rhetoric.

commander, Philippe Pétain, said there would be no more offensives did the army return to the line. We will wait, Pétain insisted, for tanks and the Americans.

The war had produced a military stalemate across the continent. Could the entry of the United States tip the balance? No one knew the answer in late 1917.

Bolshevik Russia left the war in December 1917, conceding a huge swath of territory to end the conflict. The end of the conflict with Russia enabled Germany to move more troops to the Western Front. At the beginning of 1918, the war appeared to be going well for the two major Central powers, Germany and Austria-Hungary. Together they had secured one of the few offensive victories in the war. The Italian position at Caporetto, in what is now Slovenia, was broken by a surprise commando attack led by the young German captain Erwin Rommel, who was to become one of Germany's most distinguished military leaders in World War II.

But the Italians dug in again, one hundred kilometers to the west of Caporetto, proving again that attempts to break through enemy lines would not win the war. The entry of the United States into the war, with huge infusions of cash and personnel, made an Allied victory inevitable. The successful transport of two million American soldiers across the Atlantic, without a single loss to submarine attacks, showed how drastically Germany had underestimated the United States in early 1917. But the most powerful incentive for Germany to sue for peace was not American triumphs in 1918: it was the prospect of the arrival of the additional three million US troops in training, who in 1919 or 1920 would face a German army that was running out of men, materiel, and ideas.

Before the German leadership recognized the disastrous mistake they had made in provoking the United States to enter the war, they made one last throw of the dice. On March 21, 1918, a massive German assault broke through British and French lines on the Western Front in France. It used innovative tactics, avoiding long bombardments in order to ensure surprise, mounting diagonal attacks, and bypassing strongpoints to ensure mobility. This approach yielded huge and unprecedented gains of territory.

But the great weakness of the German army was evident once again. When an aide asked the German general Erich Ludendorff to explain the strategy behind the breakthrough, the commander answered, "First we break through, then we shall see." Germany's tactics were excellent, its strategy nonexistent.

What the German army saw during its rapid advance was the depth of Allied supplies. German infantry units stopped to eat and stock up with British rations, because their own were running out. So were tires for trucks; so were shells for the guns; so was hope that this advance would lead anywhere. When crack German troops reached the eastern rim of Paris in May 1918, they were blocked by British, French, and American troops. Men of the Fifth and Sixth Marines endured the bloodiest battle in the Corps' history at Belleau Woods in early June, but they turned back the German advance, as Australian and British troops did farther north, near Amiens.

By the summer of 1918, the German army had lost its last desperate attempt to win the war by breakthrough. At the same time, the unbalanced German economy broke down, causing massive food shortages, which soldiers tried to ameliorate by sending some of their own rations home. By August 1918 the German troops knew they had no

ALLIED SUPPLIES

All soldiers carry with them objects necessary for their survival. While the basic necessities are the same, the specific equipment supplied to each solder depended on where he was fighting and the flag he was fighting under. For sustenance, biscuits and canned meat—primarily corned beef known by the British as "bully beef"—were the primary staples of a soldier's diet in the trenches. In addition, clean drinking water was imperative to the health of a soldier. African American soldiers of the 93rd Infantry who were embedded with the French troops may have been issued French supplies including canteens to carry fresh water in the trenches.

In order to avoid detection in the trenches by well-trained snipers, soldiers were trained to use lights sparingly and carefully. Battery-powered flashlights could be hung from a belt or carried by the handle, while oil lamps would have been used far from the front lines or while safely concealed in a dugout. When going "over the top," wire cutters were essential survival and tactical equipment for breaking through the miles of barbed wire strewn across No Man's Land.

Beacon army flashlight

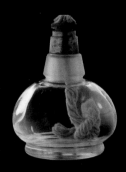

Trench lantern

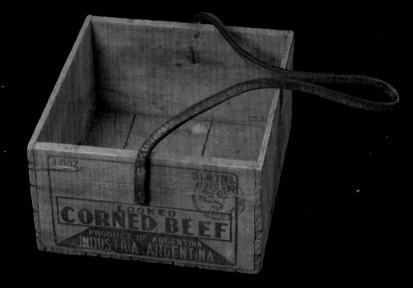

Box to carry canned corned beef rations

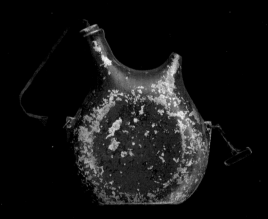

French canteen

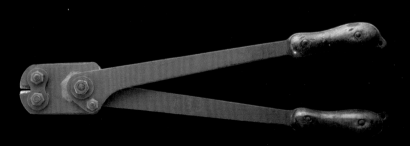

Barbed-wire cutters

chance of victory. Thousands gave themselves up, preferring prisoner-of-war status to waging an unwinnable war.

The Allied victory was due in part to greatly superior air power. Aircraft were the eyes of the artillery, enabling the Allies to locate and destroy German guns and thus allow Allied forces to advance. Even so, victory came at a huge cost. In northeastern France, in the Meuse-Argonne offensive of 1918, roughly forty thousand American soldiers were killed in combat. Even in a losing cause, the German army showed its prowess, brilliantly managing one of the most difficult military maneuvers: that of mobile withdrawal, or moving backward as a line and not as scattered and vulnerable units. American soldiers paid the price of going against the finest army in the world, just as the French and British had done before them.

To account for their defeat, the German command concocted lies about being betrayed by civilians at home, especially the Jews. Nothing could have been further from the truth. The German army was defeated in France and Belgium in 1918 by Allied troops, including one million American soldiers. It was the military leadership of Germany, and the politicians and industrialists who supported it, who betrayed the nation by involving it in a war against the entire world.

Wilson insisted that he would not negotiate with the Kaiser: Germany had to have a democratic regime before the war would end. Thus the Kaiser was forced by his army to abdicate, both as emperor and as king of Prussia. He was driven to the Dutch border, where he presented his sword to a shocked postman. He spent the rest of his life in exile there.

A delegation of the German provisional government signed the Armistice agreement in a railway car in Compiègne, France, on November 11, 1918. It had been hard to make

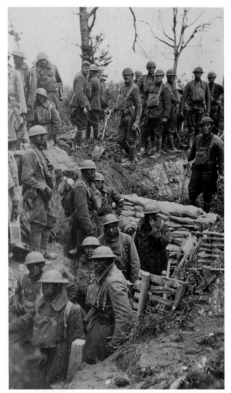

the arrangements, because in the days before the cease-fire, the German artillery was still strong enough to impede their journey south virtually until the last minute. But at 5 A.M. on a cold autumn day, they signed the Armistice, and the war on the Western Front was over.

The Armistice of November 11 ended the war on the Western Front only. Revolutionary, counterrevolutionary, and national wars continued throughout eastern and southern Europe until 1924, when general exhaustion, economic stabilization, and the victory of the Bolsheviks in the Russian Revolution put a stop to a very violent period of world history. Yet a decade after the war, the world was an even more dangerous place than it had been before. All that blood—more than ten million men killed, including more than fifty thousand American lives lost in combat—had been shed for nothing.

African American soldiers of the 302nd Engineer Regiment repair a road over trenches in the Argonne Forest in support of the black soldiers of the 92nd Infantry Division (in trenches) as they prepare to go into battle.

TRENCH ART

Among soldiers facing the horrors of trench warfare and poison gas, religion and faith were manifest on the battlefield in ways that they were not in peacetime. Many soldiers crafted items from discarded war materials that became known as trench art. Some of them were religious symbols. These two pieces, a crucifix made from shrapnel and a miniature Black Madonna made from a revolver cartridge— poignant intersections of war and peace—epitomize the religious sentiments of many soldiers. ✸

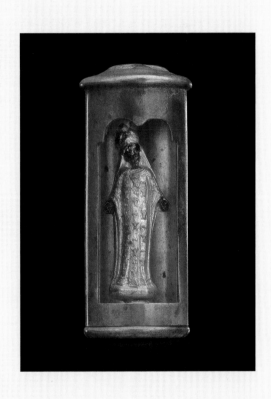

Soldiers created trench art using discarded debris of all sizes. These two objects, a crucifix about 12 inches tall sand a Black Madonna just over 1½ inches tall, are two examples of trench art made by unknown soldiers in France.

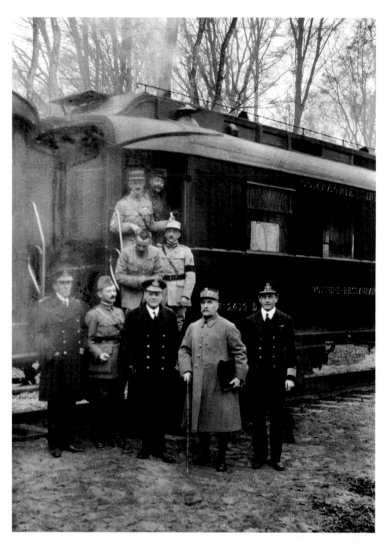

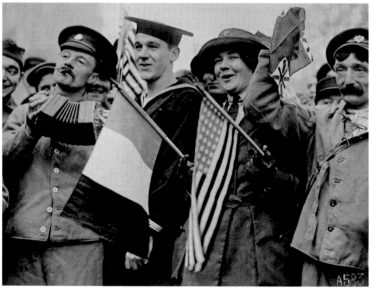

Above: French and British officers at the signing of the Armistice, November 11, 1918. In the front row are (left to right) Rear Admiral George Hope (UK), General Maxime Weygand (France), Admiral Rosslyn Wemyss (UK), Marshal Ferdinand Foch (France), and Captain Jack Marriott (France).

Right: November 11, Armistice Day or Veterans Day, is still celebrated by many Allied nations. Here an American sailor, a Red Cross worker, and two British soldiers celebrate the Armistice in Paris in 1918.

The United States participated fully in the peace conference at Versailles, culminating in the peace treaty signed by a German delegation on June 28, 1919, and providing for the founding of the League of Nations. But the League so beloved by Woodrow Wilson never really got off the ground. The US Senate's refusal to ratify the treaty, the exclusion of Germany from the League (on the grounds that it had been responsible for the outbreak of the war and all the resulting suffering), and the exclusion of Soviet Russia (as a pariah state aiming to overthrow the capitalist West), weakened the League to the point of ineffectuality. Without a Russian presence, the League could not guarantee the eastern borders of the successor states of the former Russian, German, and Austro-Hungarian Empires. In a huge arc from Finland to Turkey, wars of succession continued, most of them civil wars in which the vast majority of victims were civilians.

In addition, the terms of the peace treaty hampered the reconstruction of the new international order by undermining its economic foundations. The huge war reparations demanded from Germany by the Allies were both morally dubious and economically disastrous. Without a healthy German economy, it was impossible to restore economic or political stability in Europe.

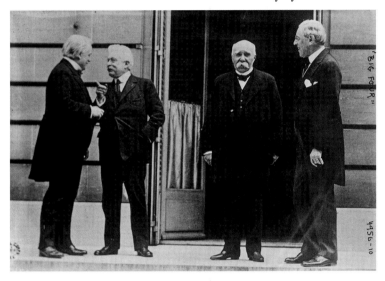

As leaders of the top Allied nations, the British prime minister David Lloyd George, the Italian premier Vittorio Orlando, the French premier Georges Clemenceau, and the American president Woodrow Wilson played essential roles in negotiating the peace.

The peace treaties also left unsolved the problem of Soviet Russia. Most delegates to the peace conference hoped the Bolshevik government would be overthrown and were prepared to offer both material and military support to its opponents. Alongside British, French, Italian, Greek, and White Russian troops, an American expeditionary force fought the Bolshevik forces in Russia from 1918 to 1920. Eight thousand US soldiers went to Siberia in August and September 1918 and another five thousand to Archangel in the far northwest of Russia. Allied intervention achieved nothing and indeed may have helped consolidate support for the Bolsheviks. All the anti-Bolshevik troops withdrew in 1920.

The League of Nations set up a mandatory structure to deal with the colonies and dominions of the defunct empires. This was another confused project, since it purported to offer pathways to nationhood while effectively reinforcing imperial power. French, British, Italian, and Greek troops fought to carve up the old Ottoman Empire. They were defeated by a Turkish army put together by Mustafa Kemal Ataturk, today regarded as the father of modern Turkey. His victory, enshrined in the 1923 Treaty of Lausanne—the last of the peace treaties of World War I—could be said to mark the beginning of the worldwide anticolonial movement. The violence arising from the botched settlements of 1918–23 still disfigures the Middle East and other parts of the world.

A decade after the outbreak of the European war, the United States found itself the leading economic power in a world that had been completely transformed. New York replaced London as the financial center of the globe. Britain and France suffered the

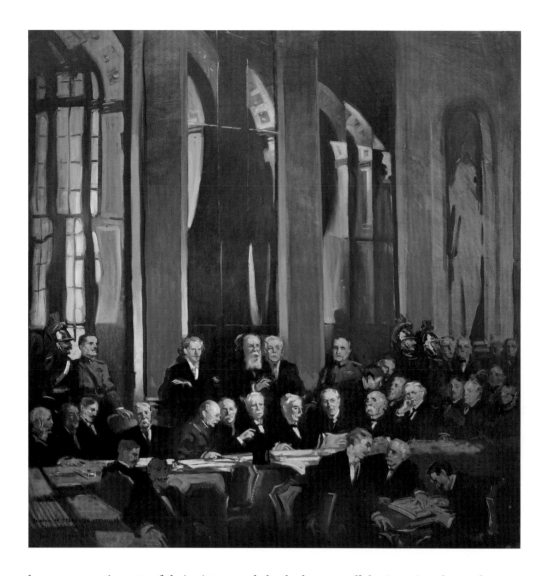

heavy economic costs of their victory and also had to pay off the American loans that had sustained them in 1917–18. The German, Austro-Hungarian, and Ottoman Empires had disappeared entirely. In their place stood a new European order, in which most of the new states were undemocratic and unstable. Anti-Semitism was reborn in the form of a twisted belief that Jewish bankers in the West somehow controlled the Kremlin in what Germany's new National Socialist Party labeled the "Judeo-Bolshevik conspiracy." The radical Right and Left crowded out the center. The fourth vanished colossus— the Russian Empire—was replaced by the Soviet Union, in effect a Russian-dominated empire isolated from the rest of the world. After the death of its first leader, Lenin, came Joseph Stalin, who waged a savage war on his own people for nearly thirty years.

When the economic crisis of 1929 hit the world, most of the new, unstable states in Europe turned into authoritarian or fascist dictatorships. In effect, World War I made the world safe for dictatorships. In 1939, another world war broke out, even bloodier than the last. World War II was the price paid by people around the globe for the failure to create an enduring peace after World War I.

Signing of the Treaty of Versailles, 1919, by John Christen Johansen. Also known as the Peace Treaty, this document set the terms for the official end of the war after the Armistice had ended the fighting.

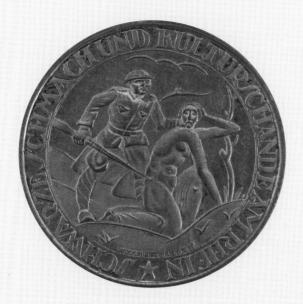

Black Shame medal designed by Wittig Friesen and minted in Nuremberg, circa 1920. On the obverse with the inscription, "Black shame and disgrace to civilization on the Rhine," an African colonial soldier terrorizes a naked woman.

THE "BLACK SHAME" MEDALLION

When the war ended, Allied soldiers were stationed in Germany, including African soldiers serving in the French army. Africans were characterized as sexual predators and blamed for all sorts of offenses, especially against German women. During the 1920s Germany created a series of propagandistic coins or medallions depicting atrocities allegedly committed by occupying troops. Among these was the Schwarze Schande (Black Shame). ⊛

W.E.B. DU BOIS

Chad Williams

"I became during the World War nearer to feeling myself a real and full American than ever before or since." W. E. B. Du Bois wrote these poignant words in his 1940 semi-autobiographical work *Dusk of Dawn*. The famed scholar-activist and editor of *The Crisis*, the magazine of the National Association for the Advancement of Colored People (NAACP), would spend the period between the two world wars and indeed much of the remainder of his life grappling with both the personal meaning of the war and its significance for people of African descent. As it was for black people across the globe, the war was a transformative event for Du Bois, whose initial optimism about its potential to improve race relations and conditions for black people in the United States gave way to a harsh realization that true change would demand a longer and even more strenuous battle.

During the war years, Du Bois, the nation's foremost black intellectual and voice for civil rights, was at the height of his influence. He had written extensively about the war when hostilities erupted in August 1914, recognizing its imperial origins and importance to the future of Africa. However, the entrance of the United States into the war in April 1917 made matters much more immediate. Like many Americans, Du Bois was enraptured by President Woodrow Wilson's call to make the world "safe for democracy." He envisioned black participation in the war as continuing a long tradition of black military service and patriotic duty stretching back to the American Revolution. By performing their civic duty and risking their lives for the nation, Du Bois reasoned, black people would be rewarded with greater rights and recognition of their identity as Americans.

Du Bois threw himself into the war effort, forcefully advocating for the use of black soldiers in the United States Army, and black officers in particular. He supported a segregated training camp at Fort Des Moines, Iowa, viewing black officers as shining examples of talent and manhood—the future leaders of the race. At the same time, Du Bois spoke out against racial injustice, such as the horrific East St. Louis massacre in July 1917 and the execution of black soldiers stemming from a violent mutiny in Houston, Texas, in August.

The tension between loyalty to nation and loyalty to race came to a head when Du Bois's friend and NAACP colleague, Joel Spingarn, who had taken a position in the War Department, presented Du Bois with an opportunity to serve with him as a captain in the Military Intelligence Division. While contemplating this offer, and feeling the pressure of government censorship as a result of the 1918 Sedition Act, Du Bois wrote his "Close Ranks" editorial for the July 1918 issue of *The Crisis*. "Let us, while this war lasts, forget our special grievances and close our ranks shoulder to shoulder with our own white fellow citizens and the allied nations that are fighting for democracy," Du Bois proclaimed. "We make no ordinary sacrifice, but we make it gladly and willingly with our eyes lifted to the hills."

The editorial generated a firestorm of controversy. Du Bois's longtime ally William Monroe Trotter labeled him "a rank quitter in the fight for

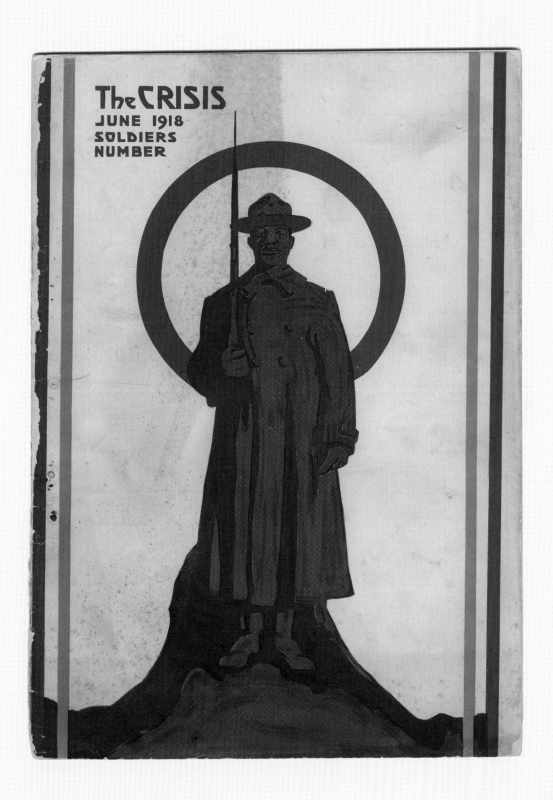

equal rights." Du Bois fired back against his critics. The captaincy offer was ultimately rescinded, but the damage had been done. As the war neared its conclusion, many African Americans viewed Du Bois as a self-serving opportunist and even a traitor to the race.

Eager to reaffirm his leadership after the Armistice, Du Bois sailed for France on December 1, 1918, as part of the press delegation covering the peace conference at Versailles. Knowing that the European colonial powers would approach Africa and its resources as the spoils of war, Du Bois hoped to intervene by organizing a rival Pan-African Congress. This historic gathering took place on February 19–21, 1919, with fifty-seven delegates from fifteen nations in attendance. Du Bois also investigated conditions of African American troops for a book he envisioned on the black experience in the war. During his three months in France, Du Bois traveled across the Western Front, visiting camps, touring battlefields, and speaking directly with black soldiers and officers about their experiences. What they told Du Bois shocked him. Most of the black soldiers he encountered were embittered and discouraged. He absorbed story after story of the systemic discrimination and racial abuse that black servicemen had endured at the hands of white officers.

Du Bois returned to the United States emboldened and enraged. He channeled his emotions, as well as the information he had uncovered in France, into articles in *The Crisis*. In the May 1919 issue, he published several top-secret documents, many of them provided by black soldiers and officers, as incontrovertible proof of the military's racist practices. He also wrote the powerful editorial "Returning Soldiers," in which he declared:

> We *return*.
> We *return from fighting*.
> We *return fighting*.
> *Make way for Democracy! We saved it in France, and by the Great Jehovah,*
> *we will save it in the United States of America, or know the reason why.*

His words would become a rallying cry for African Americans in 1919 and after. ✺

In his "Close Ranks" editorial in *The Crisis*, W. E. B. Du Bois encouraged African Americans to fight. He hoped participation in the war would win democracy and equality for African Americans.

THE CRISIS

Vol. 16 — No. 3 JULY, 1918 Whole No. 93

Editorial

CLOSE RANKS.

THIS is the crisis of the world. For all the long years to come men will point to the year 1918 as the great Day of Decision, the day when the world decided whether it would submit to military despotism and an endless armed peace—if peace it could be called—or whether they would put down the menace of German militarism and inaugurate the United States of the World.

We of the colored race have no ordinary interest in the outcome. That which the German power represents today spells death to the aspirations of Negroes and all darker races for equality, freedom and democracy. Let us not hesitate. Let us, while this war lasts, forget our special grievances and close our ranks shoulder to shoulder with our own white fellow citizens and the allied nations that are fighting for democracy. We make no ordinary sacrifice, but we make it gladly and willingly with our eyes lifted to the hills.

WAR SAVING STAMPS.

A CORRESPONDENT writes us: "Has there been put in operation any effective machinery for bringing our twelve million colored citizens, especially those living in the Southern States, into this great national movement for Thrift and Economy, represented by the War Savings Stamp movement? This movement is to have a profound effect on the char-acter of the American people; millions of prodigal, shiftless Americans are going to learn their first lessons in Thrift and Economy through buying Thrift Stamps and War Savings Stamps. It is obvious that our colored citizens should share to the full the benefits as well as the responsibilities of the movement.

"It is a voluntary effort. Thousands of voluntary committees are working to inculcate the lessons of Thrift and inspire voluntary purchase of stamps."

We are glad to say that such a movement has been begun. Various organizations are taking hold and the National Association for the Advancement of Colored People will use its more than 30,000 members in 108 branches to push this splendid movement.

Remember, June twenty-eighth is National War Savings Day!

THE COMMON SCHOOL.

MUCH mist and misunder-standing has been consciously and unconsciously put in the colored public mind by recent discussions of the schools. We colored people must, however, keep one thing clearly before us: the first fours years' of a child's life, no matter what his race or condition, must be devoted by every modern country which wishes to survive and grow to a very simple program of study: (1) The child must learn to read so as to be able easily to understand what men have writ-

A. PHILIP RANDOLPH
Curtis Young

When Woodrow Wilson brought the United States into World War I, one of his first challenges was to raise an army capable of fighting. What there was of the United States Army was woefully unprepared for such an undertaking. Congress quickly authorized the Selective Service Act of 1917, which was central to defining a citizen's wartime duties.

Only a year earlier, Wilson had won reelection on the promise of keeping America out of the deeply unpopular war. Now he had to convince the country of the righteousness of America's engagement in his "war to end all wars."

To that end, he launched a massive propaganda campaign with the creation of the Committee of Public Information, headed by George Creel, a former journalist and ad man. Creel's mission was to "oversee a program of voluntary censorship and to flood the media with news from essentially official sources in a comprehensive effort to manage the war information that reached the public"—to forge, in Creel's words, "a white hot *war-will!*"

Not all Americans were convinced. Jane Addams, well known as a labor and women's rights activist, was also an outspoken pacifist who was too popular to suppress. Wilson despised all who spoke out against the war, saying that he was opposed not to their feelings but to their stupidity, and that he had nothing but contempt for them. That summer he turned his ire into legislation when he authorized the Espionage Act. It was followed by the Sedition Act, which threatened fines and stiff prison sentences for those who publicly opposed the war effort.

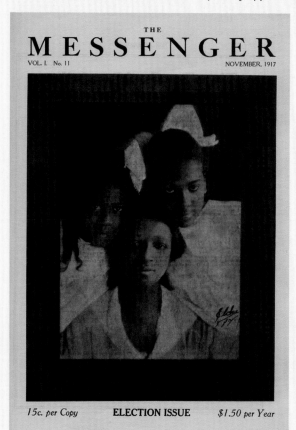

THE
MESSENGER
VOL. I. No. 11 NOVEMBER, 1917

15c. per Copy **ELECTION ISSUE** $1.50 per Year

Another powerful black voice against the war was that of Asa Philip Randolph. A labor activist and socialist, Randolph is probably best known as the founder and president of the Brotherhood of Sleeping Car Porters, one of the nation's most important black labor unions. But this was just one aspect of Randolph's lifelong commitment to seeking justice and the recognition of human rights for ordinary black women and men.

Randolph saw the war as central to a broader narrative that pitted poor, working-class black, white, and immigrant communities against each other, trapped in a struggle against their own self-interest. He saw the war not as a struggle to preserve democracy but as a capitalist venture designed to exploit the lives, labor, and resources of poor people of color, not only in America but throughout the world.

The vehicle for Randolph's militancy was *The Messenger*, a magazine he

Left: November 1917 cover of *The Messenger*. Founded by A. Philip Randolph and Chandler Owen, *The Messenger* was a radical African American magazine, critical of the black establishment.

Right: A. Philip Randolph spoke for many young African Americans who were against supporting a foreign war. Randolph is pictured here in 1911, the year he migrated north from Jacksonville, Florida, to New York City.

Messages From the Messenger

Four hundred Negro longshoremen went on strike for more wages in New York City.

Two Negro candidates were nominated on the Republican ticket for assemblyman and alderman respectively in New York City.

E. A. Johnson was the candidate for assemblyman and James C. Thomas, Jr., was candidate for alderman.

Both are practising lawyers in New York.

The 15th regiment is guarding the terminals of New York. The terminals are safer than the trenches, and only the Negro leaders will object to their absence from the bloody fields of France. But who cares for leaders now-a-days?

Let Du Bois, Kelly Miller, Pickens, Grimke, etc., volunteer to go to France, if they are so eager to fight to make the world safe for democracy.

We would rather make Georgia safe for the Negro.

Negro leaders are like the white leaders; they want war but they want to let "George do it."

This is no white man's war. Hundreds of thousands of Negroes are fighting either in Europe or in the industrial trenches making it possible for those who bear arms to continue to fight.

Napoleon said, that an army marches on its belly. Since this is true, the Negroes in the South and in Africa are the bone and sinew of the world war.

Socialism in Germany is right, socialism in the United States is wrong.

Peace talk in Germany is proper, peace talk in the United States is treason.

Suppression of free-speech and free-press in Germany is autocracy.

Suppression of free-speech and free-press in the United States is making the world safe for democracy.

A committee on woman suffrage has been created in the House of Representatives.

The Korniloff rebellion fizzled out in Russia notwithstanding the fact that the American press supported it.

The Negroes of the Houston riot will not be shot.

It is well that the Mighty Teddy is not in the chair or we might have another Brownsville.

The Independent Political Council's indictment against John Purroy Mitchel defeated him in the primaries and incidentally elected the colored candidates because the Negro Republican voters did not vote the Mitchel ticket.

The indictment was prepared by A. Philip Randolph and Chandler Owen.

It was such a cogent argument and so clearly presented that the Voice and all of the Bennett speakers used it as their textbook.

founded in 1917 with his friend Chandler Owen, a student at Columbia University. It would become one of the country's most influential cultural and literary magazines, headlining itself as "the only Radical Negro Magazine in America." The magazine was the quintessential representation of early twentieth-century New Negro radicalism, a philosophy that held art, culture, and critical thinking in high esteem.

Randolph and Owen's writings against the war were deeply analytical. They spoke out against the war in a robust and clear voice, suggesting at one point that Du Bois and the other flag-waving leaders should "volunteer to go to France, if they are so eager to make the world safe for Democracy." Randolph wrote that he would "rather fight to make Georgia safe for the Negro."

An avid socialist, Randolph was inspired by the writings of the German socialist Ferdinand Lasalle, who, unlike Karl Marx, advocated action through state institutions, including political parties. In 1916, Randolph and Owen had joined the American Socialist Party, determined to bring about change in the lives of the African American community. Randolph celebrated "the New Negro," in contrast to "the Old Crowd Negro." That latter label he applied to Marcus Garvey and Du Bois, among others. Ironically, Du Bois's book *The Souls of Black Folk* had been the early inspiration for Randolph to leave the South to pursue a life of intellectual and cultural enrichment in Harlem.

The editors of *The Messenger* used the magazine as a platform to counter President Wilson's rhetoric about making the world safe for democracy, writing in this editorial: "We would rather make Georgia safe for the Negro."

The phrase *New Negro* has always been closely associated with the book by Alain Locke describing the Harlem Renaissance. But it has been argued that the expression was hijacked by Locke and other conservative African American intellectuals as a means of transforming the virulent revolutionary tendencies of the war years into a literary movement. Randolph's New Negro, by contrast, was a militant socialist who would never turn the other cheek.

For Randolph, the war was the straw that broke the camel's back. The violence perpetrated against African Americans in the South during the war years—humiliation, rapes, and lynchings—led to the Great Migration, in which thousands of blacks fled north with little more than the clothes on their backs. These atrocities continued with rioting and murderous attacks against black veterans returning from France during the Red Summer of 1919.

Through the pages of *The Messenger* and in his public discourse, Randolph consistently criticized the powers driving the war and its debilitating effect on the African American working community.

On August, 10, 1918, Randolph and Owen, whose publication was considered by the Justice Department as the most dangerous in America, were arrested at an antiwar demonstration in Cleveland, Ohio. The two men were charged with treason under the Espionage and Sedition Acts. In a quirk of destiny, it was the judge's racist views that saved Randolph from a long prison sentence. The judge refused to believe that two young black men could write such an eloquent and sophisticated argument against the war, and so he released them. By contrast, Eugene Debs, the head of the Socialist Party, was sentenced to ten years in prison for speaking out against the war, and he remained in prison until pardoned by President Warren G. Harding in 1923. In November 1918, Randolph was drafted into the military. But he never served, as the war ended a few days later on November 11, 1918.

Randolph never relented in his activism on behalf of African American workers. During World War II, he made plans for a march on Washington (the first protest of its kind) to bring the nation's attention to discrimination against black workers in the munitions industry. After Randolph held several meetings with President Franklin Roosevelt, Eleanor Roosevelt, and Fiorello La Guardia, the mayor of New York, the president signed an executive order that outlawed discriminatory hiring practices in defense plants. Randolph later pressured President Harry S. Truman into signing Executive Order 9981 of 1948, which ended segregation in the military. Plans for the march were shelved until 1963, when Randolph, with Bayard Rustin at his side, organized the famous March on Washington for Jobs and Freedom.

A. Philip Randolph rearticulated Woodrow Wilson's call to make the world safe for democracy into a language of personal freedom and of an active, rights-based citizenship that would echo throughout the twentieth century and after. ◉

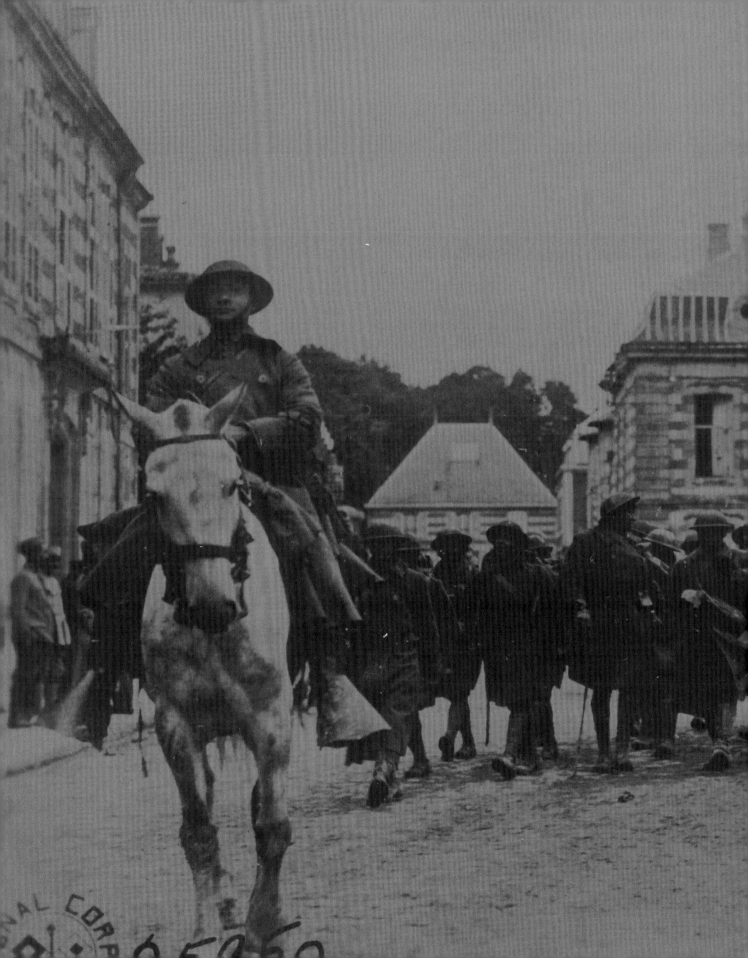

From Civil War to World War:

African American Soldiers and the Roots of the Civil Rights Movement

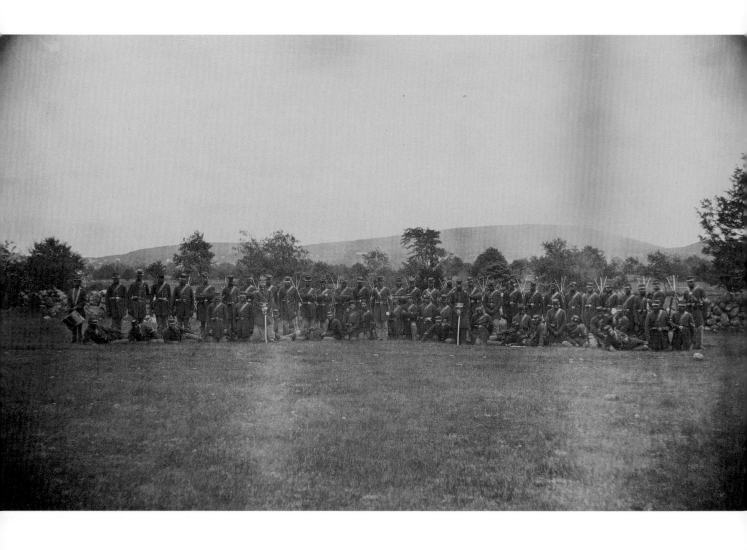

Taken during the Civil
War in the summer of
1863 at their training
camp in Readville,
Massachusetts, this
photograph of the 55th
Massachusetts Infantry
shows two officers and
fifty-eight men in uniform
ready for deployment.

From Civil War to World War: African American Soldiers and the Roots of the Civil Rights Movement

Krewasky A. Salter

African American military service is older than the United States itself. About six thousand black soldiers fought in the Revolutionary War (1775–83). Black soldiers fought again in the War of 1812, the Mexican-American War (1846–48) and, most significantly, the American Civil War (1861–65). Two themes resonate throughout these conflicts: white reluctance to arm and train African American soldiers, for fear that they might turn those skills and weapons on their oppressors at home; and the failure to grant African Americans the social, political, economic, and cultural equality that, in a just system, would naturally have been extended to the veterans and their communities. The events of the Revolutionary War and War of 1812 show us that African Americans were willing to fight for the side that offered them the best chance at freedom. In the three Seminole Wars fought between 1816 and 1858, African Americans fought with the British and Seminole Indians against the United States. Thus, when the Emancipation Proclamation of January 1, 1863, made it clear that the Civil War was confronting the institution of slavery head-on, African Americans answered the Union call to arms in large numbers.

About 179,000 African Americans served in the Union Army and roughly 30,000 more in the navy. Some were Northerners and others formerly enslaved people. Some had been freed from Southern regions seized by the Union Army, and many had emancipated themselves by running away. For the most part, African Americans fought as infantry soldiers, serving in more than 135 regiments known as the United States Colored Troops (USCT) and commanded mainly by white officers. The valor of black soldiers was exemplified by actions in more than 430 engagements, including the assault on Fort Wagner, in Charleston, led by the all-black 54th Massachusetts. In the navy, black sailors were mostly restricted to a servant rank disparagingly known as "boys," but a few eventually became skilled combatants, attaining the ranks of navy gunners and captains.

Reconstruction

The service of black soldiers in the Union Army undoubtedly contributed to the passage of three key constitutional amendments aimed at protecting and enfranchising the nearly four million newly freed African Americans after the Civil War. The Thirteenth (1865), Fourteenth (1868), and Fifteenth (1870) Amendments abolished slavery, granted citizenship to African Americans, and extended the right to vote to African American men. (Though the Nineteenth Amendment, passed in 1920, granted women the right to vote, black women had to wait until the passage of the Voting Rights Act of 1965 to freely exercise this right.) The Army Reorganization Act of 1866 created allocations for six African American regiments in the regular army, although only four were formed: the 24th and 25th Infantry and the 9th and 10th Cavalry. Thus the country recognized that African Americans would be a permanent part of the (segregated) national military.

The Reconstruction Acts passed between 1863 and 1877 were aimed not only at rebuilding the South but also at establishing new roles for formerly enslaved people in

THE FIFTEENTH AMENDMENT .

CELEBRATED MAY 19th 1870.

A North Carolina Convict Camp.

the region. Yet despite the contributions of African American soldiers and sailors during the Civil War and the strides made by black Americans in the years just after, racist violence against African Americans grew rather than abated. Steps forward—such as the establishment of the Freedman's Bureau, which helped provide newly freed African Americans with necessities such as food, clothing, shelter, and jobs, and the election of some African Americans to political office—were met with constant backlash. Exploitative laws and legal loopholes allowed slavery to emerge in other forms and under new names.

Among the most nefarious instances of that backlash were the Black Codes, which emerged across the South starting in 1865. These largely spurious laws made it possible for states to imprison African Americans on trivial pretexts. One Florida law, for example, stated that any African American farmworker could be arrested if he "deliberately disobeyed orders, is impudent or disrespectful to his employer, refuses to do the work assigned, or leaves the premises." Caught in the web of these laws, thousands of innocent African Americans spent long periods imprisoned or working without compensation through an arrangement known as the Convict Lease System, which provided labor to individuals and corporations. African Americans who escaped the Black Codes were menaced by the Ku Klux Klan (founded in 1865), the Knights of the White Camelia (founded in 1867), and other terrorist organizations, which attacked both African Americans and whites who supported them in the struggle for civil rights.

During Reconstruction, federal troops, including African Americans, were stationed in several Southern states to protect some black Southerners exercising their basic citizenship rights, such as going to school, working, and voting. Newly elected black officials included the USCT veteran P. B. S. Pinchback, who served briefly as Louisiana's lieutenant governor, and Robert Smalls of South Carolina, a ship captain during the

Civil War, who served in the US House of Representatives. The Civil Rights Act of 1875 ostensibly capped off the decade of postwar progress by implementing "equal and exact justice to all, of whatever nativity, race, color, or persuasion, religious or political" and barring discrimination against African Americans in several realms, including public transportation and public accommodation. Yet the act's practical effects were limited, and President Ulysses S. Grant's Justice Department did little to enforce it.

The End of Reconstruction and the Rise of Antiblack Violence

The disputed presidential election of 1876 was resolved by the Compromise of 1877, an informal agreement that brought the Republican Rutherford B. Hayes into office. During the campaign, he had promised to remove federal troops from the South, and he did so with alacrity. With their departure, the rights of African Americans were erased. There were now virtually no checks on the night-riding activities of the Klan and its other extralegal spinoffs, which abused and killed thousands of African Americans.

Such physical violence was soon accompanied by a judicial shift: in an eight-to-one ruling in the consolidated *Civil Rights Cases* of 1883, the Supreme Court made it legal to discriminate against African Americans in almost every walk of life. States no longer had to provide for "full and equal enjoyment" of public transportation, lodging, polling places, or other "places of public amusement," as required by the largely toothless Civil Rights Act of 1875. With the 1896 *Plessy v. Ferguson* ruling, the US Supreme Court codified the doctrine of "separate but equal," which allowed for full-scale segregation. Thus the Black Codes hardened into the persistent oppression of Jim Crow laws. By the late nineteenth century, around the country, African Americans generally had the lowest-paying jobs and lived in the poorest neighborhoods. They traveled in segregated public transportation, were effectively disfranchised, and were imprisoned by the thousands on insubstantial charges.

They were also, in increasing numbers, being murdered outright. Robert Smalls told a South Carolina state constitutional convention in 1895 that "since the reconstruction times, 53,000 negroes have been killed in the South." Largely unchecked and unpunished, mob violence and lynching had become commonplace. Between 1882 and 1909, the journalist Ida B. Wells (see page 102) documented more than 3,284 victims of lynching, 3,182 of them African Americans. It was the 1892 lynching of three men in Memphis —including a close friend, Thomas Moss, a successful and well-respected businessman— that set Wells, as well as the black educator Mary Church Terrell (see page 102), firmly on the path of activism. In 1893 Wells reported on the murder of Henry Smith in Paris, Texas. A white mob of thousands gathered to watch as Smith was tortured with red-hot irons, blinded, and burned alive. The lynching of Sam Hose near Atlanta in 1899 similarly caused the sociologist W. E. B. Du Bois to become an activist (see page 40).

In some cases, entire African American communities became targets of destructive mob violence. In the long-established black community in Springfield, Illinois, the political home of Abraham Lincoln, at least four lives were lost in a riot in 1908.

Left: Portrait of Robert
Smalls, circa 1870. A
formerly enslaved man
and Civil War hero, Smalls
served as a US represen-
tative from South
Carolina for five terms
between 1875 and 1887.

Above: The lynching
of Thomas Moss in
1892 led Ida B. Wells to
launch an antilynching
campaign. Wells is
pictured here at left
with Moss's widow,
Betty, and her two
children in Indianapolis,
circa 1893.

EAST MADISON ST. AFTER RIOT SPRINGFIELD ILL. AUG. 14-08

Ruins

AFTER RIOT — ARROW SHOWS
WHERE TREE STOOD ON WHICH NEGRO WAS HU—
TREE WAS CUT DOWN FOR SOUVENIRS

This image of destruction in Springfield, Illinois, in 1908, is documented in a hand-drawn photograph album titled "In the Wake of the Mob: An Illustrated Story of Riot, Ruin, and Rage."

Women at Fisk University in Nashville, Tennessee, 1915, by photographer Arthur P. Bedou. Historically black colleges and universities (HBCUs) such as Fisk were established to provide higher education for black students when segregation barred them from attending most predominantly white universities.

Springfield was neither the first nor the last instance of racist mob violence, but it was the event that led the remnants of the all-black Niagara Movement, founded in 1905, to join forces with a group of concerned white Americans to establish the National Association for the Advancement of Colored People (NAACP) in 1909. Wells, Du Bois, and Terrell were among its founders.

Despite ongoing racist attacks, African Americans made consistent progress. Education was one route out of penury and oppression: by the turn of the century, approximately thirty-four black colleges had been founded by African Americans, occasionally aided by white philanthropists. Some, such as Tuskegee and Hampton, focused on industrial and agricultural curricula, while others, such as Howard and Fisk, provided a classical liberal arts education. Political activism was another avenue of progress: in addition to the Niagara movement and the NAACP, other groups, including the Grand United Order of Odd Fellows and the National Association of Colored Women, began to fight the strictures of Jim Crow.

In the South, African Americans were effectively abandoned by the federal government and disfranchised at the voting booth by poll taxes, literacy tests, and grandfather clauses that protected voters—generally meaning whites—from a variety of voting restrictions if their ancestors had voted. Lynchings were rising. Men were disappearing

Above: The National Association of Colored Women was formed in 1896 with Mary Church Terrell as president. Their motto, "Lifting as We Climb," shown here on a pin, speaks to their mission of uplifting African American families and communities.

Right: The Grand United Order of Odd Fellows (GUOOF) in America was founded in 1843 by African Americans who were barred from existing white lodges. Pictured here are leaders of the GUOOF in 1908, including William L. Houston, grand master of the GUOOF and father of World War I officer and civil rights lawyer Charles Hamilton Houston.

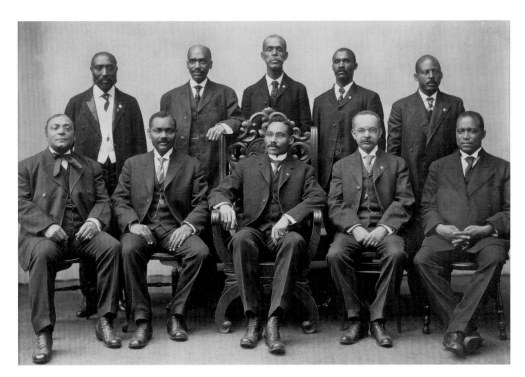

WAR SERVICE BY AFRICAN AMERICAN WOMEN AT HOME AND ABROAD

Lisa M. Budreau

The desire among African Americans to serve the nation during World War I was not limited to men. Women, too, sought opportunities to serve, hoping that their demonstration of leadership and competence would also help the cause of full citizenship and racial progress at home. Yet they faced considerable discrimination from predominantly white organizations that significantly limited the scope of their involvement both at home and abroad.

Many of the African American women seeking to contribute to the war effort were middle class and college educated, but their options were limited. They established a network of volunteer service agencies at the local, regional, and national levels, and they looked to the local branches of the National Association of Colored Women (NACW), founded in 1896, for guidance and support. This organization was known for its letter-writing campaigns, support of servicemen and their families, and its highly successful Liberty Loan fund drives.

The few national organizations that brought African American volunteers and service members into their ranks were Christian organizations with a focus on social morality, such as the Knights of Columbus, the Salvation Army, and the Young Men's Christian Association (YMCA). The largest private welfare organizations for black women's war work were the Ys. The YWCA was the only women's volunteer organization fully dedicated to serving women. It was the first organization to send professional white workers overseas to provide administrative leadership and support to the US armed forces. The efforts of Y volunteers of both races focused solely on female workers in the war industries, mothers and wives of soldiers, women workers abroad, and nurses in American hospitals in France. Volunteers also participated in hostess programs during the war. Although fairly progressive, the organization retained elements of racial inequality by limiting funds and employment for African Americans at home and abroad.

African American women also joined war service organizations like the YMCA to meet the specific needs of black soldiers. Hostess Houses and canteen services enabled women to support the war effort while offering them a degree of autonomy, a clear mission, and financial stability. The YMCA had a headquarters in Paris that offered support to the two hundred thousand black soldiers on duty overseas, but for much of the war they were served by only three black women volunteers. The first to arrive for YMCA service was Mrs. James L. Curtis, who was sent to aid black troops stationed near Bordeaux. She was followed in the summer of 1918 by Addie W. Hunton and Kathryn M. Johnson.

All three women were later sent to the southern French port of Saint-Nazaire, the site of the largest YMCA center in France, where seven thousand black troops were laboring mainly as steve-dores. They served hot chocolate and cookies, wrote letters home for soldiers, provided books and a schoolroom where black soldiers could learn to read and write, and generally boosted troop morale. The women remained there for the duration of the war and through the following winter, bearing witness to the ongoing injustices endured by black soldiers. Hunton and Johnson later described black men being prevented from entering segregated Y recreation huts, refused the right to purchase food, and denied medical treatment in dispensaries. They also recounted efforts to place black soldiers in steerage on ships returning home.

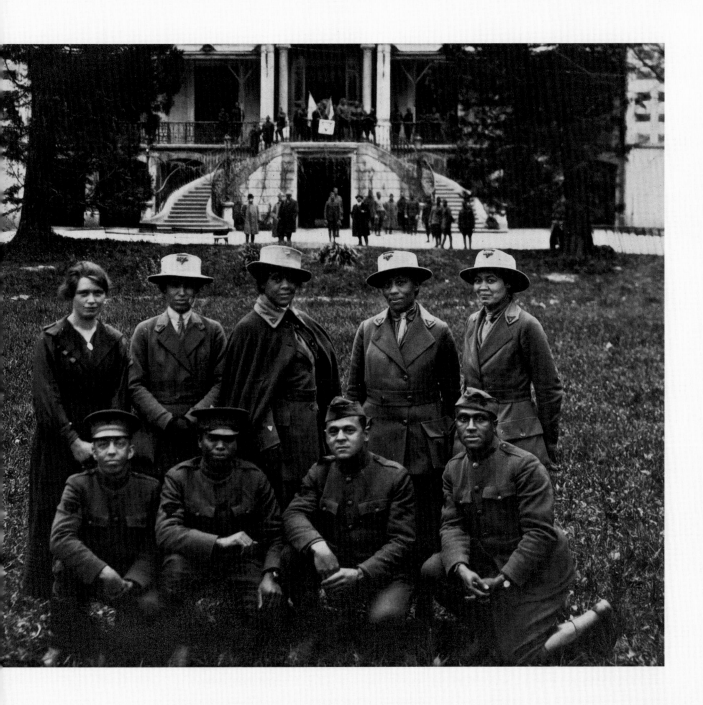

YMCA volunteers Kathryn Johnson (back row, second from left) and Addie Hunton (back row, center) pose with soldiers and staff at the Casino, a segregated YMCA leave station in Challes-les-Eaux, France.

The American Red Cross (ARC) was an important vehicle for women's war work, and thousands of trained African American nurses expected the ARC to welcome their participation. They offered their services as early as December 1917 but were merely permitted to enroll and told to wait. In the spring of 1918, when the US Surgeon General, William C. Gorgas, and the ARC issued a public plea for more nurses, the organization still refused to accept African Americans, ostensibly because of a lack of segregated facilities in the places where they might be assigned. The Red Cross claimed that while the organization accepted volunteers of all colors and religions, it had no control over black nurses' assignments to hospitals, where they might serve only segregated military units. Assigning white and black nurses to the same posts was not considered advisable.

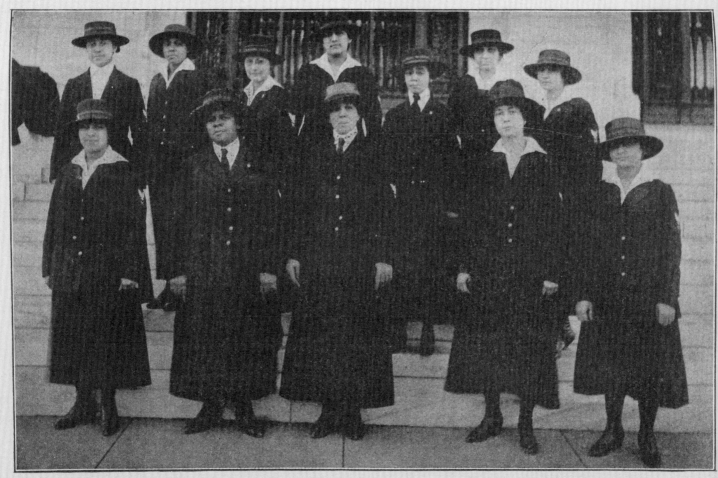

COLORED YEOWOMEN.
Employees of Navy Department, Washington, D. C.

It is estimated that some 1,800 black nurses were certified by the Red Cross for duty with the military, but none were called up until the final days of the war, when the Spanish influenza pandemic swept the world and medical help was desperately needed. A small number of ARC African American nurses were called up to serve in the Army Nurse Corps in the United States, but none were ever sent overseas.

Large contingents of African American women also logged thousands of service hours and miles with the American Red Cross Motor Service, founded in 1917. They aided in the transport of troops and supplies, and worked in canteens, military hospitals, camps, and offices across the United States.

The aftermath of the war brought swift disillusionment and dashed hopes that honorable participation in the war effort would usher in racial equality for African Americans. Yet the experiences gained through war service led to greater self-determination for women and propelled their political and social activism well beyond the postwar years. ✪

The first African American women in the US Navy, known as the "Golden Fourteen," worked in the muster-roll section of the Department of the Navy in Washington, DC, during the war. This photograph was taken circa 1918.

into the Convict Lease System. In addition, the boll weevil was ravaging cotton crops and reducing the demand for agricultural labor. African Americans began voting with their feet. In the early twentieth century, thousands of Southern blacks traveled north and west in the largest migration in American history, drawn by industrial jobs and the promise of a better life in cities that were, at least to some degree, desegregated.

Serving Anyway

Throughout all the turmoil and violence of the postbellum years, black soldiers continued to serve with distinction in the US military. Their presence was never easy: relegated to all-black units, they had little hope of promotion or opportunity for command, and they were subjected to discrimination from soldiers and civilians alike. In Brownsville, Texas, in 1906, 167 soldiers of the 25th Infantry Regiment were dishonorably discharged on unsubstantiated charges of shooting two white citizens and raping a white woman.

Nevertheless, more than 12,500 African American and Seminole Negro-Indian Scouts served on the frontier between 1866 and 1891 during the wars of Western expansion. Approximately one in five cavalry soldiers and one in ten to twelve infantry soldiers in these conflicts were African American. These were the so-called Buffalo Soldiers, a

This Medal of Honor was awarded to Sergeant Thomas Shaw of the 9th Cavalry Regiment (among the original "Buffalo Soldiers") for extraordinary heroism fighting against Apache warriors in the Battle of Carrizo Canyon, New Mexico Territory, in 1881. Formerly enslaved, Shaw served in the army for almost thirty years before retiring in 1894.

name originally applied to the 10th Cavalry Regiment stationed at Fort Leavenworth, Kansas, but eventually extended to all the black units. Their service was crucial to the opening of the American West and controlling locations then distant from federal authority. They participated in battles and campaigns against Native Americans; built

forts and roads; escorted wagon trains, stagecoaches, and mail runs; installed telegraph lines; and patrolled the Mexican border. Eighteen of these soldiers and scouts were awarded the Medal of Honor, the United States' highest individual military decoration for valor.

The Buffalo Soldiers also helped build infrastructure in and bring order to the newly established Sequoia and Kings Canyon National Parks in California. There they were, for a time, under the leadership of Captain Charles Young, one of the first African Americans to graduate from West Point. The military academy had admitted its first black cadet in 1870, and twelve were admitted before the beginning of the twentieth century. Three graduated—Henry Ossian Flipper in 1877, John Hanks Alexander in 1887, and Young in 1889.

Black soldiers also served in regular army, volunteer, and state militia units during the 1898 Spanish-American War. Six, including one sailor, were awarded the Medal of Honor. Soldiers from the 10th Cavalry and 24th Infantry came to the aid of Theodore Roosevelt and the Rough Riders at the critical moment in the fight for San Juan Hill in Puerto Rico in 1898. Three African American volunteer and state units also deployed to Cuba. African American soldiers served overseas again during the Philippine Insurrection (1899–1902) and on the Mexican border during the 1916 Punitive Expedition against the forces of Pancho Villa. Meanwhile, African Americans were serving in the navy and staffing Coast Guard lighthouse stations, including the one at Pea Island, North Carolina. Between 1872 and 1901 eight African American sailors were awarded peacetime Medals of Honor. African Americans' service was tangible proof of their contribution to the nation.

Black Soldiers in World War I

The question of whether African Americans should volunteer for service in World War I, and their experiences in the European theater of war, marked a watershed in black life. When Wilson declared war, there were only 126,000 men in the standing army. Raising the number of troops needed to support a foreign war would require drafting men of all races. Wilson, the first Southerner to be elected president since 1848, had segregated the

John Hanks Alexander graduated from West Point in 1887, the second African American to do so. He was preceded by Henry Ossian Flipper in 1877 and followed by Charles Young in 1889.

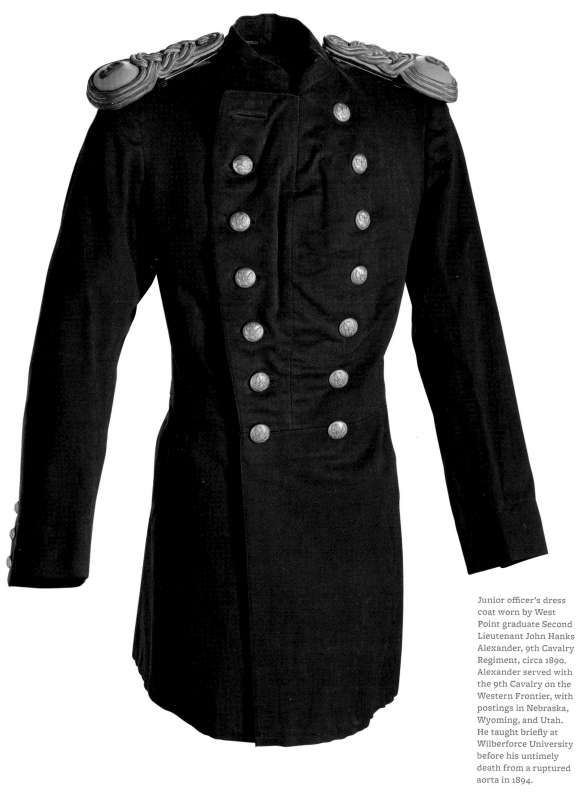

Junior officer's dress coat worn by West Point graduate Second Lieutenant John Hanks Alexander, 9th Cavalry Regiment, circa 1890. Alexander served with the 9th Cavalry on the Western Frontier, with postings in Nebraska, Wyoming, and Utah. He taught briefly at Wilberforce University before his untimely death from a ruptured aorta in 1894.

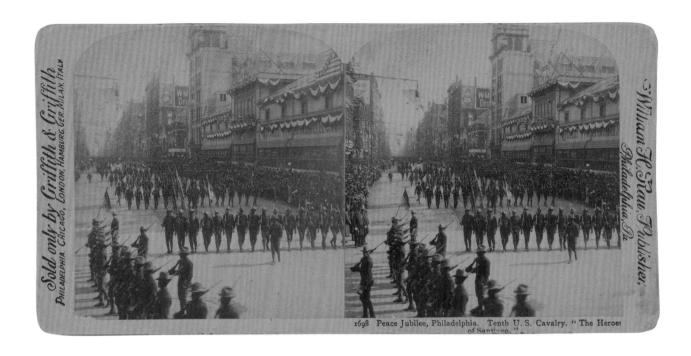

1698 Peace Jubilee, Philadelphia. Tenth U. S. Cavalry. " The Heroes of Santiago."

Sold only by Griffith & Griffith
PHILADELPHIA, CHICAGO, LONDON, HAMBURG, GER. MILAN, ITALY.

William H. Rau, Publisher.
Philadelphia, Pa.

government workforce in 1913, shortly after he took office. To avoid "friction" between the races, he asserted, the military would also be strictly segregated.

Even before the official draft began, on May 18, 1917, thousands of young black men had volunteered. Many leaders in the African American community were urging service. Most prominent among them was Du Bois, who saw the struggle against imperial Germany as a way for black Americans to validate their worth and advance the cause of civil rights at home. Others dissented, including the journalists and civil rights activists A. Philip Randolph and Chandler Owen (see page 44), who viewed the ostensible defense of democracy abroad as hypocritical given the United States' oppression of its African American citizens.

Learning a lesson from the Civil War draft riots, the federal government decentralized World War I draft boards into 155 district boards and 4,648 local boards. Draft exemptions, especially in the South, were disproportionately granted to white draftees: an Atlanta county board granted exemptions to 526 of 815 white draftees but only 6 of 202

Above: Soldiers of the 10th Cavalry Regiment march in the Peace Jubilee in Philadelphia, October 1898. Their performance in battle during the Spanish-American War earned them the nickname "Heroes of Santiago."

Left: Mexican Border Service souvenir medal made by the Schwaab Stamp & Seal Company, circa 1916. Featuring the Lord's Prayer on the back, these medals were sold to commemorate military service during the Punitive Expedition, one of the many campaigns in which African American soldiers served.

GOLD STAR MOTHERS

Lisa M. Budreau

In the summer of 1930, Mrs. Louise Kimbro, a fifty-seven-year-old African American woman from Columbus, Ohio, boarded a train for New York City. She was one of 6,685 women who accepted the government's invitation to join the Gold Star Mothers and Widows pilgrimage between 1930 and 1933. Her son, Private Martin A. Kimbro, had died of meningitis in May 1919 while serving with a US Army labor battalion in France, and his body lay buried in one of the new overseas military cemeteries. Now she would see his grave for the first time.

The journey was enabled by legislation signed by President Calvin Coolidge on March 2, 1929, just before he left office. It authorized mothers and unmarried widows of deceased American soldiers, sailors, and marines buried in Europe to visit their loved ones' final resting places. All reasonable expenses for their journey were paid for by the nation.

Newspapers promoted the democratic spirit of the event, reminding the public that all the women, regardless of religion, social status, income, or place of birth, were guests of the US government and would be treated equally. In early 1930, however, President Herbert Hoover's administration announced that "in the interests of the pilgrims themselves," the women would be divided into racially separate groups but that "no discrimination whatever will be made." Every group would receive equal accommodation, care, and consideration.

Hoover's staff did not anticipate the political backlash awaiting the War Department once these intentions were revealed. Inviting African American women to participate on these terms required their acquiescence to the same segregated conditions under which their sons and husbands had served during the war. The ensuing protest by the black community, though largely forgotten today, prefigured events from the civil rights movement decades later.

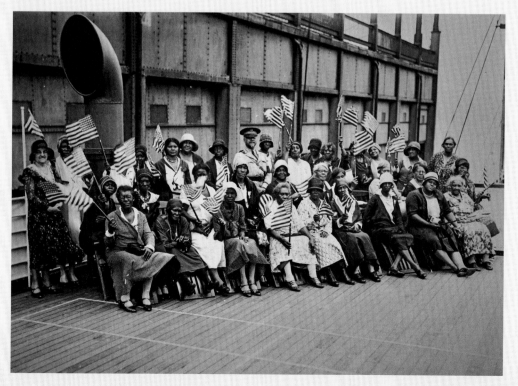

Gold Star Pilgrims with Col. Benjamin O. Davis Sr. (center) aboard ship in 1931. Although nearly 1,600 African American mothers and widows were eligible to travel to Europe, fewer than 200 participated, partly because of the segregated nature of the program.

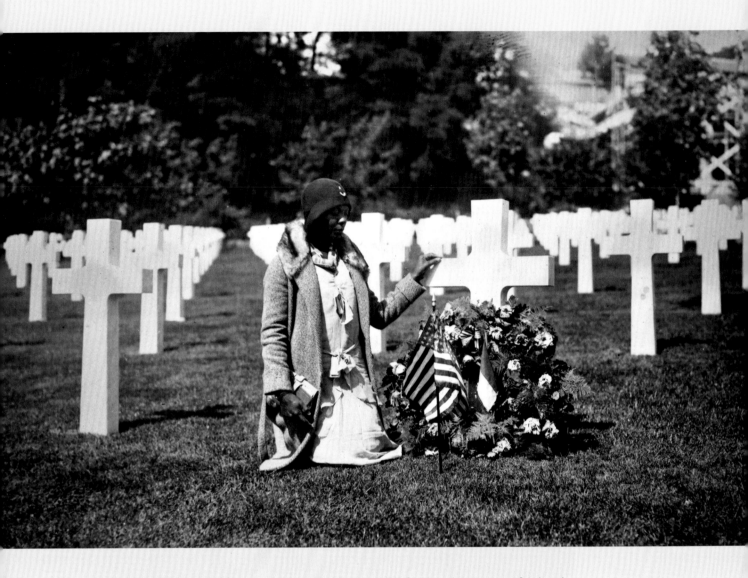

Walter White, executive secretary of the National Association for the Advancement of Colored People (NAACP), held a press conference in New York City just as the first ship carrying white women to the cemeteries was sailing out of the nearby harbor. He explained that his organization had written to all eligible black Gold Star mothers and widows encouraging them to boycott the pilgrimage if the government refused to change its segregation policy. Consequently, hundreds of cards were sent to the secretary of war with signatures protesting the government's plan, along with a separate letter directed to the president, vehemently objecting to the proposal. Signed petitions from around the nation began arriving at the War Department, claiming that "the high principles of 1918 seemed to have been forgotten." Others reminded policy makers that "colored boys fought side by side with the white and they deserved the due respect." One resentful Philadelphia mother asked, "Must these noble women be jim-crowed, [and] humiliated on such a sacred occasion?"

Undeterred, the Hoover administration insisted that "mothers and widows would prefer to seek solace in their grief from companions of their own race." But this rebuttal failed to satisfy black mothers, who continued to send in their petitions as part of the NAACP's efforts. They claimed they would decline to go at all unless the segregation ruling was abolished and all women could participate on equal terms.

Between 1930 and 1933, the US government funded segregated trips to American military cemeteries in Europe for mothers and widows of fallen soldiers. This Gold Star Pilgrim is visiting a soldier's grave at Suresnes American Cemetery, west of Paris.

The NAACP campaign, threats that black voters would switch to the Democrats, and even the adept pen of W. E. B. Du Bois ultimately failed to alter the government's stance. In a sharp assault, Du Bois referred to the more than six thousand African Americans whose "Black hands buried the putrid bodies of white American soldiers in France. [Yet,] Black mothers cannot go with white mothers to look at the graves."

Walter White had hoped that when the mothers and widows understood the separate conditions governing their travel, they would "repudiate the trip." For some mothers, however, refusing the government's invitation was one sacrifice too many. Most seem to have signed the petition without intending to forfeit this unique offer. When they were forced to choose between motherhood and activism, motherhood prevailed.

The number of eligible African American women was, in the event, too small to influence policy. Approximately 1,593 black mothers and widows were deemed eligible to make the pilgrimage. Many declined, largely because of ill-health, death, or remarriage. Only 233 accepted the invitation, and fewer than 200 actually sailed.

For those who went, traveling posed challenges: most of the women were mothers in their sixties, but a number were over seventy and in failing health. Some were so poor that they were unable to buy even the suitcase necessary for the trip, and most had never traveled so far on their own. And for women like Louise Kimbro, who endured a twenty-hour train journey across a segregated nation before boarding a ship to Europe, there were additional hardships involved. With no luggage racks in the "colored" section of the train, passengers were forced to cram their suitcases around their feet in the crowded compartments. "Colored" train bathrooms were smaller and lacked the amenities of the "whites" bathrooms, and while traveling through Southern states, women were required to move to "colored only" railcars so that white passengers could board. On arrival in New York, African American women were accommodated at the YWCA hostel, rather than the more comfortable Hotel Pennsylvania where white pilgrims stayed.

The African American women who embarked on the SS *American Merchant*, a freighter-passenger vessel (rather than a luxury liner), hailed from a variety of states and social backgrounds, from illiterate women to college graduates. They were escorted by Colonel Benjamin O. Davis Sr., the army's highest-ranking black officer.

Once they landed in France, separate trains carried African American and white pilgrims to Paris, where they were welcomed at the station by the trumpeted notes of "Mammy," played by Nobel Sissle's orchestra. The African American women enjoyed many of the same elegant restaurants and receptions offered on the white women's itinerary but were again lodged in different hotels, since French hoteliers hesitated to accept black women for fear of offending some of their white American clientele.

Most women returned from their pilgrimage without regrets. One Georgia mother told reporters, "Every effort was made to get me not to come. I think it is a shame that some mothers were induced not to come by people who had nothing to lose, and who, if they were in our places, would certainly have come." No one seems to have publicly challenged those who accepted the government's offer, which required of them a compromise that white mothers and widows had not been asked to make.

It is estimated that twenty-three women, their identities no longer known, refused the invitation at the urging of the NAACP. Although they may not have achieved their objective of an integrated pilgrimage, this minority of older and mostly poor, uneducated black women had challenged the injustices of Jim Crow and succeeded in shifting the balance of power nationally by questioning the hypocrisy of the program and the violation of the democratic principles over which the war had been fought. ✸

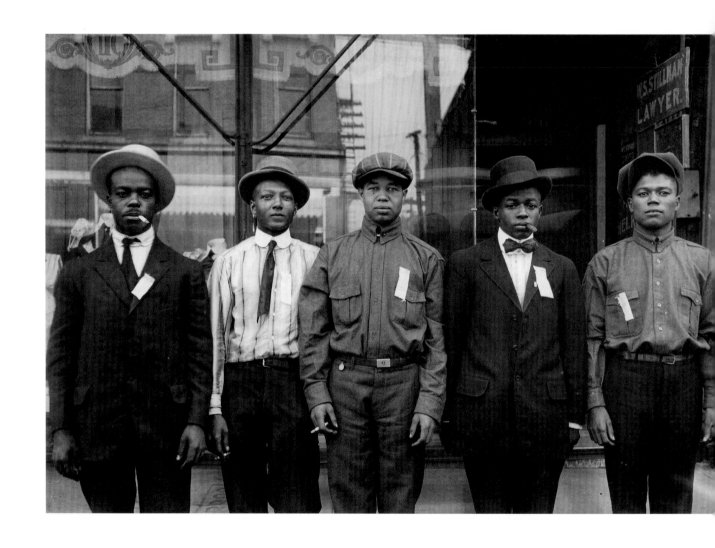

Five young Iowa men report to a selective service board in Council Bluffs, Iowa, September 1, 1918. They would be sent to Camp Dodge in Johnston, Iowa, for training.

African Americans (rates of approximately 70 percent and 3 percent, respectively). In 1917, 51 percent of African American men examined by local draft boards were categorized as Class I, or eligible for the draft, while only 32 percent of white men examined were categorized as Class I. Of these eligible men, one-third (or about 36 percent) of the African Americans were drafted, and one-fourth (or about 24 percent) of the whites.

Of the nearly 400,000 African Americans who served during World War I, nearly 370,000 were draftees. Most were destined for services of supply (SOS) units, which performed functions such as loading and unloading ships, transporting food and other supplies, and moving supplies from depots to combat divisions. More than 200,000 African Americans were deployed overseas in segregated units, 160,000 of them in SOS units. The balance were the 92nd and 93rd Infantry Divisions.

Assigning most African American men to SOS units rather than to combat roles proved to be both problematic and inefficient. Through its reluctance to arm or properly train black soldiers, the United States hobbled its own fighting force. In addition to the 93rd Infantry Division (Provisional), consisting of three African American National Guard volunteer regiments, the War Department initially planned for sixteen additional infantry regiments of black draftees. Out of hesitancy over the very idea of the black combat soldier, however, it reduced that number of black draftee regiments to four (the 365th, 366th, 367th, and 368th), which became the 92nd Infantry Division. This compromise was meant to appease white demands to maintain the status quo while satisfying black demands for inclusion in infantry units.

Barring black soldiers from combat units made them essentially laborers in uniform (if, indeed, they were issued proper uniforms at all) and also made them vulnerable to mistreatment. In comparison to white soldiers, they were ill equipped and poorly billeted. While visiting Camp Hill, Virginia, an African American investigator named Charles Williams reported: "During the coldest weather Virginia has experienced in twenty-five years, the stevedores lived in tents without floors or stoves."

Black soldiers were paid the same amount as white soldiers of equivalent rank. Promotions for African Americans, however, were less common than for white soldiers and slower to be awarded. Even in integrated units, African American soldiers were generally not allowed to outrank white soldiers, so they were effectively prevented from attaining higher ranks. The results were predictable: black soldiers were, in the aggregate, the lowest ranked and lowest paid in the US military.

A segregated military also sometimes pitted blacks against blacks. Unlike most white regiments, which were organized largely by region, African Americans from all over the country were often concentrated into a few units. Clashes sometimes resulted, as they did at Camp Meade, Maryland, where "the Philadelphia negroes asserted a superiority over the Tennessee negroes, which the latter resented," in the words of Wilson L. Townsend, a Texan who visited the camp on December 2, 1918.

Fort Des Moines

Throughout the nation's history, African Americans had been called upon to fight in times of war, but they were generally permitted to serve only under white officers. This was the case in World War I as well, until the creation of the Fort Des Moines Provisional Army Officer Training School, a segregated camp established specifically to prepare African American men to become commissioned officers and lead black soldiers into battle.

The camp owed its origins in part to the efforts of Du Bois and other black leaders, including Colonel Charles Young (see page 94). In February 1917, the NAACP president, Joel Spingarn, wrote an open letter to educated African American men: "It is of the highest importance that the educated colored men of this country should be given opportunities for leadership." Perhaps the most important organization fighting for

Wool service coat worn by a soldier in the 93rd Infantry Division. The African American soldiers of the 93rd served with the French Army, where many of them experienced for the first time the equality with white people for which they were fighting.

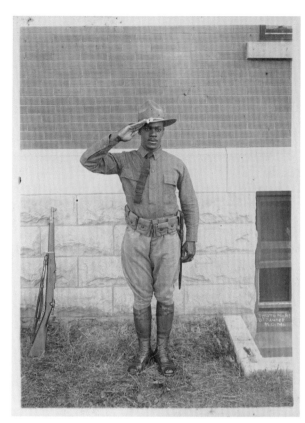

the camp was the Central Committee of Negro College Men (CCNCM). Established on May 1, 1917, at Howard University, the committee quickly began soliciting support throughout the country for black officer training. Explaining why well-educated black men and key African American leaders, many of them against segregation, would lobby so enthusiastically for a segregated training camp, the CCNCM men observed: "This camp is no more 'Jim Crow' than our newspapers, our churches, our schools. . . . Can we furnish officers to lead our troops into battle; or will they have to go again . . . under white officers?" These astute young men knew that one way or the other, they could be drafted into the army, so they might as well go as officers.

The War Department conceded the argument on May 19, 1917, and less than a month later, 1,250 African Americans were sworn into the training school at Des Moines. Candidates had to meet highly selective criteria. One-fifth came from the black regular army regiments—the 9th and 10th Cavalry and the 24th and 25th Infantry (the Buffalo Soldiers)—and most were experienced veterans. Four had seen action at Carrizal in Mexico during the Punitive Expedition, and a hundred hand-picked black troops were sent from the Philippines. The remaining one thousand civilian trainees were either recent college graduates or successful professionals. One company included fourteen lawyers, ten physicians, four dentists, three engineers, and a college professor. The camp housed at least four Harvard graduates from the class of 1917 and two students who had left

Above: Lt. Peter L. Robinson served with the 368th Infantry Regiment, part of the 92nd Division "Buffalo Soldiers." He was exposed to a German gas attack while fighting in France.

Right: Officer's campaign hat worn by Lt. Peter L. Robinson. After graduating from the Fort Des Moines Officers' Training Camp in 1917, Robinson was assigned to Fort Meade in Maryland.

Harvard Law School to serve. The largest contingent from any single university came from Howard University.

The Des Moines training program was patterned after rigorous officers' training camps throughout the nation, with days beginning at 5:30 A.M. and ending at 9:30 P.M. The men underwent standard training, ranging from rifle and bayonet instruction to signaling and reading maps. The candidates became the pride of both the national and the Des Moines African American communities. The *Literary Digest*, a public opinion magazine with a national readership, observed: "No member of the camp can walk through the town without a dozen small darkies trailing worshipfully at his heels."

Fort Des Moines graduated its first—and only—class of infantry officer candidates in October 1917. The graduation date was delayed a month because the War Department found itself in a dilemma over what exactly to do with its new black officers. As a result of the delay, some candidates, feeling tricked, departed. Others were dismissed despite completing all requirements. Of the original 1,250 enrollees, only 639 graduated (106 as captains, 329 as first lieutenants, and 204 as second lieutenants). A subsequent class graduated military dentists and physicians who were meant to serve as medical officers in African American units.

Though no explanation was given at the time for the attrition rate of nearly 50 percent, hindsight suggests that the War Department, having decided to reduce the number of black draftee infantry regiments from sixteen to four, decided it no longer needed that many black officers. After Fort Des Moines closed its doors to black trainees, a handful of African Americans gained officer status, but they trained at a few white officers' camps that began to accept black candidates.

Fort Des Moines was both a controversy and an achievement. On the one hand, it was yet another institution that segregated African Americans from their white counterparts. On the other, it offered African Americans a chance to become commissioned officers, and—perhaps more significantly—it meant that black officers might be able to lead black soldiers into combat, thereby demonstrating their worth as leaders to white society and their value as role models to the African American community.

One officer candidate, Charles Hamilton Houston, exemplified the generally stellar achievements of the Des Moines enrollees. He had graduated from M Street High School in Washington, DC, at the age of only fifteen. At nineteen, he had graduated from Amherst College (where he was selected for Phi Beta Kappa) and was teaching at Howard, where he became a founding member of the CCNCM. After graduating from Fort Des Moines, Houston trained at Fort Meade and became a field artillery officer with the 368th Infantry Regiment. Yet his disillusioning experiences overseas (see page 87) would also come to exemplify the experience of even the most highly qualified black soldiers in World War I.

Right: Charles Hamilton Houston's wartime experiences inspired his postwar career. As a lawyer, he defended veterans and challenged the Army's discriminatory practices. He also mentored young black lawyers, including the future Supreme Court justice Thurgood Marshall.

Left: Colt Model 1917 service revolver issued to Lieutenant Charles Hamilton Houston, 1918. This is one of the few known revolvers whose ownership can be directly traced to an African American officer who served in World War I.

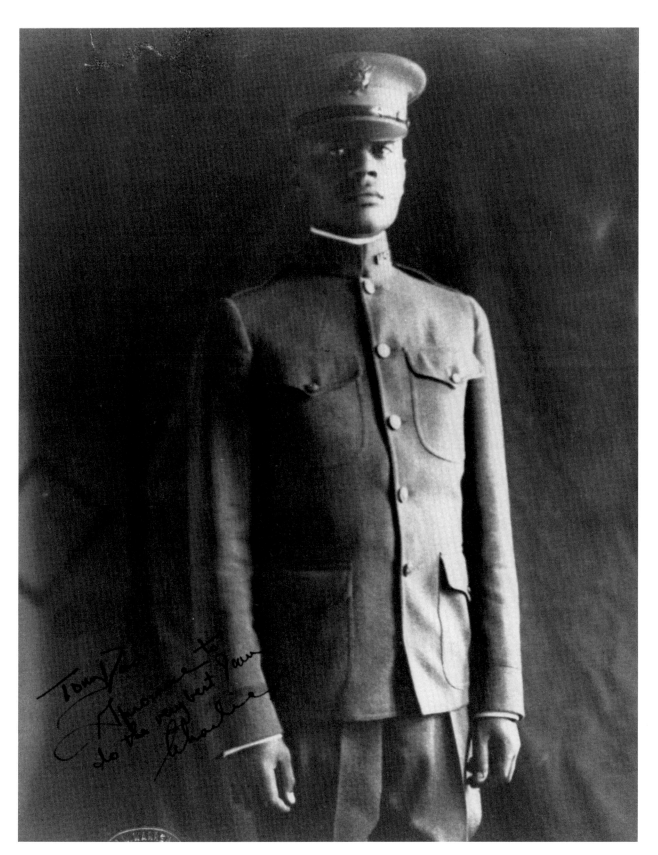

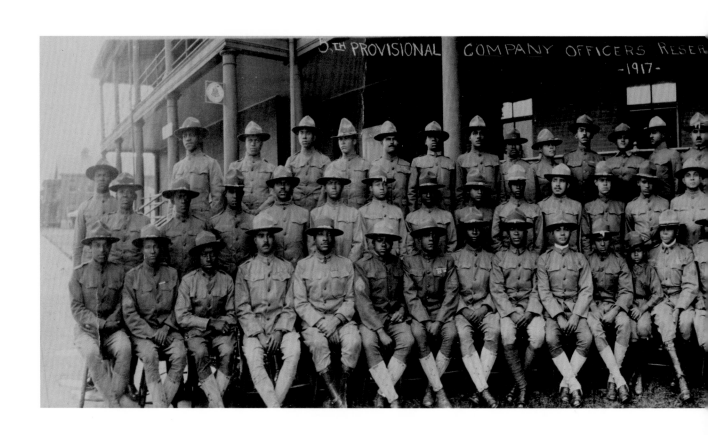

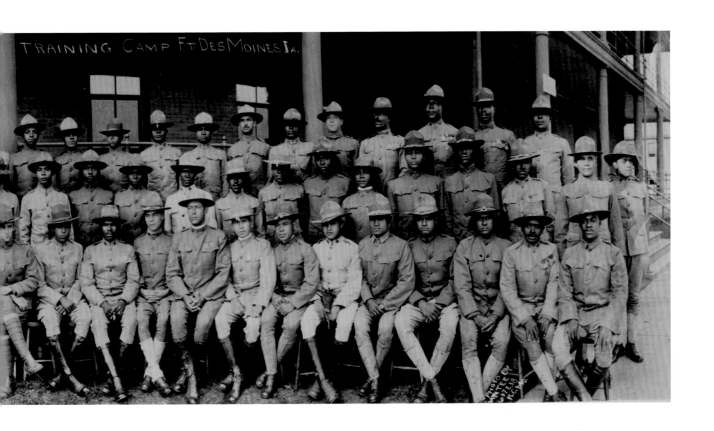

Officer candidates of the 5th Provisional Company at the Fort Des Moines Officers' Training Camp in Iowa, 1917. Charles Hamilton Houston is in the second row, fifth from the right.

Services of Supply (SOS) Units Abroad

The mostly segregated military of World War I resembled America itself. Black soldiers did what they had done as black civilians: they made a way out of no way, accomplishing monumental tasks under constrained conditions and contributing to national success while receiving few accolades. The work of the SOS units was vital to that of the combat units: from Hannibal crossing the Swiss Alps to Napoleon in the Pyrenees, all great military commanders have known that success on the battlefield depends on securing a solid supply network.

African Americans constituted more than one-third of the forces maintaining that network in World War I. It helped ensure that the gigantic army that was efficiently transported across the Atlantic—an undertaking so daunting that Germany had long dismissed the prospect of US involvement as impractical—got what it needed to fight in France. Black stevedores were among the first Americans to arrive in France, in June 1917, and black graves registration soldiers were among the last to leave, in the summer of 1919. African Americans in SOS units served at major ports, including Bordeaux, Brest, Saint-Nazaire, Nantes, and Bassens. They served throughout the French countryside, too, in locations such as Lyon, Château-Thierry, Nevers, and Le Mans. On one occasion, stevedores unloaded 5,000 tons of cargo and 42,000 men and their gear in a single day. A black stevedore unit in Bordeaux unloaded nearly 800,000 tons of needed materials in a single month. A group of black soldiers at Brest unloaded 1,200 tons of flour in eighteen hours and, in a competition of sorts against themselves, they unloaded an

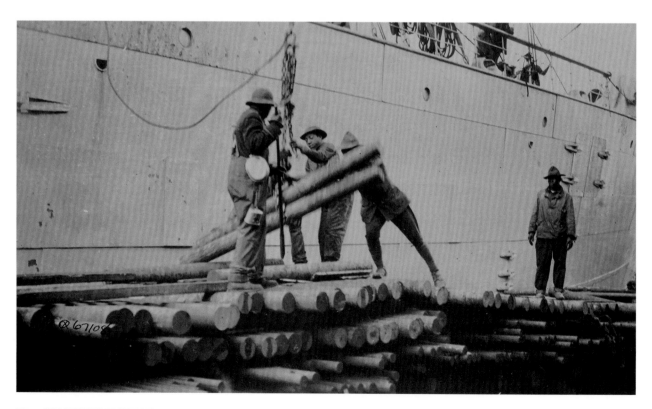

Legend:
- Ports used by SOS
- Important towns
- Major SOS railroad lines
- Western Front line trace ~January 1918

American Expeditionary Forces Services of Supply Network

Nearly 400,000 African Americans served during World War I, 200,000 of them served overseas in the American Expeditionary Forces (AEF). The 200,000 African Americans who served overseas consisted of National Guard, draftee, and volunteer soldiers. Approximately 160,000 (or roughly 80%) of them served as Services of Supply (SOS) troops in service/labor battalions, stevedore units, engineer service battalions, and pioneer infantry regiments. The other 20% were combat troops in two infantry divisions. Though African Americans constituted about 10% of all AEF soldiers, they comprised more than one-third of the SOS forces charged to maintain the supply networks depicted in this map.

average of 2,000 tons per day in the following five days. As one unknown white observer of the SOS units stated: "They packed and unpacked the American Expeditionary Forces in a manner never attempted since Noah loaded the Ark. Indeed, SOS soldiers were the lifeblood that sustained the AEF throughout the war."

Graves registration soldiers, among whom black soldiers were disproportionately represented, had the gruesome task of locating, retrieving, and burying the dead bodies of American soldiers, often decaying and dismembered. In their book *Two Colored Women in the American Expeditionary Forces*, Addie Hunton and Kathryn Johnson recalled: "At Camp Romagne [in the Argonne Forest] . . . there were about 9,000 colored soldiers engaged in the heartbreaking task of reburying the dead." Later they added: "It would be a gruesome, repulsive and unhealthy task. . . . Strange that when other hands refused it, swarthy hands received it!"

Left: African American stevedores unload iron from a ship in Saint-Nazaire, France, 1917. Stevedores worked long hours loading and unloading thousands of tons of cargo that enabled the Army to function.

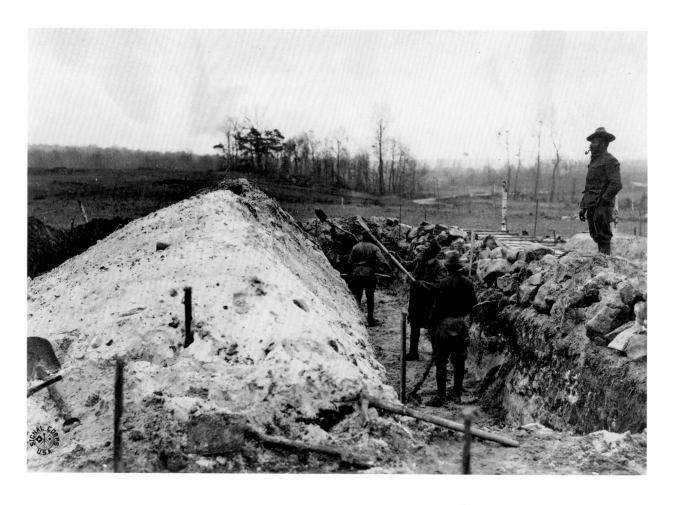

Black Soldiers on the Battlefield

While the SOS's achievements were impressive—and essential—the American military remained far less efficient and effective than it would have been had it allowed more black soldiers to serve in combat. The accomplishments of those African American soldiers who did see battle make this point abundantly clear.

African American men who fought in France were assigned to two infantry divisions, the 92nd and the 93rd. The disparate experiences of the two units offer a study in both the treatment and leadership of black soldiers by the French and by white Americans.

The 93rd Infantry Division (Provisional) was composed mostly of African American National Guard units, including the 369th, 370th, and 372nd Infantry Regiments; its 371st Infantry Regiment was made up of black South Carolina draftees. It was dubbed "provisional" because it lacked the support units of white divisions and the 92nd Division, such as field artillery regiments, machine-gun battalions, and engineering regiments. With the exception of the 370th, whose officers initially were all African Americans, from the colonel in command down to lieutenants, most of the 93rd's officers were white. Unlike white divisions, the 93rd never achieved full divisional strength; nor, due to segregationist policies, did it train or fight as a division. The cards seemed to be stacked against the 93rd, but its achievements on the battlefield proved otherwise.

African American graves registration soldiers dig a burial trench at Fère-en-Tardenois, France, in December 1918. More than six thousand soldiers are buried at what is now the Oise-Aisne American Cemetery and Memorial.

The 369th was the first African American regiment to arrive in France, on January 1, 1918, and the division's other three regiments landed in April. General John J. Pershing ordered the 369th assigned to the overtaxed French army, where the black Americans received reasonably equitable treatment and excellent—albeit brief—precombat training from their French counterpart units.

In late March 1918, the 369th was sent to the Argonne Forest along with the French 16th Division. There they held front lines against German assaults for more than a month. Afterward they were moved to another front-line position, at Minacourt. In intense fighting from mid-July to early August, they helped the French 161st Infantry Division drive back the Germans during the Aisne-Marne counteroffensive.

Serving in the 369th was the budding artist Horace Pippin, who entered the trenches in April 1918, shot his first German soldier on April 14, and later created books of sketches that would become an influential visual record of the war and prefigure his career as one of the twentieth century's most notable artists. Throughout that summer, Pippin and his fellow soldiers rotated in and out of front-line trenches, soon becoming seasoned combat veterans. In late September, during the battle for Séchault, in which the 369th suffered a high number of casualties, a sniper's bullet disabled his right arm. "I did not care what or where I went," Pippin recalled later. "I asked God to help me, and he did so. And that is the way I came through that terrible and Hellish place. For the whole entire battlefield was hell, so it was no place for any human being to be."

The various regiments of the 93rd not only participated in the Argonne and the Aisne-Marne offensives but also saw combat in Champagne, Thur, Vosges, and Verdun. There are compelling arguments that the equal treatment and solid leadership provided by the French played a significant role in the unit's notable performance. France later

Dogfight over the Trenches by Horace Pippin, circa 1935. A self-taught artist, Pippin first returned to art as physical therapy for a debilitating war wound. His art ultimately helped him to process difficult wartime experiences.

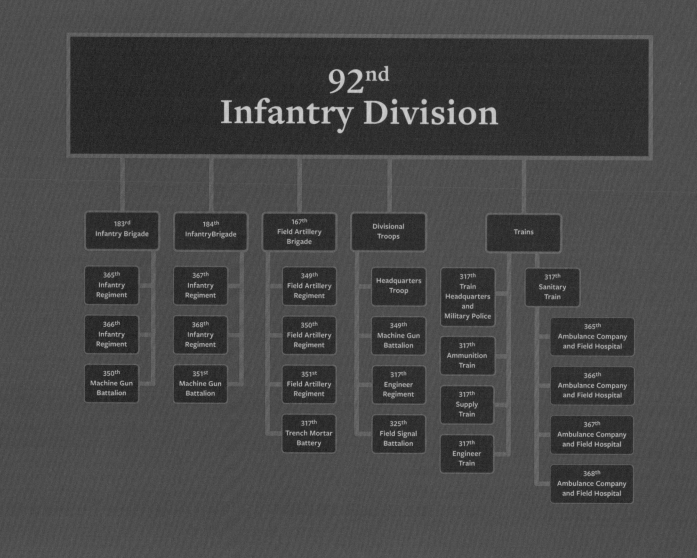

92nd Infantry Division

183rd Infantry Brigade
- 365th Infantry Regiment
- 366th Infantry Regiment
- 350th Machine Gun Battalion

184th Infantry Brigade
- 367th Infantry Regiment
- 368th Infantry Regiment
- 351st Machine Gun Battalion

167th Field Artillery Brigade
- 349th Field Artillery Regiment
- 350th Field Artillery Regiment
- 351st Field Artillery Regiment
- 317th Trench Mortar Battery

Divisional Troops
- Headquarters Troop
- 349th Machine Gun Battalion
- 317th Engineer Regiment
- 325th Field Signal Battalion
- 317th Train Headquarters and Military Police
- 317th Ammunition Train
- 317th Supply Train
- 317th Engineer Train

Trains
- 317th Sanitary Train
- 365th Ambulance Company and Field Hospital
- 366th Ambulance Company and Field Hospital
- 367th Ambulance Company and Field Hospital
- 368th Ambulance Company and Field Hospital

awarded the 93rd Division the Croix de Guerre, along with 170 awards to individual soldiers for acts of valor.

Some African American officers attached to French units had opportunities to lead. Among them were those in the 370th Infantry Regiment—the old 8th Illinois, Chicago's historic National Guard unit—which had deployed to France with all black officers, including the colonel. However, once in France, the AEF replaced most of these officers with white ones. One of the few senior African American officers not forced out was Lieutenant Colonel Otis B. Duncan, commander of the 3rd Battalion, 370th Infantry. During the Allied advance from September to November 1918, his battalion was the first to enter Petite-Chapelle in Belgium, eventually forcing out the Germans there. Duncan and his entire battalion were awarded the Croix de Guerre for their actions. There might have been more like Duncan had other African American officers been allowed to lead their own units.

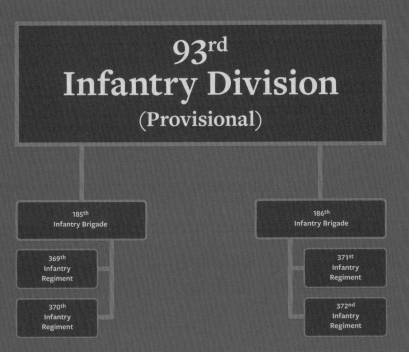

93rd
Infantry Division
(Provisional)

185th
Infantry Brigade

369th
Infantry
Regiment

370th
Infantry
Regiment

186th
Infantry Brigade

371st
Infantry
Regiment

372nd
Infantry
Regiment

The 92nd Infantry Division served under the American Expeditionary Forces while the 93rd Infantry Division (Provisional) served under the French Army. The 92nd largely consisted of African American draftees. White officers held the ranks of major and above (some captains) and black officers held the ranks of captain and below (mainly lieutenants). It consisted of the 365th, 366th, 367th and 368th infantry regiments and had a full contingent of organic support division troops. The various 92nd regiments participated in battles throughout the Meuse-Argonne offensive and the Marbache sector.

The 93rd (Provisional) largely consisted of African American national guard units. Regiments included the 369th, 370th, 371st, and 372nd. With the exception of the 370th Infantry Regiment—which initially had all black officers—most officers were white. *Provisional* meant it lacked organic support division troops such as artillery, machine guns, engineers, signal, ammunition, and a few other units. The various 93rd regiments participated in the Meuse-Argonne offensive—Champagne and Thur sectors—and the Vosges, Argonne, and Verdun sectors.

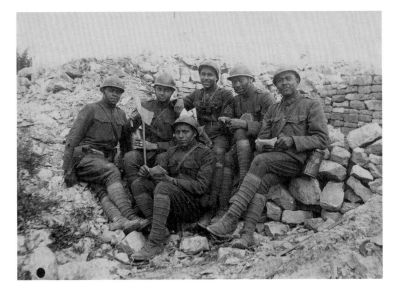

Soldiers of the 372nd Infantry Regiment including Oscar Calmeise (far right) at Verdun, France, in July 1918.

THE 369TH INFANTRY REGIMENT

Krewasky A. Salter

The 369th Infantry Regiment demonstrated what African American soldiers could achieve in combat under good leadership from white and black officers. Trained by French forces and led by African American noncommissioned officers and white commissioned officers who believed in their potential, the 369th Infantry proved that they could equal or exceed the performance of any American fighting unit during World War I.

The 369th had its roots in one of the first African American national guard units. Although US military leaders were notoriously reluctant to employ African Americans in roles requiring them to bear arms, after six years of campaigning by African American advocates and a few key white supporters, in 1916 the State of New York authorized the recruitment of an African American national guard unit, the 15th New York. Since African Americans were prohibited from joining white national guard units, many felt it was imperative to have African American units to give them the opportunity to serve. To overcome the political hurdles to raising a regiment led by black officers, a well-connected white lawyer from New York, William Hayward, was selected to command the regiment. Hayward quickly gained the confidence of both African Americans and white New Yorkers, building public support for the regiment. He had the foresight to select key African Americans, such as the popular bandleader James Reese Europe and the well-known lawyer and Harvard graduate Napoleon Marshall, to help with recruitment.

Once the regiment was fully manned, the 15th New York was sent to Spartanburg, South Carolina, in early October 1917 for training. Clashes soon developed between African American soldiers—many of them from the North—and Southern whites intent on maintaining the racial status quo. In one case, Captain Napoleon Marshall had paid his fare to ride on a local streetcar but was nonetheless ordered off the car. On another occasion a 15th New York soldier was attacked on the sidewalk and thrown into the gutter. Recalling the riot at Camp Logan, near Houston, in August (see page 114), the government decided to remove the 15th New York from Spartanburg within the month. Rather than

This group of unidentified men had recently volunteered for the 15th New York National Guard (later the 369th Infantry Regiment). They are pictured on their way to Camp Upton, New York, in 1917.

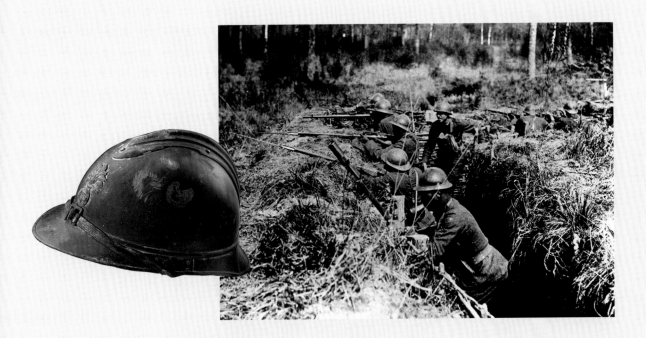

being sent to another training site, the 15th New York began preparing to deploy to France in November. It arrived in the French port of Brest on New Year's Day 1918, making it the first African American infantry regiment and one of the first American units to reach France.

Although the 15th New York had been recruited as an infantry unit, its soldiers were initially put to work behind the lines as services of supply (SOS) troops, building a supply base at Montoir-de-Bretagne. Issued with shovels, picks, and hip-length rubber boots, they were ordered to build a "dam, railroads, warehouses, and docks." Hayward made it clear to the AEF HQ that his men had not come all the way to France to do manual labor. At the time, France was clamoring for US combat power, but placing American troops under foreign command was contrary to US policy. To placate the French, the 15th was soon transferred from state to US federal authority, redesignated the 369th Infantry Regiment, and attached to the French Fourth Army in January 1918.

The 369th reached the trenches and encountered their first Germans in April 1918. A month later, Privates Henry Johnson and Needham Roberts were involved in an action in which they fought off a reported two dozen German soldiers. For their valor they were the first African Americans to be awarded the French Croix de Guerre. The AEF Commander, General John J. Pershing, issued an official communiqué stating that "two soldiers of an African colored regiment . . . should be given credit for preventing, by their bravery, the capture of any of our men."

The 369th served in the trenches for the duration of the war. In mid-August, Sergeant William Butler charged into the midst of an artillery barrage to help save his lieutenant and several other soldiers. For his actions, Butler was awarded the Croix de Guerre and the Distinguished Service Cross.

At the beginning of the Meuse-Argonne offensive in September—the culminating offensive of the war—the 369th recaptured the town of Séchault. Corporal Lawrence McVey (see page 88) and other members of the regiment were awarded the Croix de Guerre for individual acts of bravery during this action. Despite suffering high casualties, the regiment continued to occupy a front-line sector until Armistice Day, November 11, 1918. It was one of the first American units to reach the Rhine, where it remained on occupation duty until December. The 369th spent more days in front-line trenches than any other American regiment. ✹

Above: The distinctive French "Adrian" helmet was issued to African American soldiers of the 93rd Infantry Division, including the 369th Infantry Regiment, once they were attached to French units.

Above right: Members of the 369th Infantry Regiment, seen here wearing the Adrian helmet, went into the trenches in April 1918 after receiving training from the French.

The 92nd Infantry Division, composed of the 365th, 366th, 367th, and 368th infantry regiments, did not fare as well serving under the AEF. On its face, it was better trained and equipped than the 93rd: all its junior African American officers had graduated from Fort Des Moines, and it had three field artillery regiments, a trench mortar battery, three machine-gun battalions, a signal battalion, an engineer regiment, and several support units. All the officers in the ranks of major and above were white (there were also some white captains), and those ranking from captain downward were black. The regiment consisted largely of African American draftees from across the nation, which may have contributed to a lack of cohesion. Furthermore, unlike their counterparts in the 93rd, who received training from the French, the 92nd did not receive adequate preparation from the AEF before going into the trenches. Their white American officers, many of them Southerners, treated their own men as second-class citizens.

That lack of support and confidence resulted in poor performance at every level. Tension between the 92nd's commander, Charles Ballou (who had headed the Fort Des Moines Officers' Training Camp), and his superior, Robert Lee Bullard, commander of the Second Army and an unrepentant racist, did not aid matters. The breaking point was the Meuse-Argonne, where, in late September 1918, the 368th, sent to perform a difficult defensive maneuver without adequate equipment or sufficient artillery support, failed in their mission.

The 368th was pulled from the front-line trenches after a few days in battle. They were never retrained or properly supported; nor were they put back into the fight.

Men from Chicago lining up to enlist outside the 8th Illinois National Guard Armory in 1917. Chicago's "Old 8th Illinois" was re-designated as the 370th Infantry Regiment during the war.

African American junior officers received the bulk of the blame for the Meuse-Argonne failure, but most men and officers of the 92nd fought as well and sacrificed as much as white soldiers did. Among them was Lieutenant Mallalieu Rush, a 1916 graduate of Atlanta University, who graduated from Fort Des Moines and subsequently served in the 366th. In a prophetic letter to his mother, Rush wrote: "I will fight and die with my company. We have never yet been defeated nor made to cower by the enemy." Rush, aged twenty-three, died in battle while leading his men.

As the noted historian Edward M. Coffman wrote in *The War to End All Wars*: "On the very days in late September that the 368th had its difficulties . . . the 369th, 370th, 371st, and 372nd were carrying out successfully their missions . . . in Champagne and Oise-Aisne sectors. And the 370th was officered largely by Negroes. The French praised these regiments but white Americans chose to remember the 368th." The 368th was in reality much like other AEF units. For example, the all-white 35th Infantry Division was disorganized for at least five days following its deployment and took heavy casualties as a result. But the 368th had the added burden of racism. Its failure at Meuse-Argonne would become a whip with which black officers were lashed for decades.

Men such as Lieutenant Rush, who died in battle, and Lieutenant Colonel Duncan, who had led gallantly, were among the officers whose service was carelessly denigrated by white officers in subsequent US War College questionnaires and surveys. These were later cited in a 1925 report that concluded: "The negro as an officer is a failure, and this applies to all classes of negro officers." As a result, few of the soldiers who served under these officers, such as Horace Pippin, were recognized by the United States for their World War I service.

Charles Hamilton Houston was one of the 368th's field artillery officers, and no stranger to the pervasive racism of the US military. Both at Fort Meade, where he had

trained before deploying to France, and on the front lines, he received poor treatment from white officers and observed poor leadership among them. On one occasion, Houston was called upon to investigate a black soldier accused of a crime; when he found no evidence that might lead to conviction, he was called "no good" by his superior officers. Like other black officers, he was a convenient target for any failure within his unit.

The general performance of black officers in the 92nd speaks well for the division. For example, Charles Blackwood (1896–1982), who graduated as a lieutenant from Fort Des Moines and led soldiers as an infantry officer for the 92nd, was awarded three combat battle stars in France for valor in the Meuse-Argonne and in Saint-Dié sector. He is representative of the hundreds of black officers in the 92nd who

Lieutenant Charles Blackwood, pictured here in his World War I uniform, graduated from the Fort Des Moines Officers' Training Camp in 1917. He then served with the 365th Infantry Regiment in France, earning three combat battle stars.

never received full recognition for fighting honorably during the war. After the war, he went to work as an expert electrician for C&S Railroad, remained in the military reserves, and served as a major during World War II, leading enlisted men and junior officers at Fort Huachuca, Arizona. Blackwood retired as a reserve lieutenant colonel in 1948. He was living proof that black officers, despite the 1925 report, could and did lead well.

Commemorations and the Medal of Honor

A nation honors and commemorates its soldiers by awarding individual medals for service and valor. Service medals, such as the Victory Medal, denote participation in a war, while valor medals, such as the Medal of Honor, denote individual acts of heroism. Both are important because they acknowledge individual sacrifice and character.

After World War I, America debated how to commemorate the war and soon followed the European lead by creating cemeteries and monuments for its dead across France, and by establishing the Tomb of the Unknown Soldier at the Arlington National Cemetery in 1921. State and local municipalities created their own commemorative monuments and statues. But it was veterans themselves who created a pragmatic and lasting means of commemoration by establishing the American Legion almost immediately after the war ended. The Legion became the most powerful veterans' organization in America in the twentieth century. African Americans joined in all these efforts, hoping to ensure that they, too, would be recognized and rewarded for their service and sacrifice to the nation.

Some black veterans were indeed honored for their war service. But many, especially those returning to the South, were forced to conceal evidence of their military experience and even became targets of attacks as white fear of armed black men began to reemerge. During the infamous Red Summer of 1919 (April to November), at least twelve black veterans died as a result of violence largely fueled by white fear of demobilized African American soldiers. In Elaine, Arkansas, in October, large numbers of African Americans were killed and displaced from their homes. Leroy Johnston, a native of Elaine who had survived France with the 369th Infantry Regiment, was among those killed, with three of his brothers.

As a result of such treatment and of disregard for African Americans' war service, hundreds of stories have been buried. Many African Americans today are surprised to

Photograph of Corporal Lawrence McVey in uniform, circa 1920. The Croix de Guerre with Bronze Star is visible on McVey's chest, and the rattlesnake emblem of the 369th Infantry Regiment Harlem Rattlers is visible on his shoulder.

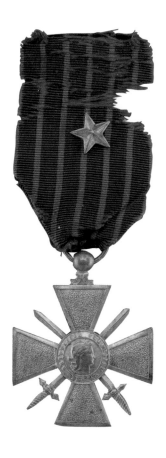

During the Meuse-Argonne offensive, Corporal Lawrence McVey led an attack on a German machine-gun nest at Séchault. For his bravery in action he was awarded the Croix de Guerre with Bronze Star (left) and a Purple Heart (right).

In recognition of Corporal Lawrence McVey's war service, he was awarded a 1914-18 Inter-Allied Victory Medal (France) (left) and a New York National Guard Recruiting Medal (right).

learn that they had relatives who served in World War I, because their families had long ago learned not to discuss the topic for fear of retribution.

Some black veterans from the South took commemoration into their own hands. Even before they left France, the 371st Infantry Regiment, composed largely of African American draftees from South Carolina, began pooling their funds to strike a commemorative coin depicting the major battles in which they had fought. Several years later, the 371st was among the many American units to erect monuments to the dead in remote locations in France. The 371st monument still sits atop Hill 188 in the Champagne-Marne sector, the site of one of its most famous battles.

In the North, by contrast, monuments commemorating African American soldiers do exist, largely associated with Northern National Guard units such as the 370th Infantry Regiment, from Chicago, and the 369th, often associated with Harlem (though not all its members hailed from there). A unique memorial is the Kimball War Memorial Building in West Virginia, dedicated in 1928 to honor local African American World War I veterans. The American Legion chartered the James Reese Europe Post No. 5 in Washington, DC, which held its original meeting on June 4, 1919. Europe was the leader of the 369th Harlem Hellfighters band.

The elaborate monuments that the US government commissioned and erected in France during the late 1920s and early 1930s tell a complex story. The monument at Château-Thierry, for example, bears a unit icon for the 93rd Infantry Division, which actually depicts the location of the 370th Infantry Regiment near Vauxaillon, the site of one of the 370th's most famous battles. The other three regiments of the 93rd Division, in the thick of the fight, were farther south. The splendid Montfaucon Memorial, at the Meuse-Argonne American Cemetery, prominently depicts the 92nd Infantry Division on the carved stone walls at the base of its two-hundred-foot tower. The 93rd Division is not depicted here, purportedly because it did not serve under the AEF, although it actually saw more combat during the Meuse-Argonne battle than the 92nd did, and more than several other US divisions depicted on the monument.

Soldiers of the 371st Infantry, consisting of South Carolina draftees, commissioned this commemorative coin to memorialize their service. The front lists the significant battles fought by the unit while the back depicts their transition from cotton farmers and sharecroppers to soldiers.

HORACE PIPPIN SKETCHBOOK

The acclaimed Harlem Renaissance artist Horace Pippin was a corporal in the 369th Infantry Regiment. He served in the trenches with his unit from the time they were deployed in April 1918 until September, when he was severely wounded during the Battle of Séchault and taken to a hospital in Lyon. After the war, perhaps in the early 1920s, Pippin created this sketchbook, with diary-style text. The sketchbook contains Pippins' earliest known drawings, which reflect his time in the trenches. This sketch, appearing on page 13, reflects his experience during a gas attack. ✺

Horace Pippin's sketches and notes recall his time in the trenches of France with the 369th Infantry.

Kindest wishes to Mrs Duggan
Lackland T. Hewitt
Major 372nd Inf. Mass. NG.
Monthois, France. 1927

Nonetheless, the fallen of the 93rd Division are honored in the Meuse-Argonne American Cemetery, including Freddie Stowers of the 371st, who was awarded the Medal of Honor for heroically leading his men against German machine guns on Hill 188 in the Champagne-Marne sector. Henry Johnson was awarded the Medal of Honor for heroic actions on May 13, 1918, while on night sentry duty in the forest of Argonne, near Champagne. But although roughly 120 Medals of Honor were awarded to American soldiers for valor during the war, none were awarded to African Americans until years later. The medal was awarded posthumously to Stowers in 1991 and to Henry Johnson in 2015. This long delay can be attributed to the prejudicial climate that existed during World War I. At the time of writing, the US World War I Centennial Commission, in conjunction with Park University in Parkville, Missouri, is investigating whether more World War I African American soldiers (and other minorities) were deserving of the nation's highest military honor.

Veterans pay tribute to the fallen at the 372nd Infantry Memorial in Monthois, France, 1927. The regiment was awarded the Croix de Guerre with Palm for heroic actions during the Meuse-Argonne offensive.

Despite the oubliette into which many black veterans' experiences have fallen, the battles that some veterans won in civilian life, long after World War I had ended, can be viewed as their own form of commemoration. Charles Hamilton Houston, for example, channeled his terrible wartime experiences into efforts to ensure that future generations would not suffer the same indignities while in uniform and after returning home. In 1919 he was admitted to Harvard Law School. After earning his degree in 1924, he began to teach at Howard University. He became dean of its law school in 1929 and worked to gain its accreditation. In that position he influenced and mentored a new generation of black lawyers. In 1934 he took on the US Army chief of staff, General Douglas MacArthur, over systemic racism in the military and the lack of officer positions in the regular army for African Americans. MacArthur denied that prejudice and discrimination existed in the army.

Houston's most famous student was Thurgood Marshall, who defended World War II veterans, including the Port Chicago mutineers in San Francisco. On July 17, 1944, 320 servicemen, mainly African American, were killed in a munitions explosion while working under questionable conditions. Many survivors were court-martialed for refusing to return to the same work and conditions. Marshall later argued and won the 1954 *Brown v. Board of Education* case before the Supreme Court, thus making desegregation of schools the law of the land. In 1967, he became the first African American Supreme Court justice. In 1951, Marshall wrote, "We wouldn't have been anyplace if Charlie [Houston] hadn't laid the groundwork for it." Houston had endured much in the trenches of France; perhaps the greatest honor that accrued to him from his wartime experience, however, was lasting gains in civil rights, a victory not only for black soldiers but for all African Americans.

In 1935, Charles Hamilton Houston and Thurgood Marshall represented Donald Gaines Murray in the landmark civil rights case *Murray v. Pearson*, which helped pave the way for the ruling in *Brown v. Board of Education*.

CHARLES YOUNG
Krewasky A. Salter

Charles Young graduated from West Point in 1889, only the third African American to do so. On the eve of US entry into World War I, he was still one of only three black officers to have graduated from West Point and the only one still on active duty. As the highest-ranking black officer in the regular army, the only West Pointer, and only the second Spingarn Medal recipient (1916), Young was something of a celebrity in the black community. He was professor of military science and tactics at Wilberforce University from 1894 to 1898 when W. E. B. Du Bois was also teaching there, and carried out at least six overseas assignments: two in combat, three as a diplomatic attaché, and one overseas peacetime assignment. He served in the Philippines twice, once during the Philippine Insurrection and again in 1908, and in Mexico during the Punitive Expedition. He also served in Haiti from 1904 to 1907 and in Liberia twice, from 1911 to 1914 and again from 1920 to 1922. In 1922 he dies in Nigeria while serving on his last assignment. Young superbly accomplished his missions without fanfare and with few missteps. Because of his skills and personality, he was several times requested by name for repeat or difficult assignments.

In early 1917 Young was selected for promotion to full colonel. But, for reasons still debated today, the government abruptly retired him at the grade of lieutenant colonel, citing a diagnosis of early-stage Bright's disease, and sent him home to Wilberforce, Ohio—even after a medical board had cleared him for further military service. Many African Americans and white supporters suspected that this was a way to ensure that Young would not lead troops in combat and subsequently become eligible for promotion to general. As laypersons and prominent Americans openly protested the decision to retire him, Young remained mostly stoic on the matter, writing: "[I] refus[e] to bellye-ache [sic] and play the baby-act." Instead Charles Young spoke volumes by riding his horse 497 miles from Wilberforce, Ohio, to Washington, DC, demonstrating his fitness for duty. He was recalled to active duty as a full colonel five days before the war ended, too late to be eligible for the rank of general.

Young was not only a career soldier but also a musician, writer, diplomat, environmentalist, and civil rights leader. At a Stanford University student assembly in 1903, he declared: "All a negro asks is a white man's chance." ✳

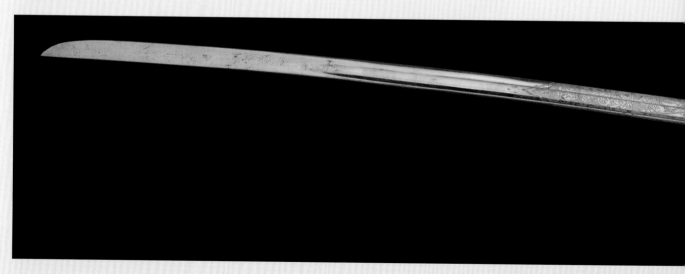

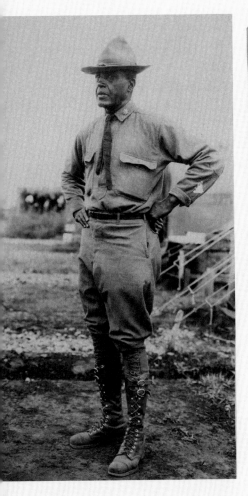

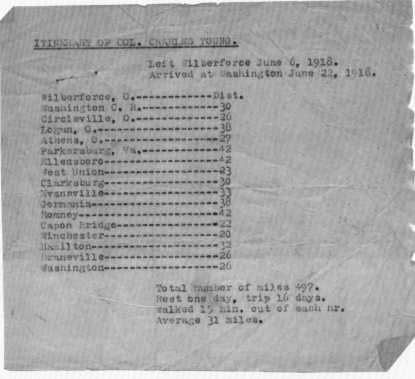

ITINERARY OF COL. CHARLES YOUNG.

Left Wilberforce June 6, 1918.
Arrived at Washington June 22, 1918.

Wilberforce, O.------------Dist.
Washington C. H.-----------30
Circleville, O.------------26
Logan, O.------------------38
Athens, O.-----------------27
Parkersburg, Va.-----------42
Ellensboro-----------------42
West Union-----------------23
Clarksburg-----------------30
Evansville-----------------33
Gormania-------------------38
Romney---------------------42
Capon Bridge---------------22
Winchester-----------------20
Hamilton-------------------32
Draneville-----------------26
Washington-----------------26

Total number of miles 497.
Rest one day, trip 16 days.
Walked 15 min. out of each hr.
Average 31 miles.

Left: Charles Young in 1916, during the Mexican Punitive Expedition. Young was eventually promoted to full colonel and died on active duty in Africa in January 1922.

Above: Charles Young's detailed itinerary of his sixteen-day ride on horseback from Wilberforce, Ohio, to Washington, DC (a distance of 497 miles), in 1918 quietly demonstrated his fitness to command troops during World War I despite being sidelined for a medical condition.

Below: This 1902 officer presentation saber is among the few surviving objects bearing Charles Young's name. "Chas. Young USA" is inscribed on the blade.

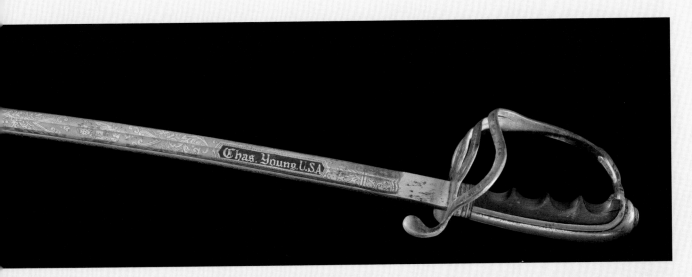

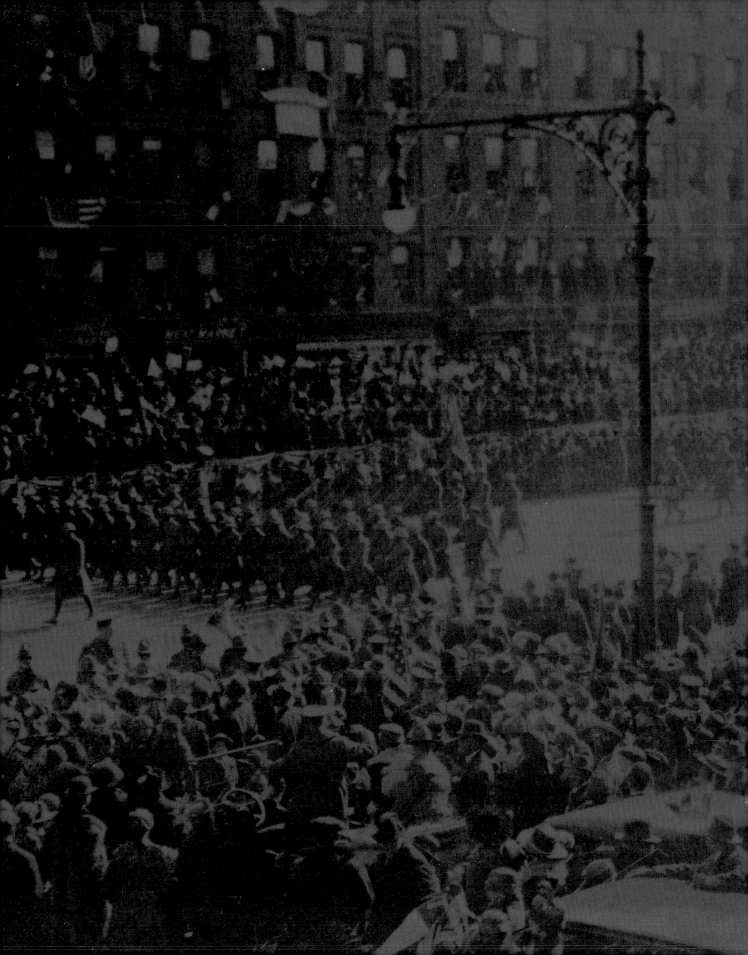

Chapter 3

At Home and Abroad:

During and after the War

At Home and Abroad: During and after the War

John H. Morrow Jr.

World War I, and the vast transformation of US and global politics that resulted from it, presented an opportunity for African Americans to exercise their agency against the manifold forces of racism and to create new lives for themselves. They challenged the old racist order by waging war abroad in the American Expeditionary Forces, and at home by fleeing the white supremacist order in the South to find work and homes in the North and pushing for racial equality through organizations such as the NAACP. They confronted daunting challenges as white Americans fought brutally to maintain their systemic privilege. Yet in a crucial way, African Americans triumphed, just as they had survived the crushing system of slavery, begun to prosper during Reconstruction, and continued to progress during the era of white supremacy. Between 1914 and 1919, black Americans found ways to demonstrate their humanity, strength, initiative, ability, and valor as they continued the struggle for equality in their own country.

In 1914, 90 percent of the African American population of nearly ten million people lived in the segregated Jim Crow South. White Southerners conceived of America as "the white man's nation" and refused black men the right to vote that had been granted them in the Fifteenth Amendment of the Constitution, ratified in 1870. They believed that African Americans had no rights that white people were bound to respect. To enforce segregation, the separate and unequal treatment of black citizens, and black subservience, white Southerners resorted to a reign of terror. Lynchings by the thousand occurred during and after the war, along with race riots and even incidents of racial cleansing—as in Forsyth Country, Georgia, where whites drove out all the black residents and took their property and possessions in 1912. Such atrocities were not limited to the South, as a race riot in Springfield, Illinois, in 1908 demonstrated. In the North, as in the South, the white perpetrators always went unpunished.

African Americans did not passively succumb to acts of hatred and violence. From the 1880s onward, some two hundred thousand black Southerners had already migrated

This 1918 poster by Charles Gustrine pays tribute to African American soldiers in the war. Despite segregation and racism, they fought with distinction and honor to ensure that "liberty and freedom shall not perish."

REOPENED SEPTEMBER 25th, 1908.

SELF-SERVING QUICK LUNCH

WHITE DENTAL PARLORS

REGULAR MEALS and A LA CARTE

LOPERS PLACE AFTER RIOT AUG 08.
AUTO BURNED SPRINGFIELD

223-225 SOUTH FIFTH STREET.

north and west to escape repression. Black religious denominations had founded schools and colleges in the South, sometimes with the help of Northern white philanthropists. Black intellectuals projected strong racial pride and consciousness, and individuals and organizations opposed lynching and launched campaigns targeting racism and discrimination. African American activists such as W. E. B. Du Bois (see page 40), the journalist Ida B. Wells, the novelist Charles W. Chesnutt, and Mary Church Terrell, leader of the National Association of Colored Women, had come together to form the integrated National Association for the Advancement of Colored People (NAACP) in 1909. By 1914 the organization included some six thousand members in fifty branches fighting for racial equality and against racial hatred and discrimination. Du Bois became editor of the NAACP monthly journal, *The Crisis*. In 1913 the NAACP opposed, but could not prevent, President Woodrow Wilson's executive order segregating the federal bureaucracy, which closed a significant path to the middle class for African Americans and anticipated his racist behavior during the war, including ignoring the lynchings of black Americans.

When war broke out in Europe and Africa in August 1914, most African Americans probably had little concern for the events thousands of miles away.

Above: A postcard of several men standing outside Henry Loper's damaged restaurant after the race riots in Springfield, Illinois, in August 1908. Loper was a white businessman who allowed his car to be used to sneak two black men to safety.

Left: Pinback button of the National Association for the Advancement of Colored People (NAACP). Founded in 1909, the NAACP is the largest and most widely recognized civil rights organization in the United States.

James Weldon Johnson (left) and William Pickens (center) at the offices of *The Crisis*. During the 1920s, Johnson served as the executive secretary of the NAACP while Pickens served as assistant field secretary.

A few, however, had been alert to the connections between African Americans and the broader African Diaspora. At the first Pan-African Congress in London in 1900, organized by black men from the Caribbean, Du Bois had led the drafting of an address exhorting the white leaders of Europe and the United States to acknowledge and protect the rights of black people. Du Bois took every occasion to remind readers of *The Crisis* of their connection to the African Diaspora.

In 1909 the *New York Age*, a leading black paper of the day, carried a front-page article headlined "Negroes for French Army," discussing the ideas of Charles Mangin, the French colonel in command of the Tirailleurs Sénégalais (Senegalese Sharpshooters). The martial qualities and valor of these black soldiers, whom he first fought and then commanded, had so impressed him that he proposed to bring them to Europe in case of war to bolster the French army, which was inferior in numbers to Germany's. The question was obvious: would the US Army likewise recognize the valor and value of its black soldiers? The paper later introduced African American readers to Mangin's 1910 book *La force noire* (The Black Force). In August 1914, when war broke out, the Senegalese force deployed to the Western Front alongside French and French North African soldiers.

In 1915, in an *Atlantic Monthly* essay titled "The African Roots of the War," Du Bois argued that the imperialist scramble for Africa had led to the conflict. The Englishman John A. Hobson's work *Imperialism* had presciently warned in 1902 of the dangers to the

101 AT HOME AND ABROAD

MARY CHURCH TERRELL AND IDA B. WELLS

Brittney Cooper

African American women performed indispensable forms of service both to the nation and to their local communities during World War I. As working men deployed to war, black women filled the positions they vacated. The terrible labor conditions many of these women encountered fomented a new period of labor organizing among black women, and no two were more exemplary in this effort than Mary Church Terrell and Ida B. Wells.

Mary Church Terrell, a Memphis native, was one of the best-known black women leaders of the early twentieth century. A graduate of Oberlin College—one of the first black women to receive a college degree—she became the first president of the National Association of Colored Women (NACW). Her leadership of the NACW in its early years made it the largest organization of African American women in the country.

In addition to helping found the NACW in 1896, Terrell was an educator, the first black woman member of the District of Columbia Board of Education, and a sought-after public speaker. In 1904, she became internationally renowned for a speech she gave at the International Congress of Women in Berlin, where, after several days of being mistaken for a white woman because of her light skin, she surprised the audience during her address to the congress by identifying as black. She spoke out forcefully against the problems of lynching, the Convict Lease System, and racial segregation, delivering her remarks in both English and German.

During World War I, Terrell continued her racial activism by coming together with other black women to form the Women Wage Earners Association to advocate for better wages, working conditions, and protections for women workers. In another effort to improve working conditions, the American Federation of Labor created an Office of Colored Women Workers, headed by Mildred Rankin, a black woman.

Terrell also served as an organizer with the War Camp Community Service (WCCS), which provided social and recreational opportunities for soldiers near military bases. However, she quit her work with the WCCS after finding severe racial disparities in the resources offered. As part of the war effort, the government had organized a Women's Committee as a subsidiary of the National Council of Defense to aggregate and oversee the efforts of women's organizations. Alice Dunbar-Nelson, a writer, poet, and clubwoman originally from New Orleans, was a field representative for the Women's Committee. She spent much of the war documenting the activities of black women involved with the Red Cross and the inequalities they faced (see page 61).

Ida B. Wells launched her antilynching career in 1892 after three of her friends were lynched in Memphis. Wells had come to Memphis as a teenager after her parents died in a yellow fever outbreak in Holly

This commemorative bell was presented to Mary Church Terrell by the International Congress of Women in Switzerland in May 1919. At the congress, Terrell again delivered a speech in German on discrimination against African Americans in the United States.

Portrait of Mary Church
Terrell by Addison
Scurlock, circa 1910.
Terrell was a power-
ful advocate for racial
and gender equality.

1893

MISS GARRITY.
PHOTOGRAPHER.

CHICAGO.

Portrait of Ida B. Wells by Sallie E. Garrity, circa 1893. As a journalist, Wells spent decades documenting lynching in America. She also advocated for civil rights and women's suffrage.

Springs, Mississippi. She and Terrell knew each other during those days and were often involved in the same organizations, though they sometimes clashed. They were of different social classes: Terrell's father, Robert Church, was rumored to be one of the richest men in Memphis, while Wells was an orphan who cared for her siblings and often struggled to make ends meet.

Terrell and Wells also diverged on the question of allegiance to Booker T. Washington and W. E. B. Du Bois (see page 40). In the late 1890s, Wells increasingly disagreed with Washington's accommodationist stances in the face of rampant and increasing racial violence. Terrell was of two minds. Because she had received a liberal arts education at Oberlin College, she believed in the importance of black people being educated in that tradition. But she also praised Washington's work at the Tuskegee Institute (now Tuskegee University), which focused on a curriculum in the industrial arts, in keeping with Washington's philosophy of self-help. Moreover, the Terrells and the Washingtons were friends, and Washington played a critical role in the appointment of Terrell's husband, Robert Terrell, to a municipal judgeship in Washington, DC. With her innate knack for diplomacy, Terrell managed to stay on good terms with Washington and Du Bois.

Wells and Terrell were both founding members of the NAACP in 1909, but Wells's name was initially left off the list of founders. Wells considered this an intentional snub by W. E. B. Du Bois, a leader whom she both respected and challenged. Wells's leadership style often alienated activist men, who expected deference from women.

The difference between Terrell's and Wells's approaches to activism is exemplified by their actions in a famous 1913 suffrage march in the nation's capital. Terrell, an honorary member of the newly founded Delta Sigma Theta sorority, advised its members that their first public act as a group should be to attend the march. Terrell and the members of Delta Sigma Theta reluctantly acquiesced in the segregation of the event and marched at the back of the procession. Wells, who had founded the Alpha Suffrage Club in Chicago, refused to march at the back, instead marching alongside the white women of the Illinois states delegation.

Both women were vehement in their condemnation of white supremacy. But Wells was the more militant and skeptical: she believed in armed self-defense and often wondered in print whether white people could be trusted to change their thinking on racial matters. Terrell would go on to be a peace activist in World War II and an advocate of nonviolent direct action as part of the civil rights movement. She believed that moral suasion could encourage white people to reject racism.

Terrell spent much of World War I doing activist work through a variety of local and national organizations. The NACW used its large membership and national influence to assist in the war effort. Members raised money to purchase war bonds, called Liberty Loans, raised over $5 million for the Red Cross, and encouraged local communities to participate in the thrift savings stamp program.

Meanwhile, Wells pursued her career in activist journalism. She reported on the race riots in East St. Louis, Illinois, in July 1917, sparked when a group of white men rode into the black side of town firing their weapons into the community. She estimated from her interviews with locals that nearly 150 black people had been killed, many of them not by rioters but by the Illinois State Guard, who had been called in to quell the violence.

In November 1918, one day before the Armistice, Wells was invited, along with the young A. Philip Randolph, to address a meeting of Marcus Garvey's Universal Negro Improvement Association in Harlem. Her advocacy on behalf of lynched black men had earned her the admiration of Garvey's constituents. That Wells was invited to address this organization illustrates her more radical approach to activism. Terrell, by contrast, aligned herself with liberal black thinkers and activists who believed that legislation and social agitation were the avenues to social change. In fact, the efforts of both activists were essential to achieving a more just society for all Americans. ✸

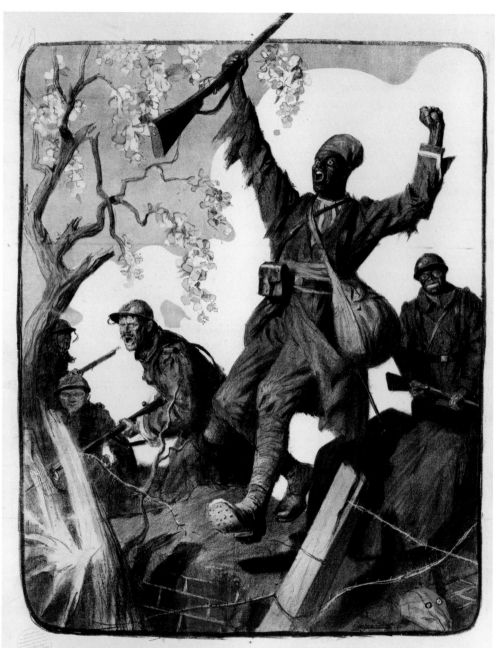

JOURNÉE DE L'ARMÉE D'AFRIQUE
ET DES TROUPES COLONIALES

DEVAMBEZ . PARIS

Created in 1917 to
celebrate the participa-
tion of French colonial
troops in World War I,
this poster, depicting
a fierce African soldier
going over the top, bears
the caption "A day for
the Army of Africa and
Colonial Troops."

Some American members serving in the Foreign Legion of the French Army.

European imperialists of their own racism, xenophobic nationalism, and Darwinian recourse to wars of conquest and extermination to prove their racial superiority. These traits, Hobson argued, would intensify the struggle of the white races, who would then deploy their colonized forces of color against other white races. British Indian and French African troops confronted Germans on the Western Front in August 1914 and Ottoman troops in the Middle East in 1915, and colonial forces led by European officers fought one another in Africa in 1914.

The United States remained neutral until 1917, reaping huge profits as its factories supplied England and France with munitions and raw materials, but individual Americans volunteered to fight in Europe. Among them was Eugene Bullard, a twenty-year-old African American, who had fled his birthplace of Columbus, Georgia, with his father for fear of being lynched. As a young teenager, he struck out on his own for France, because he had heard that it was the land of *liberté, égalité,* and *fraternité*. He arrived in Paris in 1914 and fought in the French Foreign Legion and then in the French 170th Infantry Regiment until he was severely wounded at the battle of Verdun in March 1916. After he recovered, he volunteered for the French Air Service in October and was serving as a pilot—one of the first two black pilots to fly in combat—by the time the United States entered the war in April 1917.

From 1914 to 1917, the United States and its black citizens experienced dramatic social changes. The nation's population had swelled to more than 100 million people (an increase of 9.5 million since 1900), boosted by large numbers of immigrants from

African Americans, like young men worldwide, were eager to experience war before it ended. Many, like the three in this image, traveled to France and joined the Foreign Legion, which was already integrated.

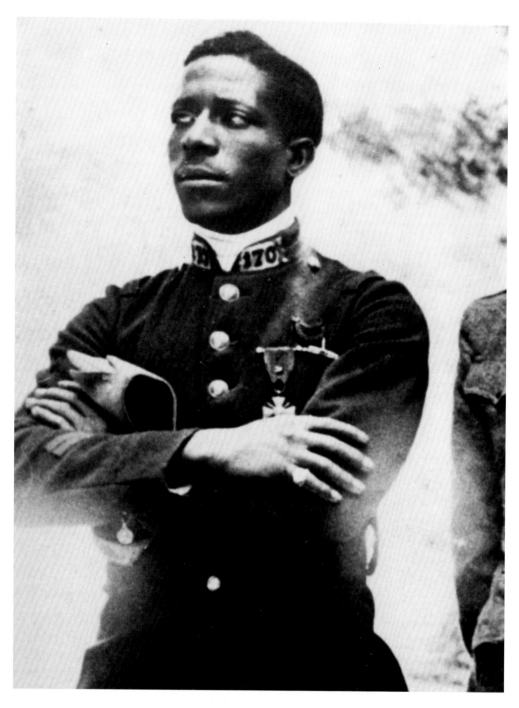

Left: Eugene Bullard fled the United States for France in 1912, at age sixteen. He trained as a pilot in the French army, becoming the first African American military aviator and earning the Croix de Guerre, shown in the picture above.

Above right: Chicago was among the most popular destinations during the Great Migration. This 1922 photograph by the Chicago Commission on Race Relations shows one of the thousands of African American families who migrated from the South to Chicago.

Right: Help-wanted ads in the *Chicago Defender* attracted thousands of Southerners. A potential wage of six dollars a week in Milwaukee was very attractive to former sharecroppers who had been forced into debt each year.

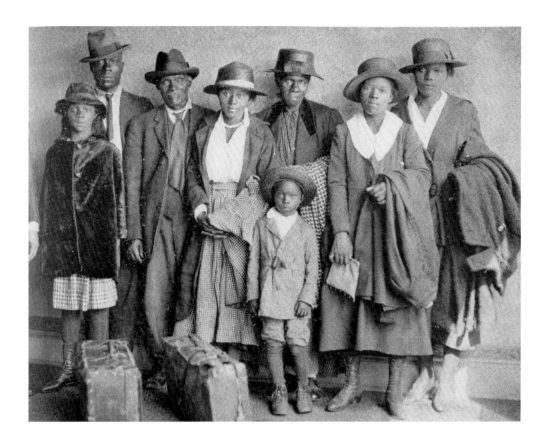

southern and southeastern Europe, many of whom were crowded together in the unsanitary slums of Northern cities. The war severed migration from Europe, reducing the pool of cheap labor, and even the entry of a million white women into the labor force could not fill the needs of the booming wartime economy.

The demand for industrial labor in the North and Midwest to supply equipment and materiel to France and Britain led to a flood of African American migration from the South. One of the great African American newspapers of the day, Robert S. Abbott's weekly *Chicago Defender*, which had campaigned against the violence of Jim Crow, promoted Chicago as an ideal destination for black citizens, and white recruiters from the North carried the word of work and opportunity throughout the South. In the ensuing Great Migration of 1915–19, more than a half million black Americans left the South. White Southerners resented this black flight but could do little to stop it, as the boll weevil infestation of 1915 severely reduced the demand for black labor on cotton plantations in the South.

This shift led to a rapid increase in the black urban population in the North. Many black professionals in Southern cities followed their clientele north. Black immigrants also came from Cuba and the West Indies. Racial prejudice existed in the North, but not to the humiliating and savage extent that it prevailed in the South. Black people could sit

anywhere on public transportation, and their children might even attend school with their white peers. However, black migrants often found themselves crowded into the worst urban ghettoes, segregated even from white immigrants, and limited to the most menial work.

To some white people, even the war was threatening. American eugenicists, the ultimate defenders of white superiority, considered the war "the most appalling catastrophe that ever befell mankind," because the white race was suffering irreplaceable losses of "genetically superior" people. In the popular 1916 book *The Passing of the Great Race*, the eugenicist Madison Grant advocated racial cleansing to eliminate "inferior" races and "inferior" segments of all races through forced sterilization and selective breeding. Grant focused on African Americans and immigrants from eastern and southern Europe and further warned that "inferior" white Southerners—from Georgia, Alabama, and Mississippi—presaged the downfall of the white race in the United States. That Grant lumped white Southerners and immigrants together with blacks as "inferiors" lends a touch of irony to the white racism of the era.

In the North and Midwest, many black men did gain a greater sense of autonomy: they could vote and aspire to work in meatpacking and automobile manufacture, in heavy industries such as steel and shipbuilding, and on the railroads, free from the shackles of sharecropping and the constant threat of lynching. Black women, on the other hand, usually found employment only in menial positions, although their income could enable a family to survive should the male breadwinner be without work for a time. The National Urban League, founded in 1911, helped these newcomers adapt to their changed circumstances. The white press in particular and contemporary literature in

Flight Into Egypt by Henry Ossawa Tanner, circa 1916. Some historians believe that this painting, depicting the Holy Family fleeing the murderers sent by King Herod, was inspired in part by the Great Migration of African Americans leaving the South.

general invariably portrayed African Americans in demeaning ways. Now the expansion of the black press and the writings of black intellectuals and activists enabled African Americans to see themselves in their full humanity, with the agency to change their circumstances. The rapid wartime growth of a black reading public laid the foundation for the radicalization and independence of African Americans that became evident in the emergence of the New Negro and the Harlem Renaissance after the war. Papers such as the *Defender*, the *New York Age*, the *Baltimore Afro-American*, and the more recent *Pittsburgh Courier* gained black readers by recording black life in general and in particular reporting in detail lynchings and mob violence against black Americans and calling for change. The circulation of the NAACP's monthly journal *The Crisis* reached one hundred thousand copies in 1920, as it, like most of the black press, urged its readers to organize boycotts of D. W. Griffith's racist film *The Birth of a Nation* in 1915 and chastised President Woodrow Wilson for screening the movie in the White House.

When Wilson declared war on April 2, 1917, declaring his intention to "make the world safe for democracy," an editorial in the *Baltimore Afro-American* wryly observed that he needed to make America safe for democracy before he went crusading abroad. A fundamental question loomed: should black Americans fight abroad for a country that refused to grant them equal rights and where they faced constant persecution?

"Oakite"
Oakley Chemical Co.
New York.

Copyright 1917
OAKLEY CHEMICAL CO.
New York

During World War I the increased production of war goods created job opportunities for many African Americans in Northern factories. Pictured here in 1917, African Americans make munitions at the Oakley Chemical Company in New York.

The Messenger, a radical monthly published by A. Philip Randolph and Chandler Owen (see page 44) with the help of the American Socialist Party, not only opposed US entry into the war; it also urged African Americans to resist the draft and instead fight for an integrated society and join radical labor unions. Yet most African Americans believed that the war offered an opportunity to demonstrate their loyalty by fighting for their country and thus proving that they merited equal citizenship rights. After all, black Americans had served in every war fought by the American colonies and the United States.

White Southerners vociferously opposed training black men for combat, as they feared such soldiers would return from battle and overthrow segregation by force. Sen. James K. Vardaman of Mississippi, a prominent racist, opposed American entry into the war and the deployment of African Americans in combat. By training Negro soldiers to defend the nation, Vardaman reasoned, "it is but a short step to the conclusion that his political rights must be respected, even though it is necessary for him to give his life in defense of those rights, and you at once create a problem far-reaching and momentous in character."

Only in the US Army did black men have any opportunity to see combat. In the twentieth century the navy relegated black men to the mess, as stewards, although they had served alongside white sailors, all of them "Jack Tars," in the nineteenth century. The marines remained lily-white according to a policy established in 1798; indeed, once they arrived in France in 1918 and were assigned to work alongside black soldiers as stevedores on the docks, they fought them, with casualties on both sides.

General Tasker H. Bliss, assistant to the army chief of staff and later wartime chief of staff, believed that black men took naturally to military service and that the army

African American officer candidates at a YMCA center to enroll in the officer training camp at Fort Des Moines, Iowa. Seated at left is A. Merrill Willis, the first man to sign up.

FLAG OF SERVICE
Douglas Remley

In 1917, Captain Robert L. Queisser of the 5th Ohio Infantry designed the Service Flag, also called the Blue Star Flag, to honor his two sons serving on the front lines. The flag quickly became an unofficial symbol denoting a family member serving in the US Armed Forces and can still be seen today hanging in the front windows of houses across the country. With a white field and red banner, the flag features a blue star for each family member in the service. For an individual who dies while on active service, a gold star is sewn over the blue star. During World War I, these flags were often handmade by mothers and wives of servicemen. Some businesses and churches created larger flags to represent their employees or members serving in the war.

This poster depicts an African American family gazing with pride at a portrait of their husband and father surrounded by framed portraits of Presidents Washington, Lincoln, and Wilson. A Blue Star Flag hangs in the window. The Blue Star Flag represents hope, pride, and sacrifice and shows that the war touched every community in the United States, regardless of race, location, or social status. ⊛

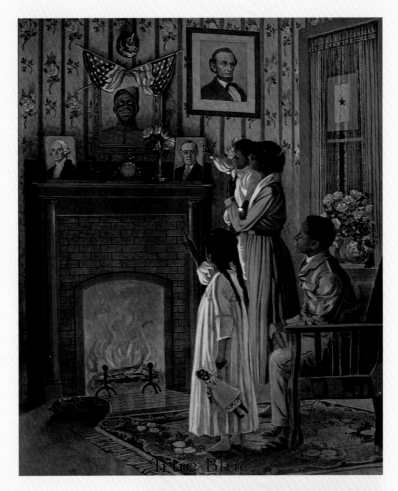

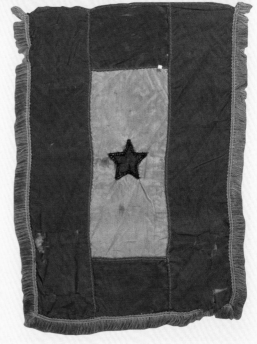

Right: Created in 1917, the Service Flag may be flown by families with members serving in the US armed forces during wartime, with a blue star for each member in military service. A gold star represents a family member who died in wartime.

Above right: *True Blue*, a patriotic poster by E. G. Renesch, is typical of African American war recruitment posters of the time, depicting an idealized world with no reference to the racism that black soldiers faced.

could easily recruit plenty of them. In June 1917, the War Department, at the urging of the NAACP, which was pressing for black combat units in the face of Southern opposition, opened a training school of black officers at Fort Des Moines, Iowa, to train 1,000 educated civilians and 250 regular army noncommissioned officers to become commissioned officers. Bliss planned to train sixteen regiments of black infantry, although he acknowledged that white Southerners would recoil at having their black populations "trained to arms."

The Houston Riot of August 23 appeared to confirm Southern fears. Black soldiers of the Third Battalion of the 24th Infantry Regiment had just moved to guard the construction of Camp Logan, outside Houston. The brutal enforcement of Jim Crow laws by the local police had led to several minor clashes with the soldiers. That day a policeman dragged a black woman in a nightgown out of her house and beat her with his nightstick. When a black soldier attempted to intervene, the police pistol-whipped and arrested him. A black corporal who came to inquire about the soldier received the same treatment. That evening 156 soldiers, led by Sergeant Vida Henry, defied their officers, armed themselves, and shot up the city, killing five policemen and nine civilians. Three of the soldiers were killed. Henry committed suicide, and several months later courts-martial condemned nineteen soldiers to death by hanging and forty to long terms in prison. African Americans, particularly women, revered the mutineers as martyrs of black manhood.

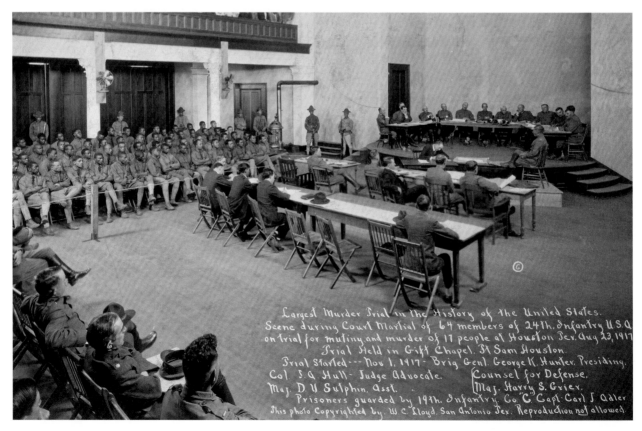

Largest Murder Trial in the History of the United States. Scene during Court Martial of 64 members of 24th. Infantry U.S.A on trial for mutiny and murder of 17 people at Houston Tex. Aug 23, 1917 Trial Held in Gift Chapel. Ft Sam Houston. Trial Started--- Nov 1, 1917 - Brig Genl. George K. Hunter. Presiding. Col J.A. Hull - Judge Advocate. Counsel for Defense. Maj. D.V. Sulphin. Asst. Maj. Harry S. Grier. Prisoners guarded by 19th. Infantry, Co "C" Capt. Carl J. Adler This photo Copyrighted by W.C. Lloyd, San Antonio Tex. Reproduction not allowed.

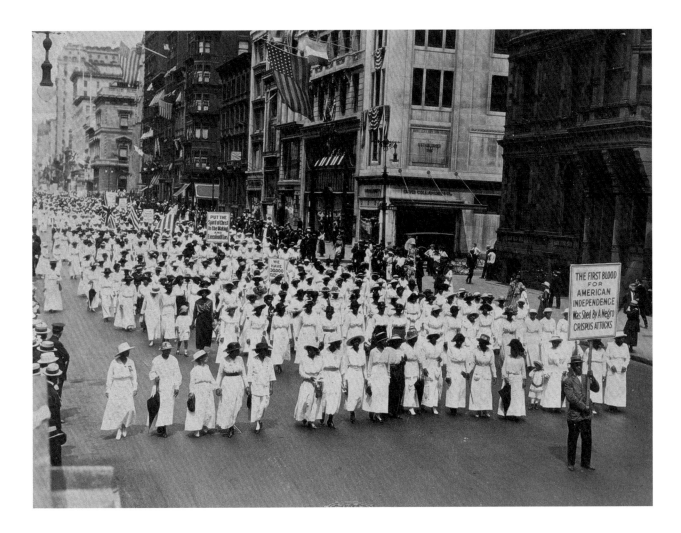

The bloodiest race riots of the time were the massacres in East St. Louis, Illinois, in late May and early July 1917. Whites, fearing that black migrants would take their jobs in this rough industrial city, killed between 40 and 250 black people, destroyed their property, and left some 6,000 black people homeless. The police and national guardsmen at best did nothing to intervene and at worst joined the slaughter. The NAACP organized a protest march of some ten thousand black people in New York, and *The Crisis* published photographs of the ruins. Marcus Garvey, a black Jamaican who had founded the UNIA (Universal Negro Improvement Association) in 1916, condemned the riots as "one of the bloodiest outrages against mankind" and a "wholesale massacre of our people." More race riots ensued. Although race relations had reached a nadir, and African Americans were pleading with Woodrow Wilson to pleas to make America itself "safe for democracy," he did nothing.

In these highly charged racial circumstances, the idea of forming black combat units was politically unpopular. Only the pressure of the NAACP managed to persuade Secretary of War Newton Baker (the former mayor of Cleveland, Ohio) to form one black division, the 92nd, with white senior officers and graduates of the Fort Des Moines officer training camp as junior officers. One black senior officer qualified for a command

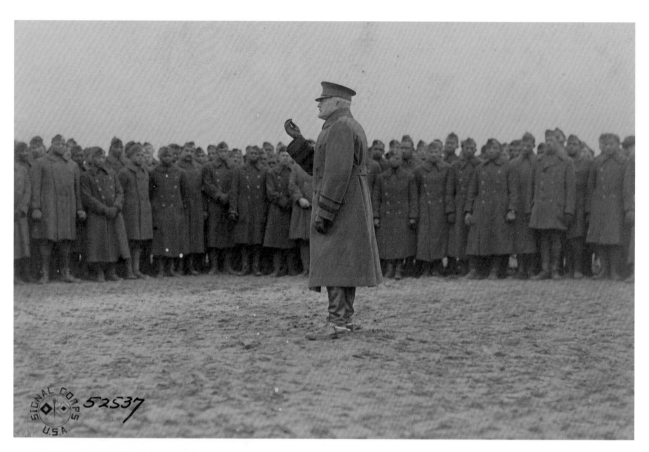

Left: Sheet music was extremely popular during the war. This 1918 song, "You'll Find Old Dixieland in France," by Grant Clarke and George W. Meyer, celebrates African American soldiers while using the racist stereotypes and language typical of the time.

Above: General John J. Pershing, commander of the American Expeditionary Forces in France during World War I, addresses African American officers of the 92nd Infantry Division.

position: Colonel Charles Young, the third African American to graduate from West Point. A stellar cavalry officer, he had commanded the 10th Cavalry Regiment in the Punitive Expedition, leading his forces in a pistol charge that routed Pancho Villa's forces without the loss of a single man in 1916. Such a victory merited consideration for promotion to brigadier general, but Southern white officers refused to serve under a black senior officer. The War Department evaded the problem by placing Young on the inactive list for health reasons in June 1917. They reinstated him at the end of the war and assigned him to Liberia as US military attaché in 1919. He died of a kidney infection in 1922 while on a reconnaissance mission in Nigeria. His career testified that race trumped rank in the US Army.

The draft of May 1917 inducted some four hundred thousand black men into the US Army. The great majority were assigned to services of supply (SOS) units, where they served in engineer and pioneer units in France and as stevedores at US and French ports, loading and unloading ships and building facilities at French ports. The engineers and pioneers built and repaired bridges, railroads, roads, and fortifications. These SOS units were the unsung enablers of the American military effort in World War I, but because their black members did not serve in combat, their service was not regarded as worthy of equal citizenship with whites. Some forty thousand black soldiers, however, did serve as combat infantry.

That task would fall mainly to the 92nd Division and its twenty-eight thousand men. The army insisted that a black division be led by white officers, but the senior officers of the division, many of them Southerners, were more concerned with threatening the men with disbandment in case of racial incidents than they were with training them. The 92nd, cobbled together from units scattered from Kansas to Long Island and trained in outmoded ways without the use of weapons, arrived in France piecemeal in midsummer 1918 and did not take the field until late September. The division's senior officers in effect trained the division to fail so that they could later claim that black soldiers were useless in combat. Fortunately for the African American cause, the army assembled four mobilized black regiments to perform labor duties—the 15th New York National Guard, the 8th Illinois National Guard, the First Provisional South Carolina Draftees, and a composite of smaller black guard units—and designated them the 93rd Division (Provisional), which existed only on paper. The regiments sailed separately for France, the 15th New York (known as the Harlem Hellfighters) arriving first, on New Year's Day 1918, and the rest arriving by April. The regiment's superb band, led by the famed composer and bandleader James Reese Europe, played its riveting syncopated music all over France, bringing the Jazz Age to Europe.

General Philippe Pétain, the French commander on the Western Front, persuaded his American counterpart, General John J. Pershing of the American Expeditionary Forces (AEF), to second the four black regiments to the French army as they arrived. On January 11, 1918, Pétain assigned the 15th to infantry duties, supplying it with French

The 93rd Infantry Division were nicknamed the "Blue Helmets" for the French helmets they originally wore. An emblem of the blue helmet eventually became the division's official insignia, as seen on this American combat helmet.

James Reese Europe leads the 369th Infantry Band at American Red Cross Hospital No. 5 in Paris, circa 1918. The 369th performed across Europe to great acclaim, introducing jazz to thousands of people.

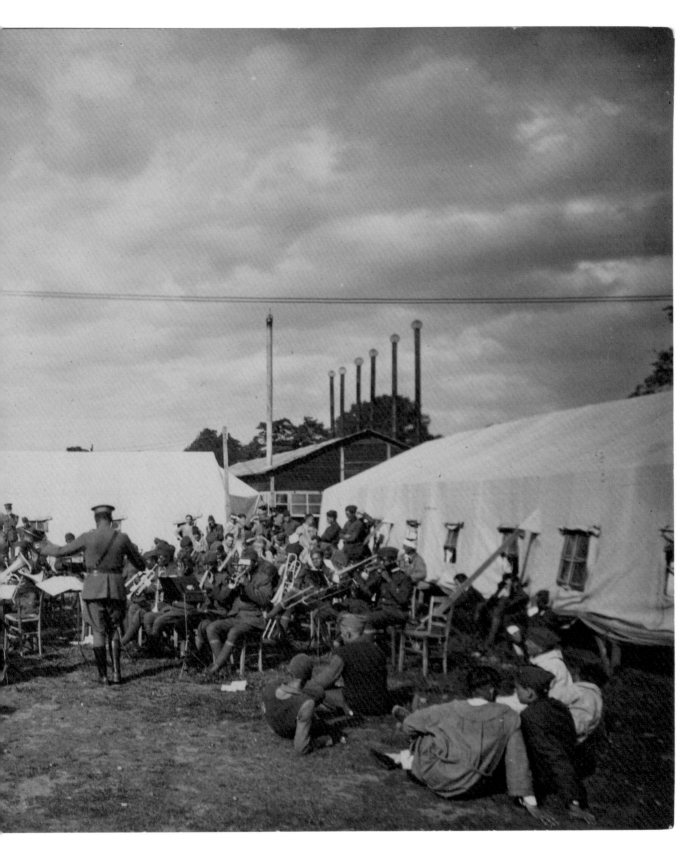

JAMES REESE EUROPE

Krewasky A. Salter

James Reese Europe was a distinguished musician and bandleader before he became Lieutenant James "Jim" Europe, leader of the Harlem Hellfighters—the 369th Infantry Regimental Band. He is perhaps best known, however, for the lasting impact of his jazz music in France during his wartime service.

When New York decided to raise an African American National Guard regiment in 1916, Jim Europe was one of the first recruits sought out by the regimental commander, Colonel William Hayward, partly because music would be an aid to recruitment and maintaining morale.

Every regiment, with very few exceptions, had a band. The repertoire typically consisted mostly of martial music. The Harlem Hellfighters, however, brought jazz to war-torn France.

Europe personally selected the members of the regimental band, which included the bandleader, singer, and composer Noble Sissle and the Puerto Rican musician Rafael Hernández. From the moment Europe arrived in France, on January 1, 1918, the music of the 369th was a hit. Europe and his band were sent on a tour of war-torn France to boost the morale of doctors, nurses, wounded soldiers, and displaced civilians.

Because Europe was a lieutenant, which was not the usual rank for a regimental bandleader, he also served as a machine-gun platoon leader. As a result, he spent a short time on the front and reportedly participated in a night raid in May 1918. This action inspired the song "On Patrol in No Man's Land." Europe's influence on jazz continues well into the twenty-first century. ◉

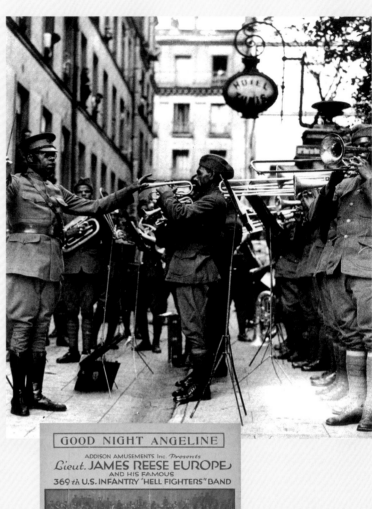

Above: Lieutenant James Reese Europe conducts the 369th Infantry Band outside a hospital in Paris.

Left: During the war, James Reese Europe composed several songs with Eubie Blake and Noble Sissle (also a member of the 369th Infantry band), including "Good Night Angeline" and "On Patrol in No Man's Land."

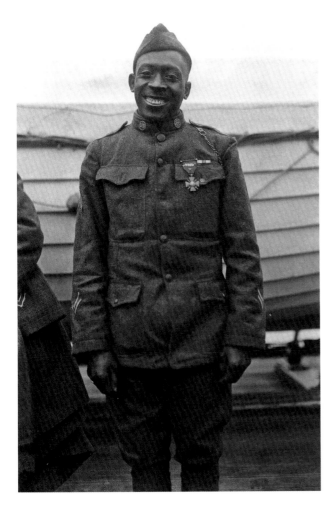

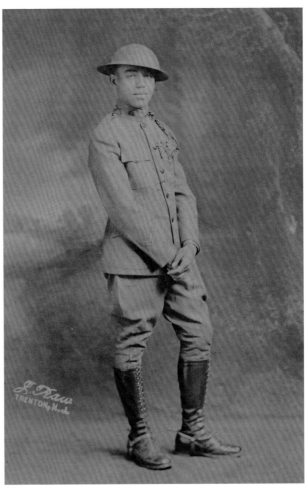

Above: In 2015 Private Henry Johnson of the 369th Infantry Regiment was post-humously awarded the Medal of Honor for actions on May 13, 1918, while on night sentry duty in the Argonne Forest near Champagne, France.

Above right: New Jersey native Needham Roberts was on sentry duty with Johnson during the attack. Seriously wounded and incapaci-tated shortly after the attack, German soldiers nearly captured him.

rifles and equipment, and it was renamed the 369th US Infantry Regiment. By April, it was serving in the front lines as part of a French infantry division. The 369th's predominantly white officer corps, which included scions of leading New York families, expected it to become an elite fighting unit. Captain Hamilton Fish, a Harvard All-American football lineman and a future New York congressman, wrote to his father, "If the regiment does not make a splendid record, it will be the fault of the officers."

The 369th met these expectations. In May two of its privates, Henry Johnson and Needham Roberts, repulsed a German patrol of some twenty men. Johnson killed three of the Germans in hand-to-hand combat, suffering multiple wounds himself. The French army promptly decorated both men with the Croix de Guerre: Johnson was awarded the cross with gold palm, the highest award in the French military. Pershing even cited them by name for their "notable instance of bravery and devotion" in his first official communiqué to the home front. Most Americans did not know there was a black unit in combat, and the news exploded in the army and stateside press. Johnson died in 1929, at age thirty-six. The US Army did not recognize his feat until after reviews in 1996, when he was awarded two Purple Hearts, and in 2015, when he received the Medal of Honor he so richly deserved.

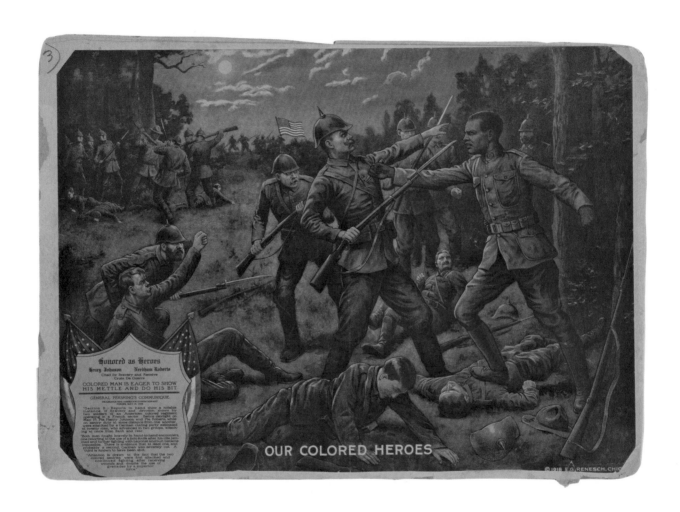

OUR COLORED HEROES

This 1918 lithograph, *Our Colored Heroes*, by E. G. Renesch, depicts Johnson and Roberts repelling the German attackers. The text quotes General Pershing's praises: "Both men fought bravely. . . . [They] continued fighting after receiving wounds and despite the use of grenades by a superior force."

The 369th spent 191 continuous days in the trenches and lost no prisoner or foot of ground to German soldiers, a record unequaled by any other AEF regiment. In the final offensive of 1918, the 369th seized its objective despite severe casualties. One of its white captains credited the black noncommissioned officers for the victory, as the white officers had fallen. The 369th ended the war on the banks of the Rhine River.

The other three regiments, redesignated the 370th, 371st, and 372nd, all fought well while serving within French divisions, and French and American commanders complimented the junior officers and men on their courage and high morale. Observing the success of these regiments, Pershing asked the French to return them to the AEF for retraining as labor battalions. It was one thing for him to praise the exploits of two black individuals, another to contend with the threat to the illusion of white supremacy posed by the achievements of entire regiments of black men. The Allied commander in chief, Ferdinand Foch, replied that the black regiments would remain with the French army through the end of the war. Thanks to the intervention of Pétain and Foch, black officers and men proved their very real abilities as combat infantry.

When the 92nd Division entered its first battle on September 28, 1918, two battalions of the 368th Regiment failed to take their objective, although a third battalion, along with French forces, filled the gap and seized Binarville. The division performed as well as its white counterparts in the AEF's Second Army in the days before the Armistice. Its achievements made no difference. The Second Army commander, General Robert Lee Bullard, and the division's chief of staff, Colonel Allen Greer, both Southerners, alleged that the black soldiers were cowards and the black officers incompetent.

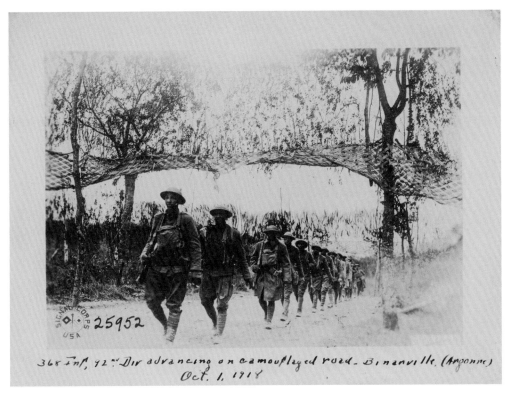

Soldiers of the 368th Infantry Regiment advance on a camouflaged road near the French town of Binarville, in the Argonne Forest, on their way to the front, October 1, 1918.

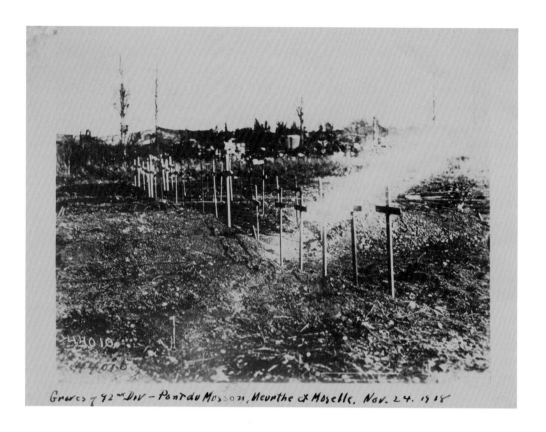

Graves of 92nd Div - Pont du Mosson, Meurthe & Moselle. Nov. 24. 1918

The evidence belied these allegations, as many soldiers of the 92nd and 93rd Divisions received Distinguished Service Crosses for their valor in combat, on the recommendations of their white captains and majors. After the war Major Walter Loving, a black officer in the army's Military Intelligence Branch, demanded a court-martial of Greer and an investigation of the 92nd Division's performance, because "if it was not a success," then "the fault rests with the division commander and his field officers and not with his men." The transparent reason for discrediting the black soldiers was to keep the peacetime army as white as possible, which is exactly what happened.

The 92nd and 93rd Divisions returned from France early in 1919. Consequently, African American soldiers were the only soldiers who did not participate in the great Allied victory parade on July 14, 1919. Nor did they appear on the great war mural of Allied soldiers in the Panthéon de Guerre in Paris. Some black soldiers remained in France: the labor battalions that completed the thankless task of clearing battlefields, digging up the bodies of the American dead and reburying them in the war memorial cemeteries of rural France, where they remain to this day. African American soldiers knew what they had accomplished in France. Their photographs show proud men in uniform, standing tall or sitting erect. The 15th New York/369th Regiment returned home to a parade through the Victory Arch and up Fifth Avenue on February 17, 1919. It marched alone, segregated from the white New York National Guard Division. This powerful mass of black soldiers, in greatcoats and trench helmets, their bayonet-tipped rifles resting on squared shoulders, marched in the close formation of the French phalanx, sixteen men across, to the music of James Reese Europe's famed band.

Above: Graves of soldiers of the 92nd Infantry Division, Pont-à-Mousson, France, 1918. African American graves registration soldiers were given the gruesome, heartbreaking task of exhuming the bodies of the fallen and reburying them at American military cemeteries in France.

Right: Jubilant combat veterans of the 369th Infantry Regiment on a ship bound for home. The 369th, assigned to fight with French troops, spent more time in the trenches than most American soldiers.

A few observers, black and white, believed that New York knew no color line that day and hoped that the parade heralded a new era of full citizenship for African Americans. Yet articles in the white press displayed a combination of racist stereotyping and ridicule typical of the time, along with alarm at the spectacle of grim-faced, disciplined black giants on the march. These were no longer the "boys" of common white reference; they were men who had met the enemy and returned victorious.

The parade in New York, and one later in Chicago for the 8th Illinois/370th Regiment, were anomalies. In the South, Senator Vardaman's exhortations to greet "French women-ruined Negro soldiers" with violence precipitated the lynching of at least a dozen black soldiers in uniform. African American soldiers had returned home to a powder keg of social unrest. The demobilization of the army and the end of wartime manufacturing combined with severe inflation and dismal working conditions to result in thousands of strikes, including major ones in the steel industry and coal mines. Any hint of radicalism

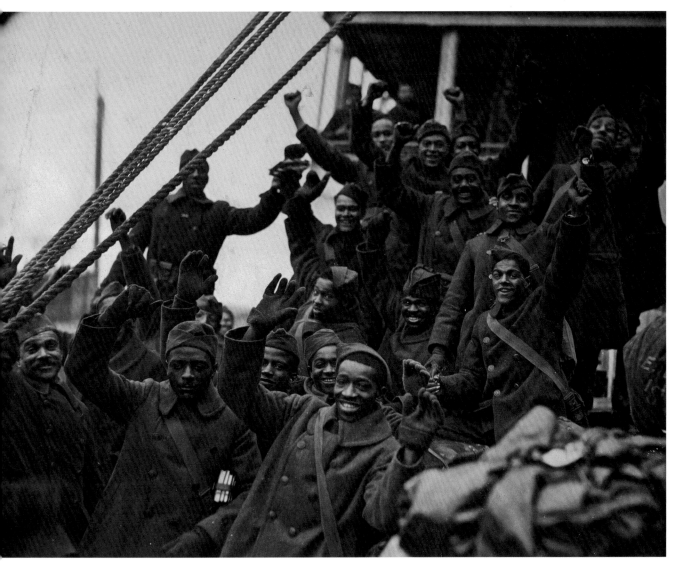

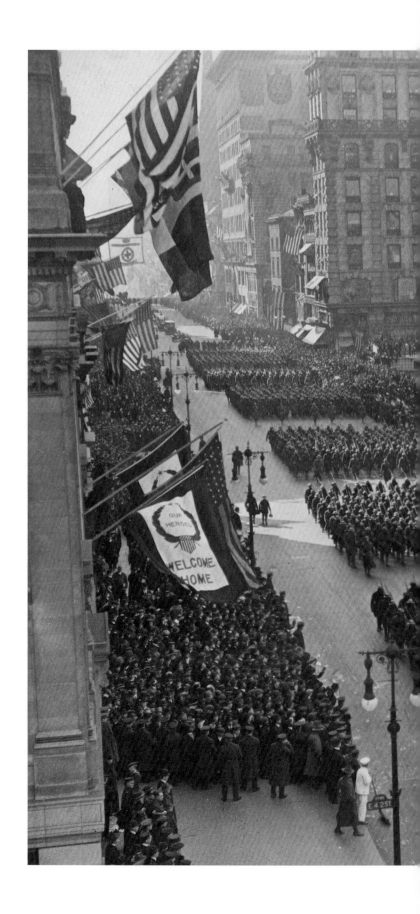

The 369th Infantry
Regiment marches up
New York's Fifth Avenue
in a victory parade,
February 17, 1919.

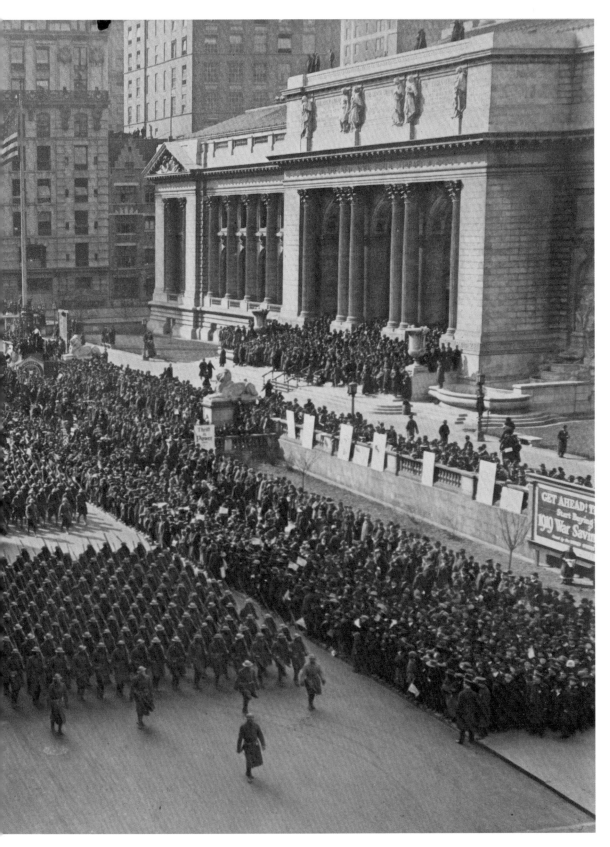

The Philadelphia Tribune

A CONTINUOUS PUBLICATION FOR THIRTY-FOUR (34) YEARS.

WE LEAD! OTHERS TRY TO FOLLOW! THAT'S ALL.

VOLUME XXXV. No. 48. TWELVE PAGES PHILADELPHIA, PA., SATURDAY, OCTOBER 18, 1919. TWELVE PAGES SINGLE COPY 6 CENTS.

Determined That Those Who Enjoyed Social Equality in France Must Know They Are Now in the United States

THE GHOST OF SOCIAL EQUALITY CAUSE OF RIOTS

A Soldier who was "Over There" Studies Conditions Upon His Return Home; Solves Problem.

TELLS AN AMUSING STORY.

Atlanta, Ga., Oct. 14.—Labor conditions and propaganda of different kinds have been given as the reason for recent race riots. But after making a careful study of the causes given by careful investigators who have been working quietly in the South and southwest, facts have been unearthed sufficient to prove that the ghost of social equality, which has haunted the mind of the white people in the United States, is responsible for recent race riots.

It so happened that, during the world war a large number of colored soldiers were stationed in Paris and in other parts of France. And with the colored soldiers in the Parisian cities there were also a large number of white soldiers, many of whom were from the South. These white southerners witnessed with awe the freedom in association which colored soldiers enjoyed with French people and white while they were in France did all in their power to try to put a stop to the freedom enjoyed by the blacks in France.

The writer knows this to be true, because he was there himself. One of the ludicrous stories which white Americans caused to be circulated among the French people was that all black men were regarded as monkeys by the white people in the States. I distinctly remember that on one occasion when a number of us were standing in front of a cafe, a number of little French children jocularly gathered around us and persisted in playfully raising our coat tails to see if we had a long tail like monkeys.

Views of a Few of the Colored Participants in Last Saturday's Peace Celebration In Honor of the City's Heroes in the World War.

MARCUS GARVEY, THE ADVENTURER, SHOT IN NEW YORK

Last Tuesday. Garvey is the Man Who Started to Promote a Steamship Trade.

FORCED TO QUIT ACTIVITIES.

New York, Oct. 14.—Marcus Garvey, editor of the Negro World, was shot when and badly wounded this afternoon by George Tyler, clerk, who was arrested after an exciting chase.

Tyler, who lives at No. 154 West 131st street, went to Garvey's office, No 56 West 135th street, as he told the police afterward, to collect a loan of $75 he had made to Garvey. Miss Clara Ashwood, Garvey's secretary, said she heard the intruder declare he had come to "clean up" and threaten to put the editor "behind bars." Garvey entered him out and Tyler fired, hitting the editor over the right eye and in the right leg.

Rushing through 135th street, Tyler was pursued by Patrolman Bell, who caught up with him at Fifth avenue. There the officer fired a shot over his head and Tyler dropped his weapon and threw up his hands.

The editor is President of the Universal Negro Improvement Association and the African Communities League. Recently he started the Black Star Line to carry on a steamship trade fee and by express, but was compelled by Assistant District Attorney Talley to stop selling stock (Continued on Page 4.)

COLORED MEN ARE TO RECEIVE A SQUARE DEAL

Charles B. Hall, New Ward Leader, to Send Colored Man to the Select Council, and

WHITE MAN TO LOWER BRANCH

Last Monday night Charles B. Hall became the sole political leader of the 7th ward, which he had heretofore divided with the late Charles Seger. Upon assuming the responsibility of the delicate task involved in such a leadership, Mr. Hall found himself confronted with the problem of choosing two men from the list of his faithful followers to fill two vacancies—one in the select council, caused by the death of Charles Seger, and one in common council, caused by the elevation of Joseph O'Brien, who recently became a magistrate by appointment of Governor Sproul.

In selecting men to fill these vacancies, Mr. Hall upset all political traditions and at the same time began to make new political history for Philadelphia and incidentally served notice on the political leaders of all Philadelphia that colored voters must hereafter be given a fair, square and right deal in consideration of their devotion to any cause successfully supported by them.

To fill the unexpired term of Mr. Seger in Select Council, Hall caused the nomination of Nathan Nutter, a (Continued on Page 12)

CONGRESS ASKED TO PROBE LYNCHING BY SOUTHERNER.

New York, Oct. 14.—The governors of Georgia, Idaho, Nevada, Arizona and Indiana are included in a list of citizens who have written to United States Senators endorsing the Curtis resolution for a Congressional Inves-

FRATERNAL BODIES PARTICIPATE IN A

THE CHURCH MUST LEAD IN EDUCATING

"GO TO WORK" IS MESSAGE OF

DOCTOR MARTIN WITH HIS CHOIR

ANXIETY TO GET A FAIR PRICE FOR

THE Chicago Defender

EXTRA! MARTIAL LAW WAS DECLARED WEDNESDAY NIGHT IN THE DISTRICT WHERE THE RIOTING HAD BEEN THE WORST, AND SINCE THEN THERE HAS BEEN LITTLE TROUBLE **EXTRA!**

Stay Off the Streets, Let the Law Settle It

WORLD'S GREATEST WEEKLY

Foolish Talk Is No Good Now. Stop It.

VOL. XIV. NO. 31. ☆☆ SATURDAY CHICAGO, AUGUST 2. 1919 SATURDAY PRICE FIVE CENTS

RIOT SWEEPS CHICAGO

GHASTLY DEEDS OF RACE RIOTERS TOLD

Defender Reporter Faces Death in Attempt to Get Facts of Mob Violence; Hospitals Are Filled With Maimed Men and Women

For fully four days this old city has been rocked in a quake of racial antagonism, seared in a blaze of red hate flaming as fiercely as the heat of day —each hour ushering in new stories of slaying, looting, arson, rapine, sending the awful roll of casualties to a grim total of 40 dead and more than 500 wounded, many of them perhaps fatally. A certain madness distinctly indicated in reports of shootings, stabbings and burning of buildings which literally pour in every minute. Wagons and children have not been spared. Traffic has been stopped. Phone wires have been cut.

Stores and Offices Shut

Victims lay in every street and vacant lot. Hospitals are filled; 4,000 troops rest in arms, among which are companies of the old Eighth regiment, while the inadequate force of police battle vainly to save the city's honor.

Fear to Care for Bodies

Undertakers on the South Side refused to accept bodies of white victims... White undertakers refused to accept black victims. Both for the...

LIST OF SLAIN IN FOUR DAYS' RIOTING

The complete list of the dead as a result of the three days of rioting includes twenty-six victims.

Baker, Henry, Colored, 3404 South State street...

LIST OF INJURED

WHITE

Gun Battles and Fighting in Streets Keep the City in an Uproar

French Give Opinion of Riot

Foreigners Say Lack of Color Line Abroad Impressed Yanks

By John DeGrand
(United News Staff Correspondent)

Paris, Aug. 1.—The American encountered no color line in France. Returned to the United States, he is determined never again to submit to race segregation in either society, business or politics.

4,000 Troops in Armory Ready to Patrol City; Scores Are Killed

The refusal of Policeman Daniel Callahan, of the Cottage Grove avenue station to arrest George Stauber (white), 2904 Cottage Grove avenue, last Sunday afternoon after the latter had knocked Eugene Williams...

128 WE RETURN FIGHTING

was condemned by those in power as Bolshevik, or Communist-inspired, and a red scare prompted increased government repression of any deemed "outsiders" in America—including immigrants and African Americans.

The powder keg exploded in 1919. The Red Summer of 1919 witnessed race riots in some fifty cities across the United States, as white mobs attacked black workers and soldiers and invaded black neighborhoods to burn black businesses and homes. This time, however, black Americans fought back. The soldiers who had returned from fighting for the freedom of Europeans now fought for their lives and communities against a white citizenry determined to keep them segregated and treated as second-class citizens.

Black intellectuals urged resistance against such oppression. In the May 1919 issue of *The Crisis*, W. E. B. Du Bois made his famous statement "We *return fighting*." In 1919 the Jamaican poet Festus Claudius "Claude" McKay, a foundational figure in the Harlem Renaissance, proclaimed in his poem "If We Must Die":

If we must die, let it not be like hogs . . .
If we must die, O let us nobly die . . .
Like men we'll face the murderous, cowardly pack,
Pressed to the wall, dying, but fighting back!

The violence in the US South persisted. In a race riot in Elaine, Arkansas, in 1919, white vigilantes murdered more than two hundred black tenant farmers to prevent their unionization. In Tulsa, Oklahoma, in 1921, whites murdered an estimated three hundred black people and burned the black business district to the ground.

The 1920s also witnessed the resurgence of the Ku Klux Klan, which staged marches of some fifty to sixty thousand members in Washington, DC, in 1925 and 1926. Yet violence and persecution in the United States could not erase the experience of African American soldiers who had traveled abroad, been treated respectfully by French men and women, and encountered the black soldiers of the vaunted Senegalese and Moroccan military units. Some of these men, like Eugene Bullard, became expatriates in Paris, where they found a warmer welcome from Europeans than at home in the United States, and where the music, art, and culture of the Jazz Age brought together individuals from the African Diaspora in a cultural community known as Paris Noir. These individuals, like their African American counterparts, confronted an international system opposed to their autonomy or independence. The proposals of the Pan-African Congress of February 1919 to hasten African self-rule were opposed by the Allied leaders meeting at the Versailles Peace Conference.

Some of the black American soldiers returned home, however, determined to change American society because of their demeaning experience in the AEF. Charles Hamilton Houston, a brilliant graduate of Amherst College, served as a lieutenant in the 92nd Division and returned so angered by the hatred and scorn shown by his white officers that he decided to study law to fight the system. On his return, he entered Harvard University Law School, where he excelled, and later he became the dean of Howard University Law School, where he trained a generation of civil rights lawyers, including Thurgood Marshall.

Top left: African American soldiers, who had been treated as social equals in France, returned home to racial tensions, riots, and lynchings.

Bottom left: Chicago experienced one of the worst riots of the Red Summer of 1919. More than twenty African Americans were killed, more than three hundred injured, and hundreds of black homes and businesses destroyed during the five days of rioting.

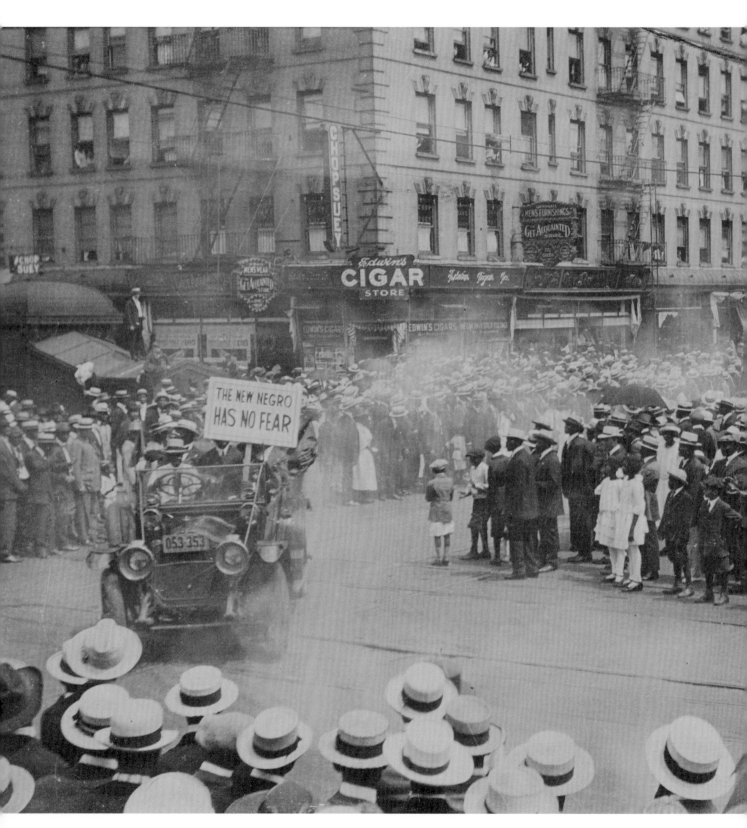

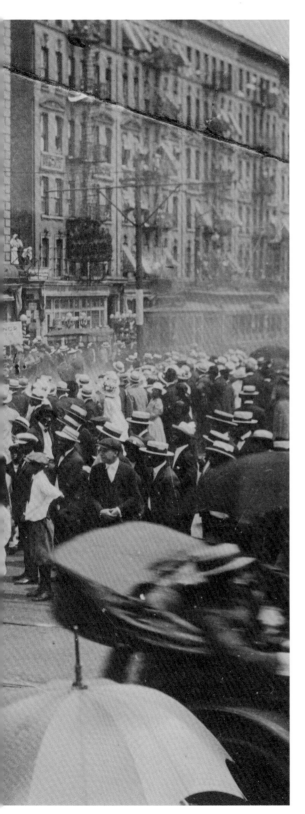

Moreover, white violence could not erase the contributions that many African Americans at home had made to the war effort, investing some $250 million in war loans and laboring in industries essential to the war effort. A black riveting team in the Baltimore shipyards, for example, had wrested the world record for driving rivets from the British. Most critically, the early twentieth century had seen the emergence of black organizations of men and women, a black literate public ready to consume black culture, and a black cultural elite ready to produce racially self-conscious and proud art and literature for universal consumption. Drawn to cities, and particularly to New York, black America entered the age of the New Negro and the Harlem Renaissance and never looked back. These developments represented yet another stage of the long struggle toward civil rights.

A Universal Negro Improvement Association (UNIA) parade through Harlem, 1920. The UNIA, founded by Marcus Garvey, espoused the ideas and sentiments of the New Negro as can be seen on the sign in this photo stating: "THE NEW NEGRO HAS NO FEAR."

THE NEW NEGRO AND PARIS NOIR

Curtis Young

African American culture enjoyed a long and rich relationship with Parisian culture even before World War I. In 1891, the African American artist Henry Ossawa Tanner moved to Paris, where he gained international acclaim. During the war, nearly two hundred thousand African American soldiers served in France. Their presence laid the foundations for a greater artistic exchange between France and black America, creating a distinctive black cultural, social, and intellectual milieu that became known as "Paris Noir."

 The experience of black servicemen in France, fifty-four years after the end of slavery but still amid the horrors of Jim Crow, engendered a spirit that A. Philip Randolph referred to as that of the "New Negro." Randolph's New Negro demanded political equality, equal wages, and absolute social equality, including the right to interracial marriage. Fundamental to the New Negro's journey, Randolph believed, was education.

The success of the Paris production of the Broadway hit *Blackbirds of 1928*, with an all-black cast, is celebrated by *Blackbirds* creator Lew Leslie, members of the cast and crew of the production, and other guests.

Among the postwar African American expatriates was Eugene Bullard (see page 111), who had come to France just before the war. He had served in the French Foreign Legion, was wounded at the battle of Verdun, and later became the first black American pilot, flying for the French Air Service. He opened the famous Grand Duc nightclub in Montmartre and remained in France until forced to flee the Germans, who had put a price on his head, at the outbreak of World War II.

Music played a key role in the welcome these soldiers received on arrival in France. James Reese Europe (see page 120), the bandleader of the popular Society Orchestra, had been recruited to the 369th Infantry Regiment to lead its band. On January 1, 1918, Europe lined up the regimental band when the regiment landed at Brest, on the French west coast, and played the French national anthem, the Marseillaise, in ragtime. The band was then invited to play one of the earliest jazz concerts held in Europe.

Members of the 369th regimental band went on to fame in Hollywood and New York. For example, Dooley Wilson (who also played Sam in the film *Casablanca*, although he was a drummer and singer rather than a pianist), was featured in *Stormy Weather*, a 1943 musical based on Bill "Bojangles" Robinson's life. In 1921, the 369th veteran Noble Sissle, with Eubie Blake, wrote and produced the Broadway hit musical *Shuffle Along*, which launched the careers of Paul Robeson and Florence Mills.

As a teenager, a high school dropout and housemaid named Josephine Baker had been a firsthand witness to the violence during the East St. Louis riots. What she heard of life in France made her determined to leave America behind. She moved to Paris and gained renown as a dancer. Her famous *Danse sauvage* in Paris in 1925 was a sensation, and she went on to star in stage performances and movies. She became a French citizen in 1937 and worked for the French Resistance during World War II, for which she earned France's highest military award, the Croix de Guerre, as well as the

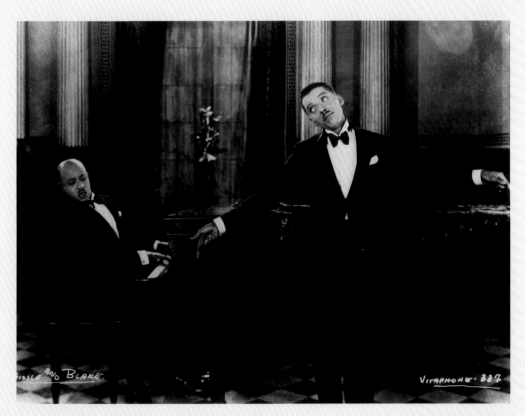

Noble Sissle and Eubie Blake perform in 1926. Their 1921 hit musical *Shuffle Along* was one of the first Broadway musicals written by and about African Americans.

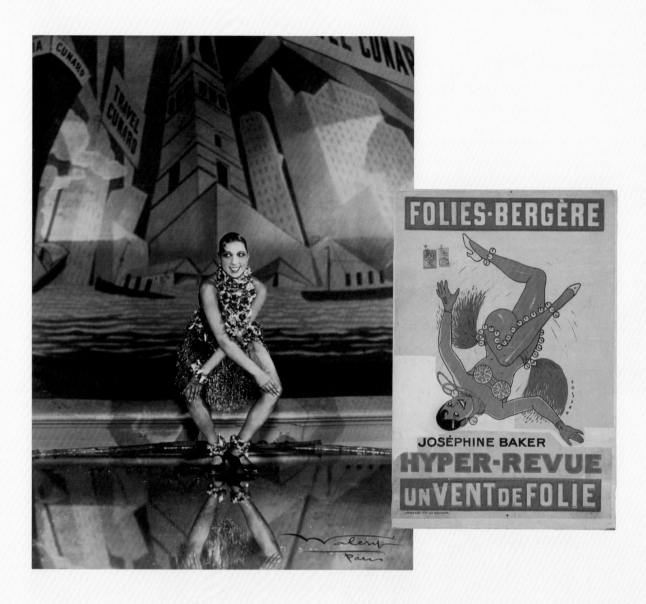

coveted Legion of Honor. She later opened an orphanage in the south of France. In Paris Noir, she lived a life she could never have dreamed of in 1920s East St. Louis. Leroy Haynes introduced France to soul food when he opened the first American restaurant in Montmartre. And France heard from Sidney Bechet how sweet a clarinet could sound when he composed and played *Petite Fleur*.

As white America intensified its Jim Crow project after World War I, the vision of the New Negro movement pointed to a different world, one in which black culture could flourish. Paris Noir offered a gateway to other parts of Europe, including Copenhagen, Stockholm, and even the former Soviet Union, where the American writer, performer, and activist Paul Robeson arrived in 1934 from Germany. (His engagement with the USSR eventually cost him his American citizenship.) In these locations, more than in most of the United States, the New Negro found an audience receptive to black music, literature, and art, and appreciative of their humanism and resilience. ✸

Left: Josephine Baker was a celebrated cabaret performer, known for her erotic and whimsical dancing and exotic costumes. Here she dances the Charleston onstage at the Folies Bergère in Paris, circa 1928.

Above: In 1927 Josephine Baker's revue *Un vent de folie* premiered at the Folies Bergère in Paris. Her costume, consisting only of jewelry and a bikini bottom with bananas attached, became instantly iconic.

Above: Sidney Bechet is considered one of the great New Orleans jazz musicians, along with Louis Armstrong and King Oliver, and was also influential in the Paris Noir community. He is best known for his innovative sound on the clarinet and soprano saxophone.

Right: Louis Armstrong is one of the best-known jazz musicians in the world. As a trumpeter and singer, he performed around the world with his band. They are pictured here in Stockholm, Sweden, in 1933.

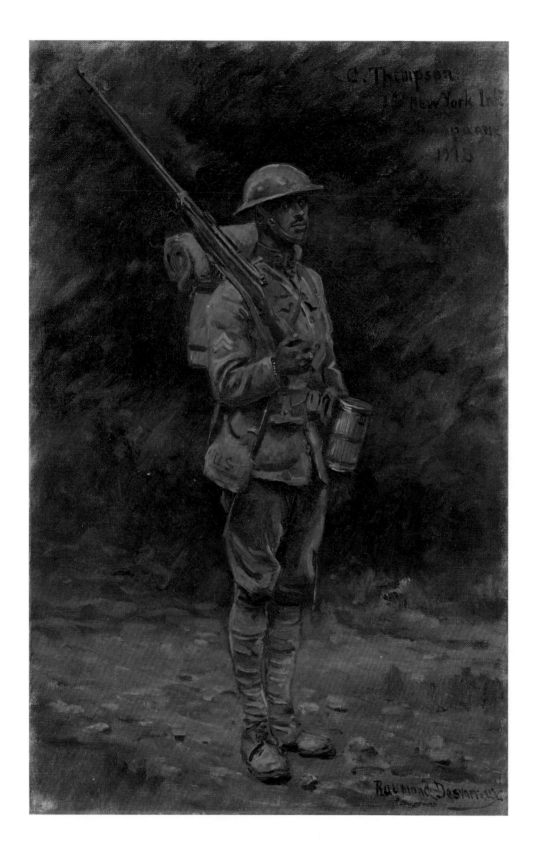

Soldier C. Thompsen
of the 369th Harlem
Hellfighters carries his
rifle and gear in this
1918 painting by the
French artist Raymond
Desvarreux.

Epilogue:
On the Horizon—
Toward Civil Rights

Tim O'Brien's "The Things They Carried" is a short story that consists mainly of lists of the almost innumerable items that Vietnam-era infantry grunts carried in their packs: everything from the small and quotidian (pocket knives, C-rations) to the personally precious (good-luck charms, love letters) to the abstract (grief, fear) to, finally, the overwhelming burdens of American history itself.

The young black soldiers who fought in World War I went abroad already carrying a heavy load: their experiences in an America of "lynching, disfranchisement, caste, brutality and devilish insult," to quote W. E. B. Du Bois. Yet many, draftees and volunteers alike, also brought Du Bois's hope that sacrifice in wartime, and in the defense of the world's democracies against the tyrannies of empire, might win them respect and political equality once they returned home. A young man who had foreseen for himself only the sharecropper's life that his father and his grandfather had scraped out in the South, or the prospect of menial labor in the North, suddenly found himself far from home, participating in a titanic struggle in countries that had once been just names on a map. Even as they found themselves consigned to service regiments and often denied the equipment, rations, and medical care that white soldiers received, black soldiers must have found resonance in the Bible's lessons on sacrifice as a path toward the Promised Land. A newfound confidence and a sense of contributing to a greater endeavor enabled some, at least, to feel their burdens ironically lightened a bit under the terrible pressures of war.

Whatever baggage a soldier carries to war is only multiplied by the experience of combat. African American soldiers returned home in early 1919 changed men, their vision broadened not only by glimpses of a freer life in a cosmopolitan France, where the flowers of Paris Noir had begun to bloom, but by meeting, befriending, engaging with, and fighting alongside other black Americans from distant parts of the United States. Whether they were clearing mines, burying the dead, unloading supply ships, digging trenches, or fighting through the mechanized nightmares of the Argonne Forest and the Aisne-Marne counteroffensive, these young men developed a new sense of expectation. As a group they had sacrificed, and as a group surely they had earned their country's respect.

As the essays in this book show us, it was not to be. From the early 1880s to 1914, America had been setting in place the legislative bulwarks of segregation. For many

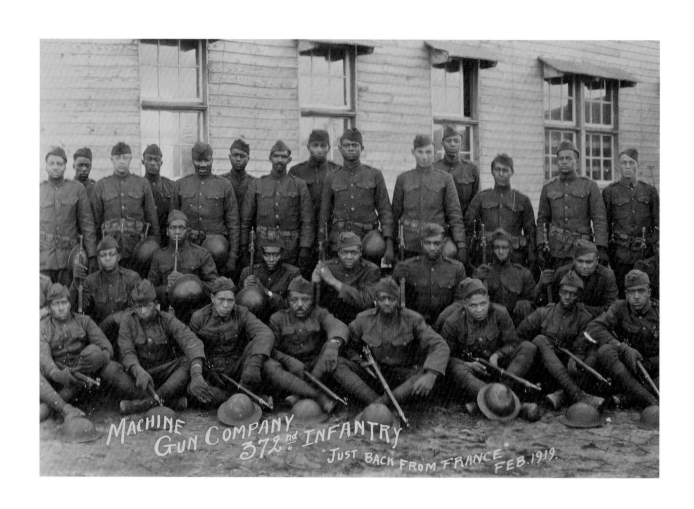

MACHINE GUN COMPANY 372ND INFANTRY "JUST BACK FROM FRANCE" FEB. 1919.

The 372nd Infantry Machine Gun Company "just back from France," February 1919. The 372nd was composed of National Guard units from across the country, including Connecticut, Maryland, Massachusetts, Ohio, Tennessee, and Washington, DC.

white Americans—especially Woodrow Wilson, the progressive Southern gentleman who nonetheless saw Reconstruction as a Radical Republican overreach—World War I was implicitly about defending their own society: their democracy, their ideals, their freedoms, their ability to rule over others.

Wilson was a paradox. An American Progressive (in the sense of his own time), he believed that federal government had an interventionist role and that it should "make those adjustments of life which will put every man in a position to claim his normal rights as a living, human being." He backed up that sentiment with four major emphases during his administration: banking reform, trust regulation, tariff reduction, and protection of natural resources. He instituted labor protection laws, imposed graduated income taxes, favored women's suffrage, sought to back off from the imperialist actions that had preceded his administration, and in many ways seemed one of the first truly "modern" presidents. Yet he was also a child of the South, and many of his policies and political appointments were unapologetically racist—including Postmaster General Albert Burleson and Wilson's own son-in-law, Treasury's William McAdoo, who swiftly segregated their departments, as did the navy. Wilson's first wife, Ellen, added fuel to the fire by encouraging segregated working and rest facilities for federal employees.

Wilson may have framed his racism in a language more genteel than that of some of his predecessors, saying to black leaders that his segregationist actions were meant only to "reduce the friction. It is as far as possible from being a movement against the Negroes. I sincerely believe it to be in their interest." Yet his paternalism was as damaging to black interests as open animus would have been. In 1914, the president told the African American newspaper editor Monroe Trotter:

> The white people of the country, as well as I, wish to see the colored people progress, and admire the progress they have already made, and want to see them continue along independent lines. There is, however, a great prejudice against colored people. . . . It will take one hundred years to eradicate this prejudice, and we must deal with it as practical men. Segregation is not humiliating, but a benefit, and ought to be so regarded by you gentlemen. If your organization goes out and tells the colored people of the country that it is a humiliation, they will so regard it, but if you do not tell them so, and regard it rather as a benefit, they will regard it the same. The only harm that will come will be if you cause them to think it is a humiliation.

When Trotter disputed these statements, Wilson, offended, sent him away and refused to meet with him again.

The return of thousands of young black soldiers newly skilled in fighting and handling guns, and newly conscious of their own capabilities, was profoundly threatening to many white Americans, whether their racism was of the condescending hue of Wilson's or blatant. Extralegal terrorist organizations—most notably the second Ku Klux Klan, founded in 1915—and racial riots awaited black soldiers back home, in a landscape newly primed for racial strife by D. W. Griffith's film *The Birth of a Nation*.

So too did resentful white workers, primed for violence by a shambling economy and the Great Migration that had brought millions of new black residents into cities and factories.

Yet progress was being made: the NAACP, founded in 1909 by Du Bois, Mary Church Terrell, Ida B. Wells, Archibald Grimké, and others, was already beginning its long years of litigation to protect black Americans from lynchings, win full enfranchisement, and rip out the strutwork of Jim Crow. A. Philip Randolph, the founder of the influential African American magazine *The Messenger* began organizing black workers to demand better labor conditions, founded the influential Brotherhood of Sleeping Car Porters, and went on to bend Harry Truman's ear hard enough that in 1948 the president issued Executive Order 9981, at last desegregating the US military. Meanwhile, despite the violence aimed at them, the rural black Southerners who had moved north to take jobs vacated by white men going to fight abroad generally stayed in their new cities, where they enjoyed both slightly better pay and slightly better conditions—and where they not only created new literature, new visual art, new media, and new black colleges and universities but also gained a newfound sense of their substantial cultural and political power. The Harlem Renaissance was not limited to New York: sister movements emerged in Chicago, in Los Angeles, and in Washington, DC. "Black is beautiful," that catchphrase of the 1960s and 1970s, had its birth in the cultural explosion that followed World War I. A racial identity that had been a negative, the new black cultural movements suggested, was in fact a great positive in the hands of black artists, educators, and civil rights activists: it was a burden turned into a gift.

No single account can fully capture the African American experience in World War I or tell us what the war meant for black Americans in the decades afterward, when its echoes were heard in President Harry S Truman's desegregation order, the landmark *Brown v. Board of Education* desegregation decision of 1954, and the long battles of the 1960s to gain for black citizens the democracy for which all those young men had died so long ago. Although the war did not swing open the doors of enfranchisement for African Americans, it could be said that its sheer scale—the slap across the world's face of the first truly global war—did open for us a new sense of our own potential and possibilities, and thus set into motion an incremental movement toward freedom. The burdens on the backs of black Americans, military or civilian, remain heavy, but our forebears' sacrifices in World War I—and all the wars that have followed—have not been forgotten, and they remain incontrovertible proof of our entitlement to full rights as citizens of our own country.

Lonnie G. Bunch III
Secretary of the Smithsonian

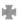

African Americans returned from the war with a new understanding of themselves and their communities, ready to fight for and defend the same ideals they fought for on the battlefields in Europe.

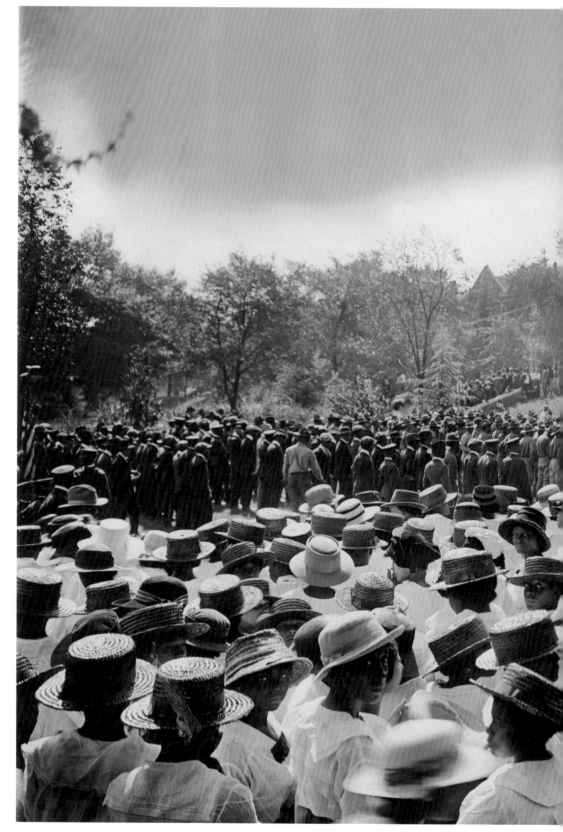

In 1918, the US government established the Student Army Training Corps (SATC) to provide military training to young men between the ages of 18 to 21 while attending college. Many HBCUs, including Tuskegee Institute, operated SATC programs. This photograph by C. M. Battey depicts a SATC graduation at Tuskegee in 1918 or 1919.

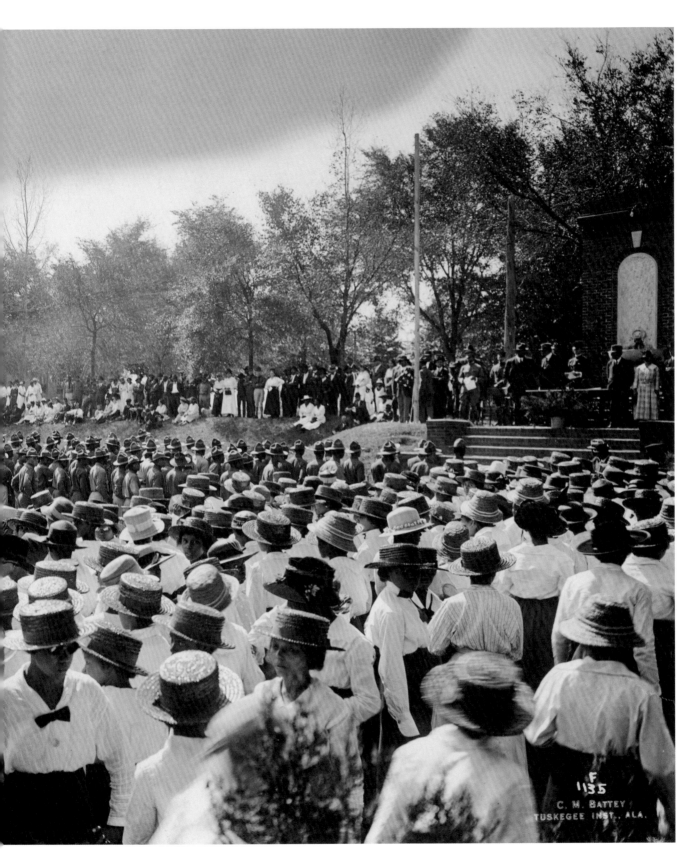

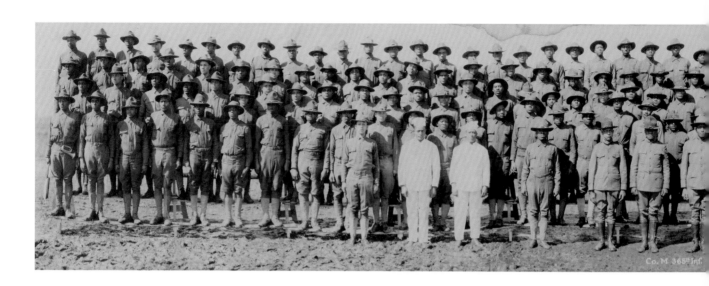

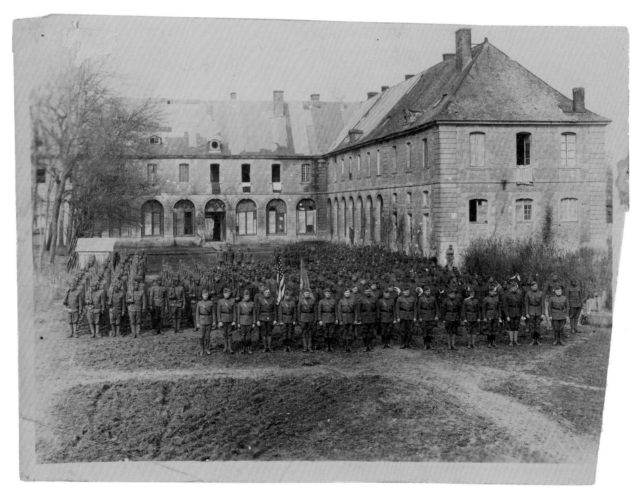

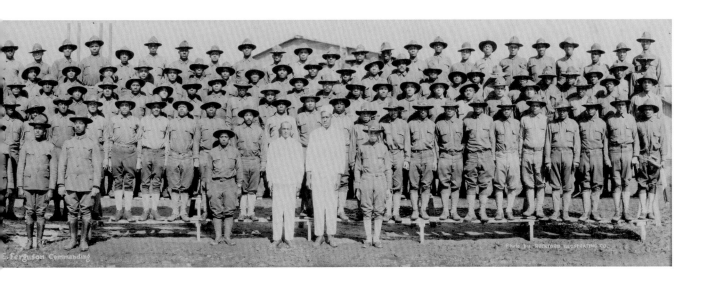

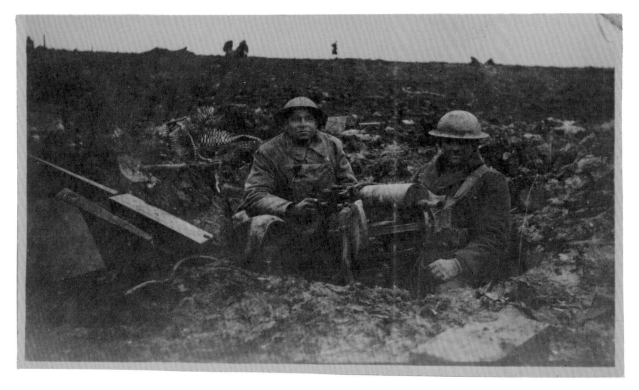

Top: M Company,
365th Infantry, 1917–19.

Left: Servicemen
standing in front of
Chateau Chehery in
France, March 1919.

Right: Two soldiers
in a foxhole, 1916–19.

Acknowledgments

We Return Fighting: World War I and the Shaping of Modern Black Identity is the work of many hands, and we wish to acknowledge those who joined us on this journey.

We thank Lonnie G. Bunch III, Smithsonian secretary and founding director of the National Museum of African American History and Culture, both for being one of the book's staunchest supporters and for delivering an introduction that sets the stage for all that follows and an epilogue that summarizes the War's larger impact. Your words encourage all who read it to applaud the African American service members of World War I for their courage and determination. You also point to the ideals and strengths of an array of activists and intellectuals who wrestle with issues of identity and self-determination, all through a clear-eyed understanding of the effects of racial injustice in America's first global war.

Krewasky A. Salter deserves singular praise for his role as the curator of the exhibition *We Return Fighting: The African American Experience in World War I*, for which this publication is a companion, and as a driving force behind the book and a major contributing writer. His considerable knowledge of military history and its context, along with his scholarship and his guidance on content, were irreplaceable.

We are indebted to the scholars whose critical knowledge of World War I and whose splendid writing illuminates this volume: Lisa Budreau, Brittney Cooper, John H. Morrow Jr., Chad Williams, Jay Winter, and Curtis Young. As advising editor, John also provided invaluable insights. All provided critical advice on the focus of the book. Their willingness to lend their expertise to this endeavor helped develop important narratives about the significant and transformative figures, contributions, struggles, and aspirations of African Americans before, during, and after the war.

On behalf of the museum, we acknowledge our French partners, including Ambassador Philippe Étienne, former Ambassador Gérard Araud, and cultural counselor Bénédicte de Montlaur for their support. We owe a very special word of thanks to cultural attaché Julie Le Saos for her unwavering friendship and collegiality at every step. We express our profound gratitude to Joseph Zimet, director general of the Mission du Centenaire de la Première Guerre Mondiale, whose initial invitation to join the official commemoration of the Centennial made possible loans from French museums of critical artifacts that are represented here and in the exhibition. We also thank his colleague, Marion DuPlaix, who made much of our work with French museums possible. Special thanks also to Bill Gwaltney, formerly of the American Battle Monuments Commission, who facilitated early work with our French partners.

It was a joy and honor to work again with our colleagues at Smithsonian Books, led by director Carolyn Gleason, in partnership with senior editor Christina Wiginton, and their colleagues Jody Billert, Laura Harger, and Jaime Schwender. In collaboration with editor Erika Büky and designer Gary Tooth, we were able to identify the right look and

tone for the publication. With their unerring support and creative gifts, we were able to realize a book that will make an important contribution to the literature on military history and African American history.

We also thank Laura Coyle, Joseph Campbell, Jeannine Fraser, Mignonette Dooley Johnson, and Minda Logan. We offer a word of special gratitude to the indefatigable Doug Remley for his research and writing and for painstakingly poring through hundreds of images, making thoughtful recommendations, and clearing rights for the illustrations that so deftly complement the incredible writing throughout the book.

We offer kudos to our NMAAHC colleagues, without whom this publication would not have been possible. Principal among them are our curatorial colleagues Rex M. Ellis, Tulani Salahu-Din, and Fatima Elgarch. We also thank William Pretzer and Jaye P. Linnen for stepping in and stepping up at crucial moments. Our sincere gratitude goes to the larger NMAAHC team: Carlos Bustamante, Tanya Cooks, Shrita Hernandez, Lindsey Koren, Danielle Lancaster, Patri O' Gan, Arlisha Norwood, Jacquelyn Days Serwer, Kassie Edwards, and Fleur Paysour, and all who contributed their counsel, creativity, dedication, and expertise in bringing this publication to life.

Finally, we thank all the courageous men and women commemorated in these pages, who "returned fighting" for freedom and justice for all.

Kinshasha Holman Conwill
Editor

Further Reading

Badger, Reid. *A Life in Ragtime: A Biography of James Reese Europe.* New York: Oxford University Press, 1995. An excellent biography of the famed composer and bandleader of the Harlem Hellfighters Band.

Budreau, Lisa M. *Bodies of War: World War I and the Politics of Commemoration in America, 1919-1933* (New York: New York University Press, 2009. An insightful history of the politics and processes of memorializing fallen World War I soldiers.

Brown, Nikki. *Private Politics and Public Voices: Black Women's Activism from World War I to the New Deal.* Bloomington: Indiana University Press, 2006. An important history of the importance of the war to the activism of middle-class African American clubwomen.

Dalessandro, Robert J., and Gerald Torrence. *Willing Patriots: Men of Color in the First World War.* Altglen, PA: Schiffer Military History, 2009. An encyclopedic photographic history of African American units and soldiers.

Ellis, Mark. *Race, War, and Surveillance: African Americans and the United States Government during World War I.* Bloomington: Indiana University Press, 2001. A history of government surveillance of African Americans that shows many white Americans' fears of and ignorance about African Americans.

Ferrell, Robert H. *Unjustly Dishonored: An African American Division in World War I.* Columbia: University of Missouri Press, 2011. A short, incisive history of the 92nd Infantry Division.

Giddings, Paula. *Icd/a: A Sword among Lions.* New York: Amistad, 2008. A biography of the renowned journalist, activist, and antilynching crusader.

Giddings, Paula. *When and Where I Enter: The Impact of Black Women on Race and Sex in America.* New York: Quill, 1984. The first historical study of the relationship in America between racism and sex.

Hine, Darlene Clark. "World War I." In *Black Women in America,* Volume 3. 2nd ed. New York: Oxford University Press, 2005. A multivolume history that celebrates the achievements of black women throughout history and highlights their ongoing contributions in America today.

Lentz-Smith, Adriane. *Freedom Struggles: African Americans and World War I.* Cambridge, MA: Harvard University Press, 2009. An exceptional history of the early civil rights movement.

Lewis, David Levering. *W. E. B. Du Bois: Biography of a Race, 1868–1919.* New York: Henry Holt, 1993. A biography of the famed scholar and activist.

Lewis, David Levering. *When Harlem Was in Vogue.* New York: Oxford University Press, 1979. A history of Harlem from 1905 through the Harlem Renaissance to 1935.

Morrow, John H. Jr. *The Great War: An Imperial History.* London: Routledge, 2004. A global history of World War I that discusses the roles of soldiers and peoples of color.

Roberts, Frank E. *The American Foreign Legion: Black Soldiers of the 93rd in World War I.* Annapolis, MD: Naval Institute Press, 2004. An excellent history of the 93rd Infantry Division, its regiments, and its men.

Salter, Krewasky. *The Story of Black Military Officers, 1861-1948.* New York: Routledge, 2014. The first complete and conclusive work to specifically examine the history of black commissioned officers.

Sammons, Jeffrey T., and John H. Morrow Jr. *Harlem's Rattlers and the Great War: The Undaunted 369th Regiment and the African American Quest for Equality.* Lawrence: University Press of Kansas, 2014. The best and most detailed history of the famed Harlem Hellfighters, under the name its soldiers applied to their regiment.

Whalan, Mark. *The Great War and the Culture of the New Negro.* Gainesville: University of Florida Press, 2008. A study of the legacy of World War I for African American culture.

Williams, Chad. *Torchbearers of Democracy: African American Soldiers in the World War I Era.* Chapel Hill: University of North Carolina Press, 2010. An exceptional, prize-winning history of black soldiers during and after the war.

Winter, Jay. *War Beyond Words: Languages of Remembrance from the Great War to the Present* (Cambridge: Cambridge University Press, 2017). A panoramic history of transformations in our global imaginings of war from 1914 to the present.

Also recommended:

The Black American Heroes of World War I. Documentary directed by William Miles. Men of Bronze, Inc. 1977. DVD. Direct Cinema Ltd., 1996. An outstanding documentary that includes lengthy interviews with the men of the Harlem Hellfighters.

Alain Locke, known as the "Father of the Harlem Renaissance," edited the anthology *The New Negro: An Interpretation* in 1925 to highlight many of the writers and intellectuals of the New Negro Movement and the Harlem Renaissance. Featured in the anthology are Countee Cullen, Langston Hughes, Zora Neale Hurston, Claude McKay, Jean Toomer, and artist Aaron Douglas, among others.

Contributors

Lisa M. Budreau is senior curator of military history for the Tennessee State Museum. A specialist in commemorative history, she has served as vice president of the National World War I Museum and consultant for the American Battle Monuments Commission. Her publications include *Bodies of War: World War I and the Politics of Commemoration in America, 1919–1933* and *Answering the Call: The U.S. Army Nurse Corps, 1917–1919*.

Lonnie G. Bunch III is a historian, educator, and author. He is the founding director of the National Museum of African American History and Culture, the nation's largest and most comprehensive cultural destination devoted exclusively to exploring, documenting, and showcasing the African American story and its impact on American and world history. In 2019 he became the fourteenth secretary of the Smithsonian.

Brittney Cooper is associate professor of women's and gender studies and Africana studies at Rutgers University. She is co-founder of the popular Crunk Feminist Collective blog and co-editor of *The Crunk Feminist Collection*. Her publications include *Beyond Respectability: The Intellectual Thought of Race Women* and *Eloquent Rage: A Black Feminist Discovers Her Superpower*.

John H. Morrow Jr. is the Franklin Professor of History at the University of Georgia. His areas of expertise include modern European history, World War I, and world history. His publications include *The Great War: An Imperial History* and *Harlem's Rattlers and the Great War: The Undaunted 369th Regiment and the African American Quest for Equality*, which he co-authored with Jeffrey T. Sammons.

Krewasky A. Salter, a US Army colonel (retired), is the executive director of the First Division Museum. As a guest curator at the Smithsonian National Museum of African American History and Culture, he curated both the museum's inaugural exhibition, "Double Victory: The African American Military Experience," and "We Return Fighting: The African American Experience in World War I." His publications include *The Story of Black Military Officers, 1861–1948*.

Chad Williams is the Samuel J. and Augusta Spector Professor of History and African and African American Studies at Brandeis University. He specializes in African American and modern United States history, African American military history, the World War I era, and African American intellectual history. Williams is co-editor of *Charleston Syllabus: Readings on Race, Racism, and Racial Violence*. His publications include *Torchbearers of Democracy: African American Soldiers in the World War I Era*.

Jay Winter is the Charles J. Stille Professor of History Emeritus at Yale University. He is a specialist on World War I and its consequences. His latest book is *War Beyond Words: Languages of Remembrance from the Great War to the Present*.

Curtis Robert Young is a lauréat of the Châteaubriand Fellowship in Humanities and Social Sciences and a visiting professor of American literature at ESSEC Grandes Ecoles Paris. His research focuses on the social and political America that produced African American soldiers who served in World War I, their reception in France and the cultural space their presence opened, and the resulting connections between France and African American music, art, and literature that continue today.

This banner, printed with the motto of the National Association of Colored Women's Clubs, was used by the Oklahoma Federation of Colored Women's Clubs, circa 1924.

Illustration Credits

1*tl*: 2011.108.17, Gift of Gina R. McVey, Granddaughter; 1*tm*: 2011.155.95; 1*tr*: Courtesy of the Library of Congress; 1*ml*: 2011.155.111; 1*m*: 2011.155.98; 1*mr*: 2011.155.92; 1*bl*: 2011.155.93; 1*bm*: Courtesy of the Library of Congress; 1*br*: 2011.155.97; 2–3: Courtesy of the National Archives and Records Administration; 6: © RMN–Grand Palais / Art Resource, NY; 8: Bettmann / Getty Images; 10: 2011.155.241; 11: © 2019 The Jacob and Gwendolyn Knight Lawrence Foundation, Seattle / Artists s Society (ARS), New York and © 2019 Artists s Society (ARS), New York / VG Bild–Kunst, Bonn; 12: 2008.2.3; 14: *Chronologically from left to right* 2012.40; 2011.51.12, Gift from the Liljenquist Family Collection; 2010.45.11; 2009.37.2; 2008.2.2; Courtesy of the Library of Congress; Courtesy of the Library of Congress; 2018.105.11, Gift of the Liljenquist Family; 2011.155.236; Courtesy of the National Archives and Records Administration; *Chicago Defender*, public domain; 2012.86; TA2014.306.2.3.6, Gift of the Scurlock family; TA2015.143.6.8.1, Gift of Jennifer Cain Bohrstedt; 2013.165.1.1ab, Gift of Ray R. and Patricia A.D. Charlton in memory of Cornelius H. Charlton; 2015.226.1–.2, Donated by the International Civil Rights Center & Museum, Greensboro, NC; 2011.159.3.25, Gift from Dawn Simon Spears and Alvin Spears Sr.; 2011.11.32, Gift of James H. Wallace Jr, © Jim Wallace; 2015.129.34, Gift of Monica Karales and the Estate of James Karales, © Estate of James Karales; 15*t*: 2016.32.2, Gift of the University of Hawai'i at Manoa, Department of Art and Art History; 15*b*: 2018.13.3.1ab, Gift of Beverly J. Blackwood in memory of Charles J. Blackwood Sr.; 16–17: 2015.97.23.1; 18: 2018.105.15, Gift of the Liljenquist Family; 20: Courtesy of the Library of Congress; 21*t*: Courtesy of the Library of Congress; 21*b*: 2017.111.3, Gift of Alan Laird; 22: Digital Image © The Museum of Modern Art / License by SCALA / Art Resource, NY; 23: Courtesy of the Library of Congress; 24: Courtesy of the National Archives and Records Administration; 25: Courtesy of the National Archives and Records Administration; 26: Courtesy of the National Archives and Records Administration; 27: Courtesy of the National Archives and Records Administration; 28–29: Musée de la Grande Guerre, Meaux / Y. Marques; 30: Musée de la Grande Guerre, Meaux / Y. Marques; 31: Courtesy of the Library of Congress; 33*tl*: 2017.111.5, Gift of Alan Laird; 33*tr*: 2017.111.4ab, Gift of Alan Laird; 33*m*: 2017.111.7.1, Gift of Alan Laird; 33*bl*: 2017.111.17, Gift of Alan Laird; 33*br*: 2017.111.11, Gift of Alan Laird; 34: Courtesy of the Library of Congress; 35*l*: Musée de la Grande Guerre, Meaux / Y. Marques; 35*r*: 2017.111.8, Gift of Alan Laird; 36*t*: Keystone–France / Getty Images; 36*b*: Courtesy of the Library of Congress; 37: Courtesy of the Library of Congress; 38: National Portrait Gallery, Smithsonian Institution; gift of an anonymous donor; 39: 2019.20.1, Gift of Alan Laird; 40: 2009.37.3; 41: 2012.84.8, Gift of Bobbie Ross in memory of Elizabeth Dillard; 43: 2012.84.7, Gift of Bobbie Ross in memory of Elizabeth Dillard; 44: Courtesy of Ronald Williams Library, Northeastern Illinois University; 45: Courtesy of the Library of Congress; 46: Courtesy of Ronald Williams Library, Northeastern Illinois University; 48–49: 2015.97.23.11; 50: 2014.115.5, Gift of the Garrison Family in memory of George Thompson Garrison; 52: 2010.45.11; 53: 2010.36.2; 55*l*: Courtesy of the Library of Congress; 55*r*: Special Collections Research Center, University of Chicago Library; 56–57: 2015.139; 58: 2010.51.2; 59*t*: A2017.13.1.45, Gift of Ray and Jean Langston in memory of Mary Church and Robert Terrell; 59*b*: 2018.59.1, Gift of Charles Hamilton Houston, J. and Dr. Rosemary Jagus; 60–61: 2014.63.77; 62: Schomburg Center for Research in Black Culture, Jean Blackwell Hutson Research and Reference Division, The New York Public Library; 64: 2016.71ab, Gift of J. Wesley Huguley IV in memory of Dr. John W. Huguley III; 65: 2012.34.1.1abc, Gift of the Family of Frances Sampson Mask; 66*t*: 2012.171.5, In memory of George M. Langellier Sr.; 66*b*: 2011.155.242; 67: Courtesy of the National Archives and Records Administration; 68: Courtesy of the National Archives and Records Administration; 70: State Historical Society of Iowa, Des Moines; 72: 2011.155.299ab; 73*t*: 2010.18.1, Gift of Peter L. Robinson Jr. and Marie Robinson Johnson; 73*b*: 2016.163.1, Gift of Marie Robinson Johnson in memory of First Lieutenant Peter L. Robinson Sr.; 74: 2018.59.3, Gift of Charles Hamilton Houston, J. and Dr. Rosemary Jagus; 75: Courtesy of the Moreland–Springarn Research Center, Howard University Archives, Washington, DC; 76–77: Courtesy of the Library of Congress; 78: Courtesy of the National Archives and Records Administration; 80: Courtesy of the Library of Congress; 81: Gift of Joseph H. Hirshhorn, 1966. Photography by Cathy Carver.

Hirshorn Museum and Sculpture Garden; 83: 2019.18.11, Gift of the Greer–Calmeise Family of Cincinnati, Ohio; 84: Courtesy of the Library of Congress; 85*l*: 2017.111.9, Gift of Alan Laird; 85*r*: Bettmann / Getty Images; 86: Courtesy of the National Archives and Records Administration; 87: 2018.13.5.1, Gift of Beverly J. Blackwood in memory of Charles J. Blackwood Sr.; 88: 2011.108.16, Gift of Gina R. McVey, Granddaughter; 89*tl*: 2011.108.9.1, Gift of Gina R. McVey, Granddaughter; 89*tr*: 2011.108.7, Gift of Gina R. McVey, Granddaughter; 89*bl*: 2011.108.3, Gift of Gina R. McVey, Granddaughter; 89*br*: 2011.108.6, Gift of Gina R. McVey, Granddaughter; 90: 2019.37, Gift of Dr. Jeff Gusky; 91: Archives of American Art, Smithsonian Institution; 92: A2014.39.9.5.19.3, Gift of Dr. Ione D. Vargus in memory of her father Lt. Col. Edward Dugger; 93: Courtesy of the Library of Congress; 95*l*: Courtesy of the National Archives and Records Administration; 95*r*: 2010.39.3; 94–95: 2018.2.1–.2, Gift from the children of Carrie E. Broadnax; 96–97: Courtesy of the National Archives and Records Administration; 98: Courtesy of the Library of Congress; 100*t*: 2010.39.9.4; 100*b*: 2011.159.3.50, Gift from Dawn Simon Spears and Alvin Spears Sr.; 101: Photographs and Prints Division, Schomburg Center for Research in Black Culture, The New York Public Library; 102: A2017.13.1.4, Gift of Ray and Jean Langston in memory of Mary Church and Robert Terrell; 103: TA2017.13.10.2, Gift of Ray and Jean Langston in memory of Mary Church and Robert Terrell; 104: National Portrait Gallery, Smithsonian Institution; 106: Musée de la Grande Guerre, Meaux / Y. Marques; 107: 2017.111.25, Gift of Alan Laird; 108: National Air and Space Museum, Smithsonian Institution; 109*t*: Schomburg Center for Research in Black Culture, Jean Blackwell Hutson Research and Reference Division, The New York Public Library; 110: 2015.2.3, Gift of Robert L. Johnson; 111: Courtesy of the Library of Congress; 112: Courtesy of the National Archives and Records Administration; 113*t*: Published with the permission of The Wolfsonian – Florida International University (Miami, Florida); 113*b*: 2017.111.6, Gift of Alan Laird; 114: Courtesy of the National Archives and Records Administration; 115: Courtesy of the Library of Congress; 116*t*: Courtesy of the National Archives and Records Administration; 116*b*: 2017.111.21, Gift of Alan Laird;

117: 2011.155.298; 118–119: 2011.57.39; 120*t*: Courtesy of David and Joanne Burke in honor of Frank Driggs; 120*b*: 2014.63.79; 121*l*: Bettmann / Getty Images; 121*r*: 2013.88.2; 122: Photographs and Prints Division, Schomburg Center for Research in Black Culture, The New York Public Library; 123: 2015.97.23.16; 124: 2015.97.23.12; 125: Courtesy of the National Archives and Records Administration; 126–127: Courtesy of the National Archives and Records Administration; 130: Photographs and Prints Division, Schomburg Center for Research in Black Culture, The New York Public Library; 132: 2011.57.27.1; 133: Courtesy of David and Joanne Burke in honor of Frank Driggs; 134*l*: 2016.135.2, Gift from Jean–Claude Baker; 134*r*: 2016.135.3, Gift from Jean–Claude Baker; 135*t*: Courtesy of David and Joanne Burke in honor of Frank Driggs; 135*b*: Courtesy of David and Joanne Burke in honor of Frank Driggs; 136: © Musée de l'Armee / Dist. RMN–Grand Palais / Art Resource, NY; 138: 2016.31.1, Gift of the University of Hawai'i at Manoa, Department of Art and Art History; 141: 2018.105.11, Gift of the Liljenquist Family, 142–143: 2013.46.30; 144*b*: 2018.19.5.6; 145*b*: 2012.171.12, In memory of George M. Langellier Sr.; 144-145: 2018.13.3.3ab, Gift of Beverly J. Blackwood in memory of Charles J. Blackwood Sr.; 149: 2013.21; 151: 2010.2.1abc.

Index

Note: page numbers in **bold** indicate photographs or art.